ART IN AMERICA
A Brief History

THE HARBRACE HISTORY OF ART

RICHARD McLANATHAN

ART IN AMERICA
A Brief History

with 189 illustrations

HBJ

HARCOURT BRACE JOVANOVICH, INC.

In memory of
George and Clara St. John

First American edition 1973

ISBN 0–15–108470–X HARDBOUND
ISBN 0–15–503466–9 PAPERBOUND
Library of Congress Catalog Card Number: 72–923–58

Filmset in Great Britain by Keyspools Ltd, Golborne, Lancashire
Printed by Roto-Sadag, S.A., Geneva, Switzerland
Bound by Hollmann K.G., Darmstadt, Germany

CONTENTS

MUSEUMS REFERRED TO IN THIS BOOK

The abbreviation used in the text is indicated in italics.

The *Albany* Institute of History and Art, Albany, New York. *Amon Carter* Museum of Western Art, Fort Worth, Texas. Addison Gallery of American Art, *Andover*, Massachusetts. Museum of Fine Arts, *Boston*, Mass-achusetts. *Bowdoin* College Museum of Art, Brunswick, Maine. *Brookline* Historical Society, Brookline, Mass-achusetts. *Brooklyn* Museum, Brooklyn, New York. *California Palace* of the Legion of Honor, San Francisco. The Art Institute, *Chicago*, Illinois. *Cleveland* Museum of Art, Cleveland, Ohio. *Colby* College Art Museum, Waterville, Maine. *Colorado Springs* Fine Arts Center, Colorado Springs, Colorado. The New York State His-torical Association, *Cooperstown*, New York. The *Detroit* Institute of Arts, Detroit, Michigan. The Wadsworth Atheneum, *Hartford*, Connecticut. Fogg Art Museum, *Harvard* University, Cambridge, Massachusetts. Col-lection of the International Business Machine Corporation, New York. William Rockhill Nelson Gallery and Atkins Museum of Fine Arts, *Kansas* City, Missouri. *Metropolitan* Museum of Art, New York. *Museum of Modern Art*, New York. Mariners' Museum, *Newport News*, Virginia. The *New-York Historical Society*, New York. National Gallery of Canada, *Ottawa*, Ontario. The *Pennsylvania Academy* of the Fine Arts, Philadelphia. *Historical Society* of *Pennsylvania*, Philadelphia. *Philadelphia* Museum of Art, Philadelphia, Pennsylvania. *Phillips Collection*, Washington, D.C. Adams National Historic Site, *Quincy*, Massachusetts. *Reading* Public Museum and Art Gallery, Reading, Pennsylvania. *Roswell* Museum and Art Center, Roswell, New Mexico. Abby Aldrich *Rockefeller* Folk Art Collection, *Williamsburg*, Virginia. City Art Museum, *St Louis*, Missouri. The *Smithsonian* Institution, Washington, D.C. Museum of Fine Arts, *Springfield*, Massachusetts. The *Tate* Gallery, London. *Toledo* Museum of Art, Toledo, Ohio. Munson-Williams-Proctor Institute, *Utica*, New York. National Gallery of Art, *Washington*, D.C. *Whitney* Museum of American Art, New York. *Wichita* Art Museum, Wichita, Kansas. *Worcester* Art Museum, Worcester, Massachusetts. *Yale* University Art Gallery, New Haven, Connecticut.

America has produced a generous share of colorful creative individuals and of often highly idiosyncratic works of art. To anyone attempting to write a brief survey of so various a subject, the problem of omission becomes as challenging as that of organization. Because of necessary limitations in illustration and in length, those works and personalities finally included have been selected to represent as far as possible the major aspects, trends, qualities, and attitudes revealed in the development of American architecture, painting, and sculpture, with some reference to other arts, from early colonial times to the present, and to suggest the continuing variety of American art.

Dates of production of works of art are generally given in parenthesis directly after their titles, with the collections to which they belong (the latter are omitted when a work is illustrated). To present less interruption to the reader, most of the collections are cited in a shortened reference, many, as is customary, by naming their location. The complete list of collections, with identification of the abbreviated references, appears opposite.

As in all such surveys, the present study rests on the foundation of the contributions of many scholars working in the American field, a number of whose publications are listed at the end of this book. My appreciation and indebtedness to them are gratefully acknowledged, as to all whose aid and cooperation have made this work possible.

RICHARD McLANATHAN
New York City

Americans are the western pilgrims, who are carrying along with them that great mass of arts, sciences, vigor, and industry which began long since in the east; they will finish the great circle.

Hector St John Crèvecoeur

'A land of divers and sundry sorts'

This is the story of the arts in America after the coming of the foreigners, the Europeans and those who accompanied them, who were driven by the restless forces of expansion that led to the 15th and 16th centuries being called the Age of Discovery. The story of the arts in America before that period is another and far different one, full of mystery and darkness, revealing only occasionally such dramatic evidences of ancient and developed cultures as the great mounds of the Southeast, the ruined cliff dwellings of the Southwest, and the temples of the Aztecs and the Mayas. But knowledge of them and their builders is woefully incomplete, and, lacking written record, scholars are but gradually and painstakingly assembling the necessary ingredients of this earlier history.

Despite persistent attempts by the newcomers, generally motivated by unshakable religious prejudice, to destroy the various evidences of the country's original inhabitants, too often along with those inhabitants themselves, the American Indian nevertheless played a significant part in later developments, though far less in the arts than in other aspects of life. He early appeared in literature and the arts in a dual role reflecting the white man's ideals and fears, being in one guise the noble savage, like Cooper's Deerslayer, and in another, the crafty and implacable foe. Only now is his cultural identity beginning to be recognized. His arts, long considered savage artifacts, have been virtually without influence on the artistic development of the country as a whole, and lie, therefore, beyond the scope of this brief account.

The story of the arts in America begins for us, then, as does almost all American history, with the sea. Except for the scattering of native inhabitants, probably numbering about the same as at present, the northern continent lay apparently empty, untouched, and limitless. Its subsequent history was to be created by those who came

across the sea, and its arts were to be the expression of aspects of numerous traditions from various parts of the Old World as they developed under the influence of conditions in the New.

In an age of instant communications, it is hard to remember what a formidable barrier the Atlantic Ocean presented to the early explorers and settlers of America. Faced with the prospect of weeks spent cooped up in the crowded cabins and holds of awkward little vessels, battered by storms and tossing seas, faced by disease and constant hardship, only the most adventurous came. Only restless and searching souls, driven by hope or despair, were willing to take the leap in the dark, for little was known about the strange New World which lay so far off across the dreadful ocean. The reports and rumors were at once alluring and terrifying, but the one thing that America offered to all alike was the idea of opportunity, a chance to start anew, to strike it rich, to have a piece of land of one's own, to worship as one wished, to save souls, to build an empire, to try yet once more to realize the Utopian dreams that have haunted the mind of man from the beginning of recorded time. For whatever reasons they came, whether to find gold and return to enjoy it, or to make a new home for themselves and their descendants, they came with a sense of adventure and purpose, looking to the future.

The sea therefore determined certain basic characteristics of those who came to America during its early history. Its immensity and peril were matched by the immensity and peril of an unknown land which also determined much of what developed here in later years. The extent and the variety of its landscape and climate made their impression, not only on how men lived but on how they thought. Men were dwarfed by its size and scale, yet their individualism was radically increased by the self reliance gained as they were thrown on their own resources to cope with situations for which their Old World backgrounds had given them little if any preparation. The limitless horizons invited their exploration and made them dreamers and wanderers. The smallness of their numbers accustomed them to loneliness. The richness of natural resources encouraged their extravagance, and the difficulties of life hardened their minds as well as their bodies, while the wildness of nature accustomed them to violence.

The style of life produced by the New World environ-
ment strengthened their emphasis on the practical over
the theoretical, leading them to prefer the doer to the
thinker. The unexpectedness of situations and conditions
here encouraged them to experiment and improvise,
tending to produce a nation of whittlers and tinkerers. The
influences of Europe were often strong and the borrowings
great, with many resulting similarities and reflections,
but these other factors often proved to be the major
determinants of the course of the arts in America. All
these aspects of the American background, the selection
of the sea, the environment of the New World, the
mixture of traditions of the early comers, and continuing
European influence are expressed in America's history
and in her arts. The country was, as a Puritan divine
early observed, 'a land of divers and sundry sorts.'

For centuries the New World remained more myth than
fact. Since the great days of Greece and doubtless earlier
still, men dreamed of a virgin land far away, another
Eden where life was free of trouble and toil, or a country
of gold and riches to be had for the taking. There were
those adventurous enough to seek it beyond the western
ocean. In the early Middle Ages the Norse sea rovers
came, but their tiny settlements on northern shores
disappeared with scarcely a trace, and the story of their
long voyages is but dimly suggested in cryptic passages in
ancient sagas. Then came the great navigators whose
names have gone down in history to make the Renaissance
the age of exploration: Spaniards, Frenchmen, Portu-
guese, Italians, and Englishmen, foremost among them
perhaps the greatest visionary of all, Columbus, Admiral
of the Ocean Sea.

Spanish conquistadors captured and enslaved the
native empires of Central and South America, shipped
untold tons of gold back to their own land to bolster a
tottering Spanish throne, and established its patterns of
civil and religious despotism in native capitals where
Baroque palaces and churches replaced the despoiled
temples and ruined strongholds of the conquered
inhabitants. The greed and cruelty of the Spanish
conquerors were matched by the dedication and deter-
mination of the *padres* who established the long string of
missions across northern Mexico and the Southwest,
eastward to Florida and westward up the Pacific coast.

In the missions, self-sufficient oases in the strange and
wild land, native skills were employed in crafts and
architectural works, and native pagan symbolism mingled
with Christian in the elaborately carved and painted
retablos at the altar end of the mission churches, which,
like all the other buildings of the complex, were con-
structed, like native pueblos, of adobe. Their style,
indigenous to the New World, is a provincial reflection
of Spanish Baroque in a picturesque fusion of European
and Indian traditions. No mission was as richly orna-
mented and as grand in scale as were the major churches
in the larger centers of Latin America, like the great
cathedral in Mexico City, begun in the middle of the
16th century, the grandeur of whose conception is
enlivened by the interpretation by native workmen of
sculptured ornament and decorative detail. The missions
varied greatly in size and elaboration from the richest of
them in Mexico to the simplest, like that at Ranchos de
Taos (1772), New Mexico, with its austere forms
untouched by ornament, or San Estevan at Acoma,
completed about 1642 (*Ill. 1*), crowning the immense
height of the cliff, of which it appears a part, rising sheer
from the New Mexican desert. All construction materials
including the forty-foot *vigas* or roof beams and even the
soil for the little cemetery, had to be carried on the backs
of Indian workmen up a trail so steep that it was inter-
spersed with ladders and often consisted of steps cut into
the face of the cliff.

Far more sophisticated in plan and more elaborate in
execution are the missions of Texas, five of which remain
in the vicinity of San Antonio, the former Spanish
capital of the province and its largest settlement. Of
these the best known is San Antonio de los Alamos,
famous as The Alamo, where in 1836 a resolute group of
less than two hundred Texans, including the scout and
Indian fighter Davy Crockett and Colonel James Bowie,
after whom the Bowie knife was named, died to a man
after holding off a force of 3,000 Mexicans for twelve days,
thus adding a heroic page to the highly colored history of
the Old West. The Alamo, however, having lacked its
vaults and twin towers since 1762, retains little of its
original character. Another, San José y San Miguel de
Aguayo (1720–31), was in its day one of the most
important. Carefully restored in the 1930s, it now
displays a handsome bell tower, and a main portal

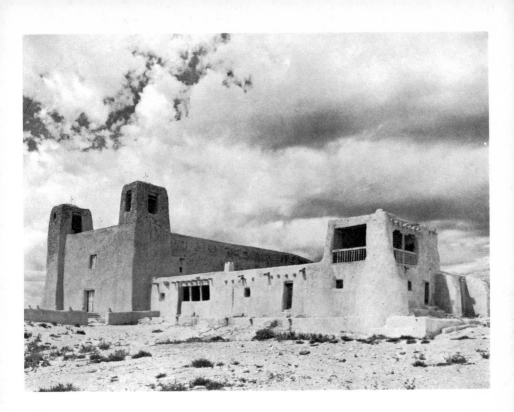

sculptured by the Mexican artist Pedro Huizar in a New
World interpretation of the ornate phase of Spanish
Baroque style of the late 17th century known as the
Churrigueresque.

The mission in Santa Barbara, California, though
perhaps less accurately restored in the late 19th century,
remains the most complete, and is the only mission still
in the hands of the Franciscan Order which founded so
many of them. Though the regularly laid out village for
its Indian inhabitants is gone, its grouping of monastic
quarters, storages, workshops, and other buildings
remains to serve as a model of the completeness of the
mission ideal.

The oldest surviving building in the United States
which is due to the new settlers is the Governor's Palace
in Santa Fé, New Mexico (*Ill. 2*). It was built in 1610–14
by Don Pedro de Peralta shortly after he was appointed
to the governorship. Indian labor and the native Indian
material of adobe were used, but with the innovation of
forming the clay into pre-cast bricks which were dried in

*1 Mission of San Estevan, Acoma,
New Mexico, c. 1642*

2 *Governor's Palace, Santa Fé, New Mexico, 1610–14*

the sun and then laid up with adobe mortar. The *portal*, the narrow porch along the one-storied façade, is Spanish in origin as are the enclosed patio, the wooden enframements for doors and windows, and the wrought-iron window grilles. But the pueblo-like roof supported on *vigas* is pure Indian. The ranch and town houses of the Southwest and California continued the tradition of the long low lines, the patios, the covered porches, and the adobe construction of the Governor's Palace, though with low-pitched shed or gable roofs, usually covered with tiles. In the south and in ranch country such houses were almost invariably of only one story, while farther north in California they sometimes were of two, with two-story porches and exterior stairs. This Spanish-American style continued until well on into the 19th century, was revived in the earlier years of the 20th, and was of considerable influence on the development of more recent domestic architecture throughout the United States.

While Spain was building a colonial empire far to the south, the northern Atlantic coasts were visited only by occasional voyagers and by fishermen from Scandinavia, the British Isles, Brittany, Normandy, and Portugal, who made landings and even established stations where they repaired nets and other gear damaged while fishing the rough waters of the Grand Banks. Then the French began serious exploration of the great waterway of the St Lawrence, seeking the wealth which comes, not from native treasuries, but from trade in precious furs. With the *coureurs de bois* – French and half-breed trappers and

hunters who roamed the wilderness – came French
priests, as eager for souls to save as their Spanish brothers,
though far less successful in founding permanent
settlements in the northern forests than were the *padres*
in the deserts and mountains of the south and far west.
Fortified trading posts were gradually established up the
valley of the St Lawrence, in the area of the Great Lakes,
and down the Missouri and the Mississippi, finally to
join the other French settlements on the Gulf in a tenuous
contact which never strengthened into empire. But
shortly after 1600 the first art school in North America
was started at Cap Tourment, downriver from Quebec,
by Bishop Laval de Montmorency to train the children
of Indians and Frenchmen alike in the skills needed to
build and furnish a church, from the crafts of the carpenter
and metalworker to those of the painter and the carver.
The results are provincial French Baroque, at best naïvely
attractive, though lacking the expressionism of the carved
figures and painted panels, the *santos* produced by the
Indians of Mexico and the American Southwest under
Christian inspiration and following Spanish models,
but embodying the fierce power of an ages-long pagan
tradition.

Some of the French trading posts gradually grew into
settlements, but many succumbed to Indian raids and
British attack, and, except in French Canada and in the
bayou country of Louisiana, there is little left but history
and legend and a few place names to remind us of the
French past. Yet the oldest building in the Midwest is
the Cahokia Courthouse (*Ill. 3*), built in Cahokia,
Illinois, about 1737 in the typical French frontier fashion
of walls formed of vertical posts called *poteaux-sur-sol*. A
few low-lying farmhouses, reminiscent of Norman and
Breton prototypes, and some religious buildings in the
province of Quebec, are unmistakably French in flavor,
while such churches as that at Ste-Famille (1742–9) on
the Isle d'Orléans in the St Lawrence, though much
restored, remain as examples of typical French Canadian
parochial architecture. Their austere lack of exterior
ornament and steeply pitched roofs have a distinctly
northern look and their vertical emphasis recalls the
Gothic.

Though similarly undecorated, such deep Southern
French plantation houses as Parlange in Pointe Coupée
Parish, Louisiana, built by the Marquis Vincent de

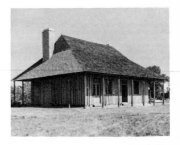

3 *Cahokia Courthouse, Cahokia,
Illinois, c. 1737*

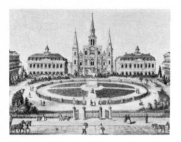

4 Jackson Square, New Orleans, Louisiana, c. 1795. Detail of a 19th-C. lithograph

Ternant in 1750, with its broad surrounding *galeries* and formal setting, complete with an avenue of ancient live oaks and matching *pigeonniers*, suggest something of the more gracious mode of Creole life fostered by a more benign climate. The original center of New Orleans, now called Jackson Square (*Ill. 4*), symmetrically laid out with civic and domestic buildings dominated by the Cathedral of St Louis, is a perfect example of a purely French square recalling its former name of Place d'Armes, and remains one of the finest pieces of city planning in the United States.

The street names of New Orleans and a number of houses in the Vieux Carré are redolent of the French tradition which still lingers there. The house on Dumaine Street known as 'Madame John's Legacy' is an example of the raised cottage style which once was common throughout much of the deep South. It was built by a French sea captain, Jean Pascal, probably shortly after he arrived in Louisiana in 1726. The style originated with early houses built on low-lying land along the waterways, which were constructed on masonry piers to raise them above flood level. This elevation and the covered *galeries*, across the façade as in the case of Madame John's Legacy, or on all sides as at Parlange, remain the hallmarks of the French tradition.

French influence was also significant in other parts of the colonies, especially Philadelphia. After the revocation of the Edict of Nantes in 1685, persecuted Huguenots, a group consisting largely of craftsmen of solid middle-class background, flowed into William Penn's tolerant capital, bringing musical and other skills. A number of the best craftsmen of New York were of Huguenot stock; the patriot Paul Revere of Boston (*Ill. 41*) was the son of Apollos Rivoire, and as a goldsmith followed the trade his father had learned in his native France. Because France was the new country's first ally, and Lafayette, as a fiery young idealist, was among the first to offer his sword in her service and thus to become an American national hero, and because the United States supplied a refuge for many fleeing the French Revolution, cultural relations with France were strong in America both before and after Independence.

Following the lead of Henry Hudson, an English adventurer in the employ of the Dutch East India Company, the Hollanders established their foothold in

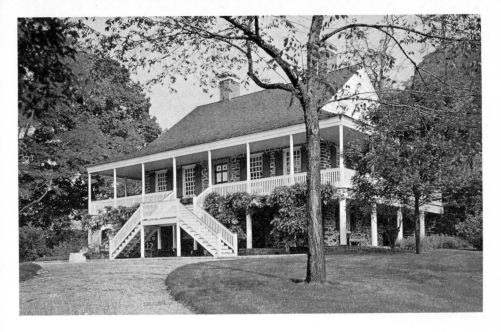

the New World so that by the middle of the 17th century their trading posts stretched from New Amsterdam on the island of Manhattan up the Hudson to Beaverwyck, later to be renamed Albany after the British captured the Dutch colonies in 1664. The Hudson River valley gave access to an area second only to the valley of the St Lawrence as fur country. The Protestant Dutch were happy with freedoms won at home and with their prosperity resulting from world trade, so few wanted to risk the dangers of an unknown continent. Their colony therefore attracted comparatively few settlers at first, and those were of a variety of faiths and nationalities – Poles, Italians, Germans, Scandinavians, Flemish Walloons, and others – many of whom congregated in New Amsterdam to give New York early in its history the polyglot and commercial character it has had ever since.

The Dutch left a long-lasting imprint on the Hudson valley. It may be seen in the typically Dutch forms of the brick houses of old Albany, with their crow-stepped gables addressed to the street as in cities in the Netherlands. It appears in the few remaining great houses of the patroons, the large landholders whose position of feudal superiority gave such an aristocratic cast to the colony of New York. The van Cortlandt House at Croton-on-Hudson (*Ill. 5*), recently restored, is an example dating

5 Van Cortlandt House, Croton-on-Hudson, New York, 1660s

17

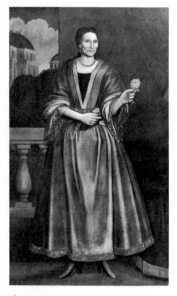

6 SCHUYLER LIMNER *Ariaantje Coeymans (Mrs David Ver Planck)*, *c. 1717–28. Oil on canvas, 6′7⅝″ × 3′11¾″ (203 × 121). Albany Institute of History and Art, Albany, New York*

from the 1660s. Constructed of heavy masonry, its shutters are still pierced for defense against Indian attack. The homely dignity of its well but soberly furnished interiors and the symmetry of its façade with the sweeping bell cast of the roof at the eaves are of definitely Dutch character. Its commanding situation overlooking the river, once the only highroad, surrounded by its mill, storehouses, stables, barns, smithy and other workshops, and smaller houses for workmen and their families, tells much about life in the valley of the Hudson in colonial times.

It is to the Dutch that we are indebted for the first regional school of painting in the colonies, which produced the portraits of the patroons and solid burghers and their wives and children during the first three decades or so of the 18th century. Their anonymous creators were artisans who translated the courtly compositions of Baroque Europe – with gentlemen in rich dress and ladies in fashionable costume posed on balustraded terraces overlooking formal gardens – into an awkward idiom made compelling through the forceful individualism of the sitters and the bold simplifications necessitated by the limited skills of the painters. One of the most interesting is the full-length *Portrait of Ariaantje Coeymans (Ill. 6)*, painted about 1717–28 by an unknown artisan sometimes referred to as the Schuyler Limner because, about a decade earlier, he may also have portrayed that doughty Indian fighter, Pieter Schuyler, the first mayor of Albany. As in the Schuyler portrait, the painter borrowed the grand manner setting from a European print, in this case a mezzotint after a picture by Sir Godfrey Kneller. The bare reduction of the design, and the contrast between the fashionable Italianate setting and the formal costume and pose with the gaunt and forceful figure of the subject, who has been likened by one critic to an Indian brave, is impressive and winning both in its forthright revelation of wishful grandeur and in its awkward but convincing likeness.

There remain a number of portraits by the so-called patroon painters, differing somewhat in style and character as well as in artistic merit, but all giving the same impression of intense objectivity and frank individualism which early became such a marked aspect of the American character, whatever national origins might be involved. Similar craftsmen's hands turned

engravings after contemporary and earlier European artists' paintings of religious subjects into naïve inter-pretations of *The Supper at Emmaus, Esther Before Ahasuerus, The Finding of Moses* (all three at Albany), and other Biblical themes, which are of a beguiling innocence, and once were proud adornments of the houses of Dutch colonials.

The Swedes, Finns, and Norwegians who established themselves on the banks of the Delaware in 1638 brought from their native northern forests a tradition of wood construction of which the log cabin is the most important expression. Contrary to the dubious evidence of the illustrations which used to appear in history books showing the Pilgrims, dressed in black, leaving their log cabins to go to church in a log meeting house, there was no widespread use of the log cabin until the 18th century, when the Scotch-Irish, who seemed naturally inclined to follow the frontier, borrowed the idea from the Swedes and made the log cabin the ubiquitous wilderness dwelling throughout the greater part of North America. The Swedes used both the common form of the log cabin – a building of unhewn logs saddle-notched at the corners, and the cracks chinked with clay – and that of logs hewn square and laid up with half-dovetail or lapped joints. Two early log cabins still exist on Darby Creek, in Pennsylvania, one of which, called the Lower Log House, is of hewn logs and is thought to date from 1640. Its corner chimneys and fireplaces, of Swedish origin, were a feature used extensively in Pennsylvania and other parts of the back country.

Two steep-roofed churches of Swedish origin remain: one, Holy Trinity at Wilmington, Delaware (*Ill. 7*), was built of stone in 1698–9 under the direction of the youthful pastor Eric Bjork, of what was then the Swedish settlement of Christina. Though there is a Swedish flavor to the design (it is popularly known as Old Swedes), its mason was the Philadelphian Joseph Yard; John Smart was the carpenter; John Harrison made the woodwork and pews; a Dutchman named Lenard Osterson did the glazing; and Matthias de Foss wrought the letters for the inscription which records the event on the western end of the building. The other church, Gloria Dei, built of brick in 1698–1700, is in Phila-delphia. They are picturesque reminders of the long-forgotten colony of New Sweden.

19

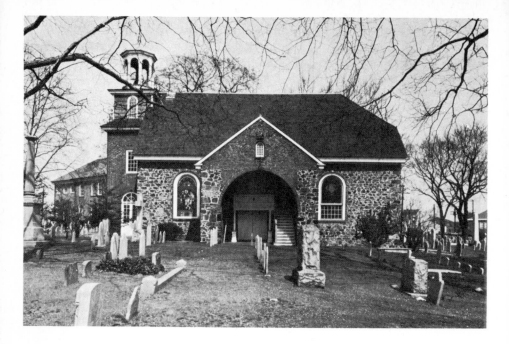

The 18th century saw the massive immigration of the Scotch-Irish, or Ulster-Scots, whose ancestors had previously moved from the Scottish Lowlands to Northern Ireland. Their contribution to American development lay rather in their service as frontiersmen who established both churches and schools wherever they went, including the famous Log College in the wilderness of North Carolina which prepared teachers for many a frontier settlement. In the same century Protestant Germans came in large numbers, entering the New World through the hospitable portals of Philadelphia. They, too, moved on. Many settled in the rolling farming country of Pennsylvania where their descendants are known as the Pennsylvania Dutch. Others gradually went westward across the Alleghenies, like the Scotch-Irish, following the frontier.

The Germans brought with them their love of music and became the principal builders of organs and other musical instruments. They were also glass-makers and ironworkers. German gunsmiths from Lancaster developed the famous Pennsylvania, later called Kentucky, rifle, and German blacksmiths developed the American ax, the two most useful tools for the conquest of the wilderness. German wagonmakers from the Conestoga

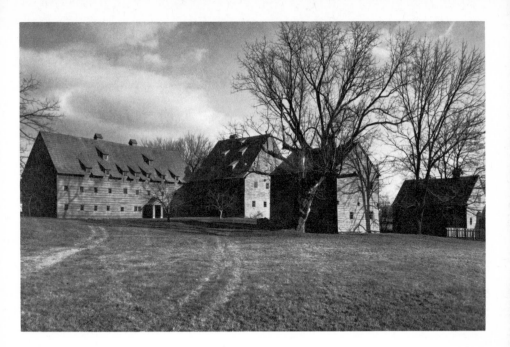

valley built the famous covered wagons which carried the pioneers westward. The Society of the Solitary, the Pietist followers of Johan Konrad Beissel, settled at Ephrata in Lancaster County where in the 1740s they built their *Kloster*, its plastered walls decorated with Gothic paintings and pious inscriptions in black letter, the *Saal* where the brothers lived, and the Sister House, to form a community still medieval in architectural style (*Ill. 8*) as well as in its mystical otherworldliness and its dedication to devotional choral singing.

In 1753 the Moravians established New Salem, North Carolina, the first planned town on the frontier, laid out by the church elders. Many of its buildings have recently been restored, including the half-timbered and brick Single Brothers House, dating from 1769, and the dwellings and shops of many of the craftsmen for whom the town was famous, all reflecting in detail and proportion the style of Central Europe from which their builders came.

Among other groups whose traditions combined to enrich the national tradition were the Welsh, Irish, and Rhenish Quakers who settled in Pennsylvania, Protestant Walloons fleeing the Spanish Netherlands, Englishmen of all sorts, from indentured servants and remittance men

8 Kloster, Ephrata, Pennsylvania, 1740s

21

to adventurers of good family. By the early 18th century, the larger cities, like New York and Philadelphia, had already become the American melting pot in microcosm, with representatives of all nationalities of Europe from east to west and from Scandinavia to the Mediterranean, with a few Africans and Orientals to boot. And in later years there were to be further waves of immigrants from both Europe and the Far East. Except for two groups, however, all these migrants had one thing in common: all came of their own choice and with hope for the future. One of the two groups which had no choice was made up of approximately 50,000 English prisoners who were sentenced by British courts to be transported to serve out their time in hard labor under colonial masters. The other was the infinitely larger number of blacks who were brought in as slaves. Among the latter there were many who became craftsmen, but few had an opportunity to make a contribution to the course of the major arts in America, except in music: the two musical forms which are generally acknowledged to be uniquely American, the spiritual and jazz, owe their origins to the traditions and the genius of black Americans.

Though all the many groups, national, racial, and religious, enriched the great mixture which makes up America, the character of American culture was set, not by the earlier adventurers and seekers of treasure, the Spanish and the French, but by those who came to stay, the British. Though there are the distinct strains of Spanish, French, German, and other cultural traditions in American art, it was to grow from an essentially British basis along essentially British lines. Yet long before the Revolution, changes were taking place which were to determine a more varied development, and increasingly to reveal a character which, though generally provincial, could no longer be identified as simply British. The mixture of traditions and the demanding circumstances of life in the New World, from the long-established colonial centers on the Atlantic coast – prosperous, secure, and growing in wealth – to the uncertainties and perils of the frontier, combined to produce the extraordinary variety of American art and thought. Yet the common experience of the New World was gradually turning all the many individuals of diverse origin into what Crèvecoeur called 'the American, this new man.'

'Orderly, fair, and well-built houses'

In 1654 Edward Johnson wrote in his *Wonder-Working Providence of Sions Savior in New England* that throughout the Massachusetts Bay Colony 'the Lord hath been pleased to turn all the wigwams, huts, and hovels the English dwelt in at their first coming into orderly, fair, and well-built houses, well furnished . . ., together with orchards filled with goodly fruit trees, and gardens with a variety of flowers.' This represented quite an achievement in less than a quarter of a century, considering the difficulties of life in the New World.

The luckiest among the early settlers found abandoned Indian villages. Others copied the wigwams which the natives had evolved over centuries as providing easily constructed shelter, made of bark or thatch over a framework of poles thrust into the ground and bent together at the top. Examples may be seen in the reconstructed village of Old Salem, Massachusetts. Some lived in dugouts in the ground, holes covered with boughs, bark, or sods, while the first settlers of Watertown, Massachusetts, took refuge against the early winter in the hogsheads in which they had brought supplies. As soon as possible, however, they constructed framed houses in the familiar British manner, with timbers fastened together with mortice and tenon, the joints secured with pegs or treenails, called and often spelled 'trunnels'.

The houses were not only British in style, but, according to Edward Johnson's description, clustered in the manner of a village in old England. The reconstruction of Plimoth Plantation is an example of an established form of early settlement, whether north or south along the Atlantic coast. Sudbury, Massachusetts, provides an example of a more developed colonial town, where sufficient time had elapsed so that chimneys of wattle and daub and clay-lined plank could be replaced with the far safer stone or brick, and at least some of the roofs

23

covered with the hand-split shakes or heavy shingles
which proved more durable and satisfactory than thatch
in the harsher climate.

Founded in 1638 by a group of families from the south-
eastern counties of England, the town of Sudbury
consisted of a group of wooden framed structures strung
along a road and around an irregular area of common
land. Houses, barns, and meeting house alike had high,
steep roofs, and many had an overhanging second story.
The native pine and spruce of which they were built was
soon weathered to silvery gray and brownish tones by the
storms and suns of the changing seasons. The appearance
as well as the plan of such villages was essentially
medieval, totally different in character from the typical
New England village of the next century, with its four-
square houses, painted white, set back from the road in
orderly rows, with yards often surrounded by a picket
fence, the whole dominated by the tall-steepled meeting
house.

Various foreign visitors have commented on America's
predominantly wooden architecture. The pamphleteer
and farmer William Cobbett, in the 1790s, and Basil
Hall, writing about 1830, found it flimsy compared to
the masonry construction of Europe. Charles Dickens
noted the toy-like neatness of the white-painted towns and
farms, and Arnold Bennett considered the old wooden
houses of Cambridge, Massachusetts, to be especially
attractive and characteristically American. Brick had
been used since earliest days, and shortly before 1700 was
beginning to become the prevailing material in the cities
because of its fire-resistant qualities, but the major
building material in America, from the 17th century
onward, has been wood. It was used for churches and
meeting houses, factories, and various public buildings
as well as for domestic construction.

In regions where wood was not available, such as the
desert areas of the Southwest, adobe and sometimes stone
were, of necessity, the common material. Otherwise stone
buildings were comparatively rare, except in certain
areas like Pennsylvania, until the 19th century and the
introduction of brownstone, a reddish-brown sandstone
from the Connecticut Valley, which during the second
half of the 19th century became the standard material for
city houses and many other urban buildings, especially
the characteristic row houses of New York. Because of

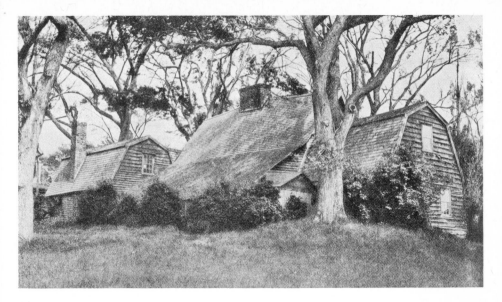

the prevalence of wood, it is fortunate that most of the early settlers came from an area of England which had been heavily forested, for they brought with them an invaluable wood-building tradition.

There are several examples left of the kind of houses built during the early years of settlement and such as one might have seen in Sudbury. One of the earliest remaining is the Fairbanks House in Dedham, Massachusetts (*Ill. 9*), probably the oldest frame house still extant in the United States. Jonathan Fairbanks, a Yorkshireman who came to Boston in 1633, was one of the founders of Dedham. When he and the others received the grant of land for the new town from the Great and General Court of Massachusetts in 1636, his share included twelve acres for a house lot. Probably the following year he built his house on rising ground near the high road, looking southward across rolling wooded country which was rapidly being cleared and planted.

The original house seems to have consisted of two rooms on each of two floors, flanking the massive central chimney which was an inevitable feature of early houses in the northern colonies. One came into a narrow entry way with a steep, boxed stair rising against the chimney opposite the entrance door. Other doors to the left led to the hall and to the right to the parlor, with corresponding chambers on the floor above. Windows were tiny – perhaps two remaining on the upper floor are original;

9 Fairbanks House, Dedham, Massachusetts, probably begun in 1637

the larger measures only 20 by 28 inches – and, since Jonathan Fairbanks seems to have been a prosperous man, the window sashes were glazed with diamond-shaped panes set in lead. The frame of the house is oak filled with clay on split oak lathing for insulation, and wainscotted inside with sheathing of wide boards with beaded edges. The exterior walls were covered with clapboards, or weatherboards.

As Jonathan Fairbanks' family grew, he enlarged the house to make room for the new arrivals. First he added two more rooms in a lean-to across the back, its roof sweeping low to the ground on the north side. Then a new wing was added to the east. Almost a complete small house in itself, it has two ground-floor rooms, each with a corner fireplace, and a large chamber above. It may date from 1641 when Jonathan's son John brought home his new bride. Perhaps about 1654 another wing, again almost a complete house in itself, was added to the west. Without fireplaces or chimney, the rooms are thought to have been intended as quarters for the hired men who worked the farm. Both east and west wings have early examples of the gambrel roof which later became very common throughout the northern colonies.

When Jonathan Fairbanks died in 1668, his land-holdings had grown along with his family and his house, which he left to his son John, who passed it on in turn. For more than three centuries the house has remained in the possession of the Fairbanks family. Its picturesque irregularity reveals the organic character of its growth, and its varied rooflines, massive chimney, ground-hugging bulk, and timbers, stained tobacco brown by time, make it a striking example of medieval architecture much like contemporary houses in south-eastern England.

Perhaps a year before Jonathan Fairbanks began building in Dedham, Adam Thoroughgood began his house in Princess Anne County, not far from Norfolk, Virginia (*Ill. 10*). Fifteen years earlier, Thoroughgood had arrived in America as an indentured servant. Like Jonathan Fairbanks, he must have been a hard worker and an able man, because by 1629 he was not only free of his bond, but had risen to prominence and been elected a member of the House of Burgesses of the colony. He acquired the land on which he built his house in 1636, and is thought to have started to work on it at once.

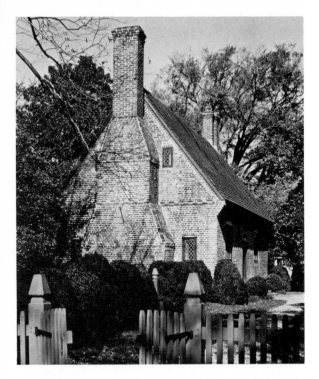

The house is sturdily constructed of brick burned
locally. A story and a half high, it has a steep, pitched
roof, and cross-mullioned windows with transom
and casements leaded and glazed with diamond panes.
Like the Fairbanks house, it is of the two-room plan,
with hall and parlor, but it lacks the entry, and the stairs
are placed in a corner of the hall. But like almost all
Southern houses, instead of a central chimney there are
end chimneys, the larger of which stands slightly away
from the house, a feature also common to the South. The
central chimney stored up and diffused warmth during
the cold months of the northern winter, but in the South
every effort was made to keep the heat from the cook
fires, which had to be kept going constantly, from
overheating the rest of the house during the long hot
summers. For this reason it soon became a usual practice
in the South in all but the more modest houses to con-
struct the kitchen as a separate building. Originally there
were no dormer windows, as was true of virtually all 17th-
century houses in the colonies, the upper chambers being

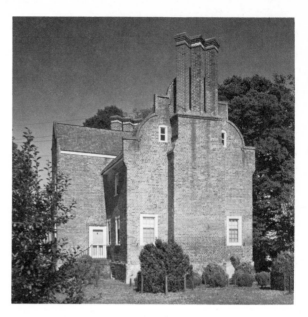

11 *Bacon's Castle, Surry County, Virginia, c. 1655*

lighted by small windows flanking the massive chimneys in the gable end. In all but the windows, which in the following century were to be replaced by sliding sashes with rectangular lights, the Thoroughgood house is typical of innumerable smaller houses built for the next century and more throughout the South.

Shortly after the middle of the century, probably about 1655, the extraordinary house known as Bacon's Castle (*Ill. 11*) was built in Surry County west of the James River. Its builder was Arthur Allen, a recent settler who chose an ambitious scheme for a house in the wilderness. Far larger than Adam Thoroughgood's house, Bacon's Castle is two stories high with a full attic, and is the first of the several cross-plan houses peculiar to the South. In such houses the not uncommon two-story porch with entry below and porch chamber above is matched by another two-story projection at the back of the house, occupied sometimes by the stair, as in Arthur Allen's house, and sometimes used as a parlor, in which case the stair is situated in the central hallway. Bacon's Castle is constructed of brick laid in English bond, with a belt course of molded brick to mark the division between stories. The ends of the house are adorned with curved and stepped Flemish gables, and, rising from massive

stacks, triple chimneys, set diagonally on the stack and free-standing, are joined only at the caps. All these elements are to be found in Tudor houses in England. What is unusual is their use together and at such a scale under New World conditions at such an early date.

The house owes its name to an incident in 1676 when the notorious Royal Governor, Sir William Berkeley, refused to call out the militia to protect the settlers against marauding Indians with whom he had arranged a personal monopoly of the fur trade. As a result, many of the planters and farmers banded together under the leadership of a forthright and vigorous burgess named Nathaniel Bacon, and marched against the Indians, decisively defeating them. So incensed was the governor at this interference with what had proven to be a highly profitable if completely illegal get-rich-quick scheme, that when Bacon appeared at Williamsburg to take his seat among the burgesses, Berkeley had him seized. An immediate uprising among the colonists forced his release, but the governor called out the militia, and in the short war which followed, Bacon and his forces used Arthur Allen's house as headquarters, whence its name. Bacon died suddenly, probably of malaria, though many believed he had been poisoned, and Berkeley was recalled for his sins, but the event took its place in American history as a significant example of group action in defense of citizen's rights.

The Whitfield House in Guilford, Connecticut (*Ill. 12*), has no such lurid history. One of the rare stone

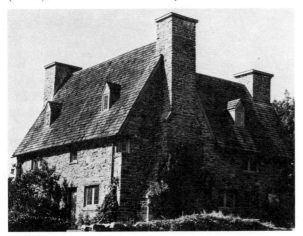

12 Whitfield House, Guilford, Connecticut, c. 1639–40

houses of colonial times, it was built about 1639–40 on almost the scale of Bacon's Castle. It wears, however, much more of a medieval air. In the autumn of 1639 a group of settlers, led by the Reverend Henry Whitfield, purchased from the local Indians a tract of land along the shores of Long Island Sound, and soon thereafter began construction of a building which was not only their minister's dwelling, but a garrison house and meeting house as well. A careful restoration sponsored by the state of Connecticut in the 1930s has removed later additions and changes and returned the house to what is probably very like its original appearance, except that the roof is shingled instead of being thatched. And a thoroughly archaic English appearance it has, with tall, steep roof, burly chimneys, tiny windows with leaded casements, thick walls, and asymmetric composition. The interior, with whitewashed stone walls and plank floors and partitions, immense fireplaces, and narrow stair in a tower tucked into the angle between the house and kitchen ell, has an appropriately Puritan austerity.

There are a number of other 'medieval' houses in America, mostly in New England, including the Whipple House in Ipswich, Massachusetts, dating from the same year as the Whitfield House, and the House of Seven Gables in Salem of about 1670, made famous by Hawthorne's romance of that name. But the most classic of the early houses is that built by his parishioners for Joseph Capen, the minister of Topsfield, Massachusetts, in 1683 (*Ill. 13*). The placid horizontality of its lines is emphasized by the framed overhang, or jetty, of the second floor, and the further overhang of the gables, a feature imported from England. The paneled chimney is one of the finest of its type. The design of the façade comes closer to symmetry than in most such early houses, and its sobriety is relieved only by the brackets supporting the overhang and the carved pendants, 'pendills', as they were called, beneath. The interiors are equally austere. As in all such houses in their original condition, all the structural members – posts, beams, joists, and rafters – are exposed and reveal their function. Everything is of wood. The floors are plank, the walls are sheathed with vertical boarding, the doors are of boards cleated together except for the front door which is made of two layers of planks fastened together with spikes, clinched over on the inside, their heads making a regular pattern on the outside. The

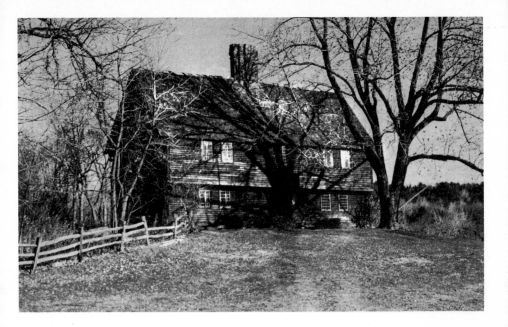

boxed stair rises against the immense chimney opposite
the front door. To the left is the parlor, the room used
primarily for formal entertaining, and to the right is the
hall, which was kitchen, living room, and dining room
combined. The chambers are on the floor above.

The Capen House has been furnished with appropriate
objects of the period, a tall settle beside the cavernous hall
fireplace, stools and joint stools, trestle tables, benches,
court and press cupboards, and turned chairs. There is
no trace of the luxury and grace of the 18th century which
was soon to come, but the atmosphere of quiet dignity and
repose says much about the Puritan ideal and the leading
place accorded the minister by the community.

Protestant emphasis on the sermon as the central feature
of the service transformed the church, with its plan and
arrangement dictated by liturgical needs, into a preaching
hall, the pulpit instead of the altar providing the focus.
The pilgrims of Plymouth had seen and worshipped in
older Dutch churches which had been changed for
Protestant needs by stripping them of decorative trappings.
They may also have seen the type of religious building
devised by the Dutch for Protestant usage which was
imported by them into the colonies, an octagonal building
topped with a steep-pitched candle-snuffer roof rising to
a belfry. Later Dutch churches were often rectangular in

*13 Capen House, Topsfield, Mass-
achusetts, 1683*

31

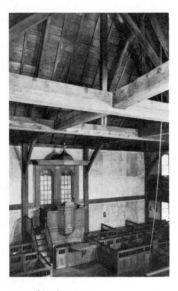

14 *Old Ship Meeting House, Hing-ham, Massachusetts, 1681*

plan according to the model of the New England meeting house, which was an original architectural form unique to the colonies. As simple as barns, and almost as un-adorned, they appeared in the first half of the 17th century and continued to be built throughout the 18th century and even into the earlier years of the 19th.

A unique 17th-century example remains, the Old Ship Meeting House, built in 1681 in Hingham, Massachusetts (*Ill. 14*), the oldest survivor of its kind in the country. It was built by the townspeople to specifi-cations voted in town meeting. The 143 members of the congregation taxed themselves to pay the cost, £430, a very considerable sum in those days of hard currency. They decided that it should be 45 feet wide and 55 long, and its posts 20 feet high. It was topped with a pyramidal roof rising to a deck bearing a turret. In 1731 it was enlarged by 14 feet to the north-east, and 24 years later a matching enlargement was added to the opposite end, the turret replaced by a steep-roofed belfry, the leaded windows removed and sash windows set in their place, while pews were installed to take the place of the original oak benches, and two Georgian porches were added. Three great wooden trusses made up of tie beams, king posts, and braces, span the width of the building. The result is a handsome example of Gothic construction as un-elaborated as a tithe barn in the straightforwardness of its timber construction, but broader than the nave of any English cathedral. Tradition has it that the building was constructed by ships' carpenters, but its name may equally come from its appearance: the effect of the massive timbering, with the curved struts which carry the thrust outward at the eaves, abutting the king post at the top, suggests the hull of a ship turned upside down.

In the South, Anglicanism generally prevailed, and churches were scattered across the country, situated where they could best serve a widely dispersed population instead of being located in towns as in the North. Though most were of wood construction and have long since dis-appeared, one 17th-century church remains, the Newport Parish Church in Smithfield, Isle of Wight County, Virginia (*Ill. 15*). Built of brick, with simple Gothic windows, wall buttresses, and stepped gables, it resembles many a late medieval English parish church of modest pretension. It is traditionally believed to have been built by two master masons, Charles and Thomas Driver, in

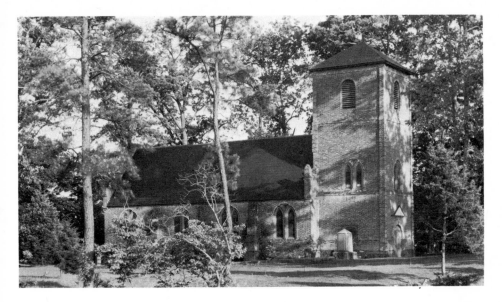

1682. It suffered the fate of abandonment and neglect which befell all such churches after the disestablishment of Anglicanism at the time of the Revolution, but was restored during the last decade of the 19th century as the last example of its kind which had not been reduced to ruin.

15 *St Luke's, Newport Parish, Smithfield, Isle of Wight County, Virginia, 1682*

Though there are, as we have seen, remaining examples of 17th-century domestic and ecclesiastical architecture, nothing survives from the categories of educational and governmental buildings. A considerable variety of records gives a good idea of what the original Old College at Harvard looked like. Founded in 1636, only sixteen years after Plymouth and six years after the establishment of the Massachusetts Bay Colony, the college started its first building in 1638. It was finished four years later in time for the first commencement. Based upon the E-shaped plan often found in Tudor houses, it seems to have been as conservative in style as the Capen House, with overhangs, cross gables, steep roofs, small windows, and panelled chimneys – a combination of elements of domestic architecture on an essentially domestic scale to house the sixty students who often paid their tuition in farm produce, livestock or wampum. They slept in dormitories and studied in separate cubicles, each with its window, attended classes in the large hall on

the ground floor, and consulted the 2,000 volumes in the library on the second.

By 1677 the Old College was replaced by the New, a four-story building of brick which was the most monumental architectural project in the colonies at that date. Samuel Andrews of Cambridge was the master builder. The project took three years to complete, probably because it was impossible to retain a steady work force during the desperate years of the Indian Wars, when the Narragansetts, the Nipmuks, and the Wampanoags, under the leadership of the implacable sachem known as King Philip, laid waste settlement after settlement and threatened the very existence of the Bay Colony. Harvard Hall was gutted by fire in the winter of 1764, and was in turn replaced by the present New Harvard Hall in 1766.

We know what the first looked like from the engraving of Harvard Yard made by William Burgis in 1726 (*Ill. 16*), in which Harvard Hall appears to the left, with Stoughton Hall (1699) in the center, and Massachusetts Hall (1720), the only one of the three remaining, to the right, to form the quadrangle which was the nucleus of the college. The latter two buildings are in the Georgian style which prevailed throughout the colonies from the beginning of the 18th century, but Harvard Hall is a strange mixture of styles with a result more curious than handsome. Its gambrel roof, a very early example of the form, is intersected by six cross gables on each façade, and crowned with a balustrade, above which rise a pair of immense chimney stacks and a central cupola. Its diamond-paned casement windows give the building a medieval look, while the ball-topped pilasters flanking the two doorways, and the string courses which undulate awkwardly upward in the center of the façade had a somewhat Jacobean flavor. Its four floors housed all the facilities necessary for the Spartan existence led by both the students and faculty members. On the ground floor there was the Great Hall for dining, chapel, lectures, and debates, and the buttery with its barrels of beer, a generous consumption of which may have somewhat compensated for the lack of adequate heating during New England winters; above were the library and tutors' quarters, and three floors of student chambers and studies.

So great was the Puritan passion for education, that the standards of the college were maintained at a level to attract students from all the colonies and from Bermuda

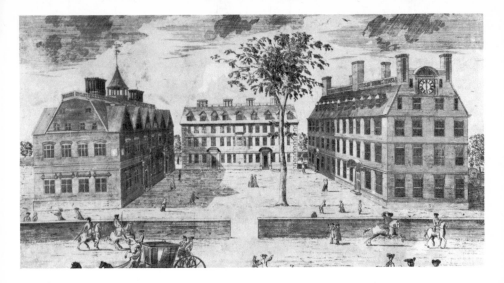

and England as well. Throughout the rest of the century, as Samuel Eliot Morison, Harvard's distinguished historian, has pointed out, more than half of the graduates went into the ministry, while a large percentage of the rest became teachers in their turn, thus early establishing New England's leadership in education among the colonies.

Of other forms of architecture in the colonies, little concrete evidence remains. We know from the records that there were a surprisingly large number of inns and taverns in proportion to the population, and that these were essentially domestic buildings put to a more convivial use. There were windmills, probably very like those in England, and water- and tide-mills, which undoubtedly were simple barnlike structures. A good deal of documentary evidence, including the contract drawn up between the magistrates of the town of Boston and Thomas Joy and Bartholomew Bernad, the builders, has made it possible, however, to conjecture the general appearance of Boston's first Town House. The earliest structure of its kind in the colonies, it was constructed on the site now occupied by the Old State House.

Built during 1657 and 1658, the Town House had a hipped roof similar to that of the Old Ship Meeting House, with balustraded platform and twin cupolas. There were three cross gables to a side, and the two-story bulk of the building was elevated on three files of heavy posts to form a covered market at ground level. Con-

16 Harvard Yard, Cambridge, Massachusetts. Engraving by William Burgis, 1726. Massachusetts Historical Society, Boston

structed of heavy planking, tongued and grooved, the Town House not only provided offices for the magistrates, a courtroom which was also used for meetings, but also the public library, and a room for the Ancient and Honorable Artillery Company of Massachusetts, 'the oldest band of citizen-soldiers in America', which is still in existence.

Utterly simple in both design and construction, Boston's first Town House must have had a Puritan directness and lack of ostentation at marked variance with its more elegant successor, which was built in 1712 in Georgian style among the ruins of the fire which, in the fall of the previous year, had devastated a considerable portion of the oldest part of the town. Fire was a constant danger and the history of most of the early communities in the colonies is punctuated by accounts of conflagrations until it seems almost miraculous that any examples of early building remain. Voluntary fire companies were organized, and increasingly brick replaced wood in urban construction until by the beginning of the 18th century colonial cities and many towns were pre-dominantly built of the safer material.

Portraits, signs, scutcheons, and death's heads

Most of the early settlers of New England had come from towns and rural communities where the medieval arts and crafts still flourished. Painting in England during the 16th and 17th centuries was limited by the Reformation almost exclusively to portraiture; it was distinctly provincial, and dominated by foreign-born artists, few of whom produced pictures of outstanding quality. The impact of the English sojourn of the German Renaissance painter, Hans Holbein, who enjoyed the patronage of Henry VIII from 1537 until the painter's death in 1543, determined the course of English painting in the direction of detailed and objective realism for a century. Despite the extraordinary flowering of literature and learning under Elizabeth, in painting the Queen preferred a hard, descriptive, shadowless manner, and thus encouraged a continued influence of late Gothic linearism.

Holbein had no English pupils of note, so Dutchmen and Flemings of limited artistic gifts largely monopolized

17 (opposite) UNKNOWN ARTIST *Alice Mason, 1670. Oil on canvas, 33¼" × 24⅞" (97 × 63.1). U.S. Department of the Interior, National Park Service, Adams National Historic Site, Quincy, Massachusetts*

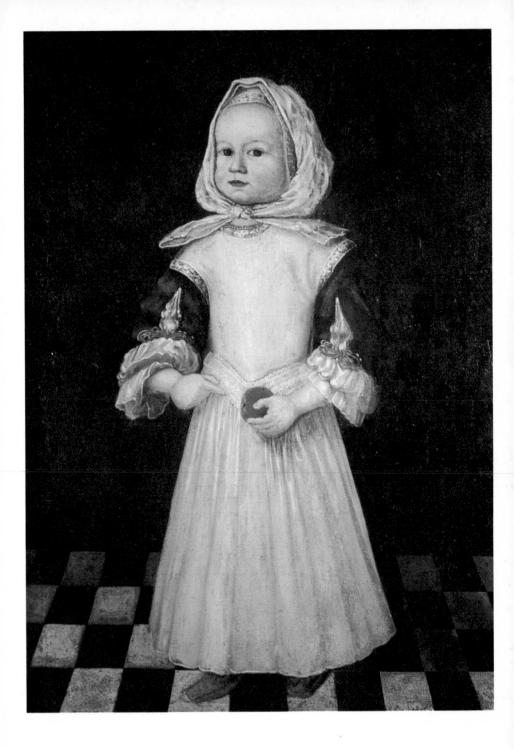

the field, until the visit of Peter Paul Rubens to the court of Charles I in 1629 revealed the full richness of the mature Baroque style. The King's appointment of Rubens' pupil, Anthony van Dyck, as court painter dramatically changed the course of British painting, and brought it into line with the rest of European development.

Thus the Pilgrims, who settled at Plymouth in 1620 after years of exile in Holland, and the Puritans who came to the Massachusetts Bay Colony in the Great Migration of 1630, had never seen any but the still largely Gothic painting style of the older English tradition, or else the hard manner of the Netherlandish portrayers of royalty and aristocracy which prevailed until the advent of Rubens and van Dyck. Works in the older style, there-fore, were the major models for the first painters in the New World, though engravings after European works in a Baroque manner became increasingly popular.

A number of the colonial leaders are known to have brought portraits with them, like those which Pieter Stuyvesant took with him when he came as governor to New Amsterdam – sober, workaday pictures which may today be seen in the New-York Historical Society. Others, like Governor John Winthrop and the Reverend Increase Mather, had their portraits painted during return trips to England.

Though Jamestown, settled in 1607, was chrono-logically older than the northern colonies, it was slower in becoming established due to the misconceptions of the directors of the Virginia Company, who clung to notions of quick fortunes in the face of the facts, as pungently reported by the redoubtable Captain John Smith, who declared that the only future lay in hard work and in sending over more 'honest artificers' and fewer 'useless gentlemen'. Royalist refugees who fled to Virginia and Maryland from the Puritan Commonwealth of Cromwell in 1649 influenced the attitude of dependence upon the mother country, which was confirmed by the one-crop tobacco economy: therefore when, with the adoption of slavery, there was sufficient wealth and ease to enable the fortunate few to think of the arts, Virginians naturally turned to England for their portraits as they did for their costumes and reading matter. Since they considered all craftsmen vulgar wretches, they imported almost every-thing from shoes to paintings, and what artisans there were were mostly slaves.

In the North there are records of artisan-painters during the earlier years of settlement, such as Evert Duyckinck, who opened a shop in New Amsterdam about 1640 where he plied his craft as a glazier and limner and established a craftsman's dynasty. Another, Thomas Child, was admitted a member of the guild of Painter Stainers in London in 1679 and is recorded as having married in Boston in 1688 and died there in 1706. We know that he painted window frames of King's Chapel and the 'out side work' of the Boston Latin School; but we know nothing of any decorative painting or portraits by him. Yet such painter-stainers, as Virgil Barker points out in *American Painting*, 'painted everything from houses to heraldic devices,' including coaches and furniture and, perhaps the most colorful element of the colonial scene, shop and inn signs. These were often highly imaginative in their pictorial symbolism, like that for the Philadelphia tavern known as the Quiet Woman which showed a woman with her severed head lying at her feet. We will never know who painted the first portraits in the colonies, but they were surely done by just such artisans as those who painted signs and hatchments, and whatever else the custom demanded, in a solid workmanlike manner. No examples from the first half of the 17th century are known, but there are more than a few from the second half, several of which, provincial though they may be, display qualities of design, crafts-manship, and interpretation which raise them above the artisan level.

No one knows whether the limner who portrayed little Alice Mason (*Ill. 17*) in 1670 at the age of two and a half brought his still medieval manner from England or used as models such portraits as are known to have been brought to the New World earlier in the century. In any event, the picture reflects that combination of flatness and attention to detail of the Dutch and a graceful quality of linear design derived from the late Middle Ages, which are typical of English painting before the advent of van Dyck. The variegated pavement is a Dutch convention to provide the narrow space in which to present the figure, but there is no reason to doubt the authenticity of the costume. Despite more recent misconceptions that the Puritans were a dour lot who always dressed in black and wore habitual expressions of disapproval, there is not only the evidence of such paintings but also a body of

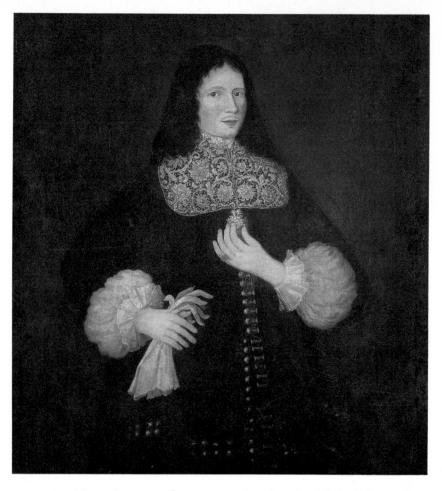

record to prove quite otherwise. Their faith may have
been stern and their beliefs inflexible, but such were the
qualities necessary to establish a new society in a wilder-
ness. And that they were capable of softer feelings is
shown by the touching verses 'To My Dear and Loving
Husband' written in 1678 by Anne Bradstreet:

> *If ever two were one, then surely we.*
> *If ever man were lov'd by wife, then thee . . .*
> *I prize thy love more than whole Mines of gold,*
> *Or all the riches that the East doth hold . . .*

and by the gentle and delicate quality of the group of
children's portraits of the period of which the *Alice Mason*
is a particularly charming example.

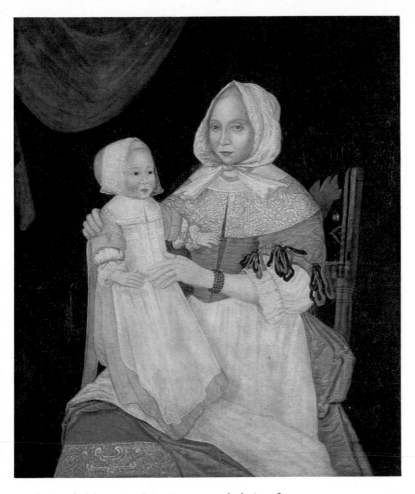

Also probably painted in Boston, and dating from perhaps four years later, is a pair of portraits, similarly anonymous, of John Freake, a Boston attorney, merchant and shipowner, and his wife with their little daughter Mary (*Ills. 18, 19*). The rich and sober tonalities of John Freake's reddish-brown coat are relieved by the delicate patterns of the lace collar, the row of silver buttons, and the white cuffs and gloves. There are gayer colors in the portrait of his wife and daughter. Mrs Freake wears a gold-embroidered red skirt with olive-green bodice trimmed with red and black ribbons, and white lace collar and apron. Little Mary's yellow dress is partly covered by her white apron, while her yellow cap emphasizes the paleness of her blonde hair.

19 UNKNOWN ARTIST *Mrs Elizabeth Freake and Baby Mary, c. 1674. Oil on canvas, 42½" × 36¾" (107.8 × 93.2). Worcester Art Museum, Worcester, Massachusetts*

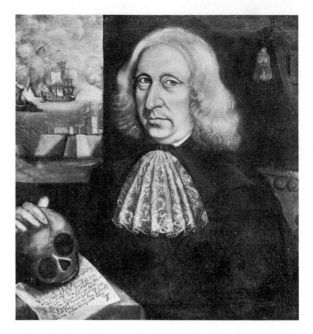

Again there is an archaic flatness, but also a greater
subtlety of design, which, modern scientific methods of
investigation reveal, was not instantly nor easily arrived at.
X-ray photographs show that the limner made several
changes in the position of the arms and hands of both
mother and child to stress their intimacy and shyly
expressed affection, changes which show something of
the evolution of a concept – the process by which an
artisan, not too familiar with the portrait genre, but a
sensitive observer with an innate sense of design, rose
above the level of craft into the mysterious realm of art.

Far different in manner is the painting believed to be
the self-portrait of a Captain Thomas Smith (*Ill. 20*), a
seaman who arrived in Boston from Bermuda about the
middle of the century, and is recorded as having painted
the likeness of the Reverend William Ames for Harvard
College in 1680. The picture, sometimes rather arbitrarily
dated at about 1690, is a vigorous if somewhat crude
essay in the Baroque style. Where the Mason and Freake
limners relied on a flat linear pattern in composing their
pictures, Captain Smith used the bolder approach of
shadows and modelling in light and dark to define
three-dimensional form. The focus of the eyes suggests

the gaze fixed upon the mirror image in a fashion typical of the self-portrait.

The significance of the naval engagement in the background has long been lost, but the sobriety of expression, the contrast between the coarse features and the unexpected softness of the gray hair and the delicacy of the lace at the throat, and the symbolism of the skull contribute to a mood borne out by the crabbed verses of the Captain's own composition carefully inscribed on the piece of paper beneath the death's head:

> *Why why should I the World be minding*
> *therin a World of Evils Finding.*
> *Then Farwell World: Farwell thy Jarres*
> *thy Joies thy Toies thy Wiles thy Warrs*
> *Truth Sounds Retreat: I am not sorye.*
> *The Eternall Drawes to him my heart*
> *By Faith (which can thy Force Subvert)*
> *To Crowne me (after Grace) with Glory.*

The firmness of faith, the strength of purpose, and the sober dignity of the Puritan are there, both in the sentiment expressed in the rough rhymes and in the mood of the painting as a whole.

The inevitability of death and judgment was never far from the Puritan consciousness and lent a fateful seriousness to their lives and all their endeavors. The skull, a *memento mori* retained from the Dance of Death – the grinning, prancing skeleton, which haunted the minds of men of the waning Middle Ages – appears on the Puritan tombstones along with a vocabulary of symbols including the weeping willow for mourning, the broken twig to signify a young life lost, the extinguished torch, the hourglass for the inevitability of the passage of time, and the strange soul symbols which are unique.

In such tombstones as the Joseph Tapping stone of 1678 in the burying ground of King's Chapel, Boston, with its curious allegorical relief of grim death and ancient time derived from an emblem book by Francis Quarles published almost a half-century earlier in London, and in the stones produced by Nathaniel Fuller (1687–1750) and the Soule and Worcester families, of Plympton and Harvard, Massachusetts, we see the work of the first regional school of sculpture in the colonies. Totally unlike any English or Continental funerary monuments, they are executed in incised relief

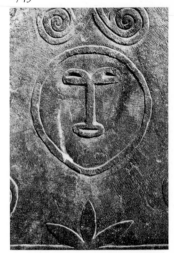

21 UNKNOWN SCULPTOR *Soul symbol on the tombstone of Mary Pickard, Rowley, Massachusetts, 1743*

in a curiously abstract style, and, at their best, are strangely
evocative. It was only after the turn of the 18th century
that likenesses of the deceased began occasionally to
appear on the tombstones, as on the slate slab of the
Reverend Jonathan Pierpont in Wakefield, Mass-
achusetts, carved by Nathaniel Lamson of nearby
Charlestown in 1709, to create an image almost as
abstract as the soul symbols (*Ill. 21*), and, like them,
suggestive of the brooding and mystical qualities of the
Puritan imagination.

Thus the last vestiges of the medieval world did not
vanish in the colonies until long after the Renaissance
had been succeeded by the Baroque in England. The
Parson Capen House, a perfect example of medieval
English domestic architecture, was built more than sixty
years after Inigo Jones had begun the Queen's House at
Greenwich to introduce Renaissance architecture in a
mature Palladian style. The portrait of Alice Mason was
painted fifty years after van Dyck had brought his
masterful Baroque manner to the British court. When
Nathaniel Lamson carved his curious, primitive portrait
relief on the Pierpont stone, Grinling Gibbons had
completed most of his virtuoso sculptures for the interiors
of the admirable series of churches with which Sir
Christopher Wren embellished London after the Great
Fire of 1666, and which were to supply models for so
many churches in America. Gibbons had almost
finished his work on the interior of St Paul's Cathedral,
the crowning example of Wren's restrained but eloquent
interpretation of the Baroque style, completed in 1710.

Such was the time lag between the Old World and the
New, and, in the future, a similar lag was to exist in turn
between the longer established settlements on the Atlantic
coast and the back country where, as the frontier was
pushed westward, the story of settlement was to be
repeated over and over again. By 1690 Boston, with 7,000
inhabitants, was as large as Gloucester in England, and
New York and Philadelphia, with 4,000 each, were
comparable to Derby. Populations were to more than
double in the following three decades, and urban life in
the New World was well established. By the turn of the
century, all the colonies up and down the Atlantic coast,
except for the still Dutch-appearing New York, had an
English look. All were prospering, and with their
prosperity came increased opportunity for the arts.

'So Fine a Prospect'

Just before Christmas 1736, Thomas Hancock wrote to John Rowe in London to request a shipment of fruit trees and shrubs for the garden of the house he was building on Beacon Hill in Boston. He specified, among other items, '100 small Yew Trees in the rough which I'd frame up here to my own fancy.' He could not refrain from adding, with obvious satisfaction, that 'the King, dom of England don't afford so Fine a Prospect as I have both of land and water. Neither do I intend to Spare any Cost or pains in making my Gardens Beautiful or Profitable . . .'

Thomas Hancock, like most of the rest of the more prosperous colonials, North or South, was a hard, working, ambitious man. He started as a bookseller's apprentice, opened his own shop, added stationery, branched out with a paper manufactory, and went on to become one of the leading merchants and importers of the period. Like other wealthy colonials, he determined to have a house and garden as like that of an English gentleman as possible. He sent to London for the latest in furnishings, and insisted that Joshua Blanchard, the master mason who built the house (*Ill. 22*), carry out the ashlar masonry of Braintree granite and the architectural trim and detailing of fine sandstone, quarried and cut in Middletown, Connecticut, 'workmanlike and Ac, cording to the Rules of Art every way Agreeable.'

The work of Blanchard, like the superb interiors executed by the joiner, William More, were up to the standard to which Hancock aspired. The spiral turnings of the broad stairway, three of different profile repeated on each step, with a composite newel post made up of one spiral turning inside another, twisted in the opposite direction, set a new standard of opulence for the colonies. The large parlor and the living room were hung with 'painted paper' with a 'great variety of different Sorts of

45

Birds, Peacocks, Macoys, Squirril, Monkys, Fruit and Flowers, etc.' Fireplaces had surrounds of blue and white Dutch tiles. There were gilded looking glasses and chandeliers, and fine mahogany furniture, much of it made in Boston. Beds had figured hangings and spreads. There were damask draperies and Oriental rugs on polished floors, with silver, also largely from Boston, and imported porcelain for the table. His coach, one of the finest in the colonies, was also from London, and bore his coat of arms. Thomas Hancock, like all but a handful of other wealthier inhabitants of the colonies, was self-made and proud of his success. His achievement was one to which virtually all the other colonists aspired. His house was up-to-date Georgian, the latest style. He considered himself as English as anyone in the kingdom.

The 18th century was to see a flowering of Georgian architecture in the colonies based upon English practice as learned from such excellent handbooks as James Gibbs's *Book of Architecture* (1728) or Isaac Ware's *A Complete Body of Architecture* (1756), designed to provide the provincial housebuilder with working plans and details in proper style. Many such houses, churches, and other buildings were constructed in the colonies during the period, and the best of them more than live up to contemporary British standards. Yet, generally sparing of decorative detail and usually built of wood and painted white, the traditional American material and color, they early began to assume a slightly different character from their British counterparts; particularly attractive examples may be seen at Deerfield, Massachusetts, and Portsmouth, New Hampshire. And their builders, whatever their aims and aspirations, were more different than their architecture suggested, or than they themselves were probably aware. The colonies were growing fast, and with growth came change. Something of the character of that difference we will see revealed more clearly in the painting of the period.

From his house on Beacon Hill, Thomas Hancock looked out across a panorama of a fast-growing Boston, with a harbor crowded with ships which plied the seas of the world, and whose captains and crews were as familiar with the ports of Europe, Asia, and Africa as with the rival ports of New York, Philadelphia, Portsmouth, Newport, or Charleston. During his lifetime, Canada had been won from the French through the

heroism and strategy of Wolfe at Quebec, and except for the Negroes, who were victims of the strongly established institution of slavery in the South – only a few remained in the North, though there were some in every colony – American colonials enjoyed a greater degree of personal freedom and home rule than the inhabitants of any other colonies in the Empire.

Before Thomas Hancock died in 1764 in the Old State House during a meeting of the Governor's council of which he had long been an active member, there had been signs of change. The British government had gone into debt during the Seven Years' War, and the Revenue Act of 1764 was designed to gain greater income from the colonies and to close those loopholes of which English- men on both sides of the Atlantic were so prone to take advantage through consistent smuggling. As a result 'the Young Gentlemen of Yale College have unanimously agreed not to make use of any foreign spirituous Liquors' in protest, since the tax hit heavily on Madeira. As it did not apply to rum, the favorite New England drink, however, their resolution did not subject them to too great a hardship. But the Stamp Act followed, and during the next year bands of Sons of Liberty were organized in every colonial seaport to resist it. No one yet dreamed of independence except perhaps Sam Adams, but in their insistence on maintaining the rights they already enjoyed, the colonists started a course of events the outcome of which seemed increasingly inevitable.

Despite the efforts of Thomas Hancock to build the finest house possible, there were already houses in the South which were of yet greater architectural distinction,

and further examples were constructed in the colonies which were to surpass his. Nevertheless, the Hancock House, inherited by Thomas's nephew John – he of the famous signature – had a colorful history before it was unnecessarily torn down in 1863 on the eve of the Civil War. (A replica of it exists, however, in Ticonderoga, New York.) During the Revolution it was the head⁄quarters of General Sir Henry Clinton, and, after Independence, John Hancock, as Governor of the Commonwealth of Massachusetts, there entertained Washington, Lafayette, and other visiting dignitaries in a style that would have made his uncle proud.

The Georgian style prevailed throughout the colonies until the Revolution. The shift away from medieval forms had actually started in the late Stuart period, during the reigns of William and Mary and of Queen Anne, more than a decade before the accession of George I in 1714. There were inklings of the stylistic change before 1690, as suggested by the contemporary descriptions and by early 19th⁄century views of the Foster⁄Hutchinson House on North Square in Boston (*Ill. 23*). Built about 1688 by Colonel John Foster, who came from Buckinghamshire in 1675, it was torn down in 1833. Its giant order of pilasters with garlanded Ionic capitals, so reminiscent of Lindsay House, dating from around 1640, in Lincoln's Inn Fields in London, designed either by Inigo Jones or an architect close to him, was probably original. The balcony over the front door of the London building, which forms a central emphasis to the façade, may have inspired the similar motive in the Hancock House.

The most outstanding examples of this transitional architecture of the Stuart period are in the South in Colonial Williamsburg, the re⁄creation of a colonial capital as it existed during the early years of the 18th century. In 1699 the State House of the colony of Virginia burnt down, and the Assembly voted to move the capital to the village of Middle Plantation, and there establish a new town to be named Williamsburg after King William III. The village had increased in importance and size with the foundation in 1691 of the College of William and Mary, the second such colonial institution of higher learning after Harvard. The Assembly also decided how the new town was to be laid out.

Theodorick Bland undertook to interpret their direc⁄tions for a generally gridiron scheme, with major and

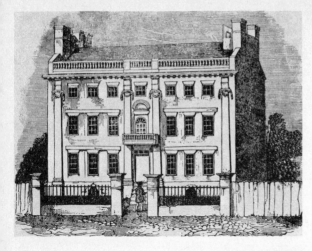

23 *Foster-Hutchinson House, Boston, c. 1688*

minor axes, in a manner common to Renaissance urban design. The major axis is formed by the Duke of Gloucester Street, almost 100 feet wide, and extending from the new College, constructed in 1695, at the westward end for almost a mile eastward to the Capitol. Halfway down the Duke of Gloucester Street the Palace Green forms a minor axis leading northward, at right angles, to the Governor's Palace. The Bruton Parish Church occupies a corner of the intersection, and the Courthouse is nearby. Houses, shops, inns, and taverns were neatly spaced by ordinance to maintain a properly open effect, leaving room for lawns and gardens.

Because of the character of the Virginia economy, with few towns and a population spread sparsely over an immense area, the number of inhabitants of Williamsburg in colonial times never exceeded about 1,600 people except during 'public times', when its population might be doubled by the influx of burgesses, judges, lawyers, traders, and planters eager to do business and to enjoy the conviviality of the suddenly activated social life, the theatricals, balls, and receptions, and the hospitality of the many public houses for which the town was famous.

Though there are a number of buildings in Williamsburg which had survived and were carefully restored to complete the appearance of the colonial capital, the three major structures, the College of William and Mary, the Capitol, and the Governor's Palace, are total re-creations. Successive fires had left only a portion of the walls of the

49

College standing and had entirely destroyed the interior, while the other two buildings had been completely razed, leaving only their foundations to show their size and location. There was, however, documentary evidence – old descriptions and prints – to guide the architects and scholars in the rebuilding.

The College is the earliest of the three, dating from 1695 to 1702 (*Ill. 24*). Though it was intended as a quadrangle in traditional academic fashion, only three sides were constructed. Said to have been based on a design by Sir Christopher Wren, Surveyor General for the Crown and chief architect of the kingdom, the building shows Wrenlike qualities in the angular gable over the main door, the round windows like those he used at Hampton Court, and the tall cupola which has some of the vertical emphasis of his church designs. Its general appearance, as a contemporary observer noted, is somewhat similar to Wren's Chelsea Hospital in London. As in the two original buildings at Harvard, the College at Williamsburg provided for all the needs and activities of the students and, in this case, of the faculty as well. Three stories and a high basement tall, and almost 140 feet long, it introduced mature English Renaissance architecture to the colonies on an impressive scale and in a distinguished style.

Next came the Capitol. Henry Carey was the master builder of this, as he was of the Governor's Palace which followed. Nothing is known of the architect of either, but Wren may have been responsible for both. In any event, the designs probably came from England. The Capitol has been recreated as completed in 1705, without its fireplaces, however, for reasons of safety. The view from the south-west is most impressive, with its two semicircular bays and the open arcading of the ground floor. Again there is a tall hexagonal cupola and dormers with triangular gables. The interiors are restrained in both architecture and furnishings except for the Council Chamber. There the panelling with Doric pilasters, the royal portrait and coat of arms, the high-backed caned chairs, and the oval table – precisely as specified by the Burgesses – show the importance of the Governor's Council as the center of power of the colony.

The Palace was started in 1706 but not completed until 1720. Similarly vertical in accent, with hipped roof rising to a balustraded deck surmounted by another tall

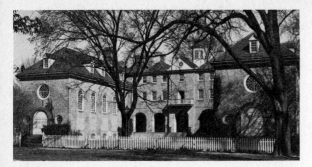

polygonal cupola between high chimneys, the building
is intimately related in style to both the College and the
Capitol, and was the most sumptuous residence in the
colonies in its day, a proper setting for the Governor, the
representative of the crown, and one of the most powerful
officials in the New World. The interiors have been
re-created with appropriate formality. The richest of them,
in the ballroom wing added to the rear about 1750, is a
striking example of the Chinese Chippendale of the
period, with pagoda-form pediments over the doors, and
wallpaper of colorful flowers and birds among gray-
green foliage against a silvery blue background.

The formality of the approach to the Palace, with the
long carriage drive sweeping up to the tall gateway,
topped with the lion and the unicorn, is equaled by the
rest of the setting. The doors of the ballroom wing lead
out into a geometrically planned garden of topiary work
and flower beds edged with trimmed hedges of box, and
enclosed by brick walls, with a vista which extended
beyond, past orchards and other plantings and continued
by a long *allée* cut through the woods. The whole
provided an appropriate setting for the long succession
of governors of colonial days and of the period of the
early republic as well, for it was the residence of Patrick
Henry and of Thomas Jefferson before it was destroyed
by fire in 1781, the fate of so many colonial buildings,
while being used as a hospital for troops wounded at the
Battle of Yorktown, after Richmond had become the
capital of Virginia.

Today, thanks to an extraordinary and continuing
campaign of restoration initiated in 1927 and largely
supported by the generosity of the Rockefeller family,
Williamsburg is an amazingly complete and consistent
example of the style of architecture, planning, and

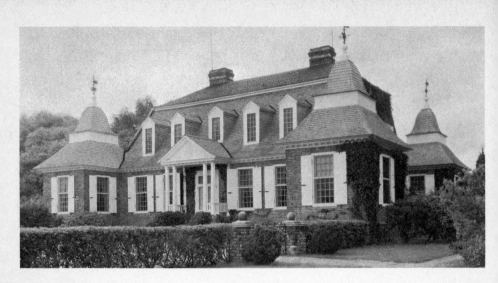

25 Mulberry, near Charleston, South Carolina, 1714

decoration of the earlier years of the 18th century. Its completely English qualities are clear and are properly interpreted as evidence that the colonials who lived and met there considered themselves to be Englishmen in every sense.

This does not mean, however, that colonial architecture could not be idiosyncratic. Mulberry, a plantation house built in 1714 near Charleston, South Carolina (*Ill. 25*), overlooking the west bank of the Cooper River, proves the point. The oblong block of the house, a story-and-a-half high with dormers, has clipped gables as did other houses of the period in that vicinity, but in this case they form an unusual hipped gambrel. Mulberry also has wrought-iron beam anchors in s-curves like those seen in Dutch houses of the distant Hudson River Valley, and flaring eaves like those introduced earlier into the Dutch colonies by the Flemings. Furthermore, it has four corner pavilions with double-pitched roofs, the upper of which are bell-form in profile and bear as finials wrought-iron weathervanes in the form of bannerets perforated with the date 1714. The pediment of the entrance porch bears the device which gave the house its name: a relief of a branch of mulberry within a horseshoe, an expression of the hope of South Carolinians of the period that by means of the newly-introduced silk-worm culture they could become even richer than the lucrative rice and indigo trade had already made them. The interiors were done over at the beginning of the 19th century in a style derived from that of the Scottish architect, Robert Adam. The plan was

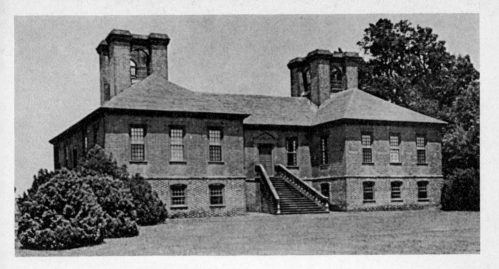

unchanged, however, and shows the formal symmetry of Georgian design. For all its quirky individuality, Mulberry is a handsome example of domestic architecture of the earlier years of the 18th century.

26 Stratford, Westmoreland County, Virginia, c. 1725–30

Stratford, the family home of the Lees in Westmoreland County (*Ill. 26*), matches it in distinction. Built by Thomas Lee about 1725–30 on the Potomac near Lee's Landing, it has a blunt massiveness which is enhanced by the almost complete lack of any decorative elements whatsoever. Constructed of brick burned locally, its main floor raised on a high basement, it has a plan in the form of a broad H similar to that of the Capitol at Williamsburg, but entirely rectilinear in character. The heavy roof carries a pair of clustered chimneys, four in each stack, joined at the top with arcading, and containing balustraded decks from which Thomas Lee could watch for the approach of his vessels on the river. The high basement floor contains service rooms and chambers, while the main floor has rooms for living and entertaining and the master bedrooms. The Great Hall in the central block of the house, almost 30 feet square, has panelling with a complete order of Corinthian pilasters. With gray-blue woodwork and crimson damask draperies, it is one of the finest Georgian rooms in America.

There is no record of who designed most of the houses of the period. Many were probably planned by their owners with the assistance of design books. Many of the best buildings in the colonies during the 18th century were the work of amateurs rather than men of any

53

professional experience. Andrew Hamilton, the architect of Independence Hall in Philadelphia, was a lawyer who held various offices in the government of Pennsylvania. John Smibert, who designed Faneuill Hall (*Ill. 50*), the famous 'Cradle of Liberty', in Boston, was a painter. There were, however, men with some architectural training as well, acquired through travel or their own study, as in the case of Thomas Jefferson and also probably John Ariss, another Virginian, who designed a group of important Southern houses in the second half of the 18th century, William Buckland who dominated the field in Maryland just before the Revolution, and Peter Harrison, who, at Newport, produced several buildings which sum up the colonial achievements in architecture and lead on to the work of the republic.

Because of the increase in immigration and in travel in England and on the Continent by colonials during the 18th century, there was a correspondingly larger number of men in the colonies who were aware of the latest developments in the arts, and whose tastes and interests greatly influenced the artistic life of the New World. Along the Eastern seaboard and even, on occasion, in the back-country there was less of a time lag stylistically than in the previous century.

It was customary in the colonies, as in the British Isles, for a man to be able to supervise the building of his own house, and sometimes of other buildings, such as churches, meeting houses, and courthouses, since some knowledge of architecture was an accepted part of a gentleman's education. There were also experienced builders, men whose essential training was usually in carpentry, but who knew construction methods and were capable of carrying out a project in all its details given only a most summary sketch or a verbal description 'to make it like Captain So-and-so's house'.

The few original drawings for buildings of the period which remain are usually awkward, rough, and unbelievably generalized and unspecific, yet the resulting buildings were usually excellent. This was possible because there was an understood basis of stylistic consistency which ran through the period and was given currency by the excellent architectural books available. These included the less expensive carpenters' manuals illustrating the correct classical orders and giving diagrams of structure and measured drawings of details of doors,

windows, stairs, and fireplaces, as well as the more expensive publications illustrating the works of such distinguished architects as Palladio, Vignola, and Inigo Jones.

Such handbooks were used by the builder and his client as well as by Ariss, Jefferson, Harrison, and the other more experienced and practised designers on both sides of the Atlantic. An architectural profession in anything like the modern sense did not exist in the colonies until after the Revolution, yet the many designers, builders, and amateurs responsible for the many architectural projects demanded by a period of such vigorous growth maintained a notably consistent quality, whether in country farmhouses and modest urban dwellings, or churches, state houses, and structures of the importance of Independence Hall, Philadelphia.

When one compares the resulting buildings with the books, it is clear that the latter may have supplied details of windows, doors, fireplaces, and cornices, but rarely of complete plans or of whole façades. The results attest the competence, practicality, individuality and ingenuity of their builders.

Richard Taliaferro, 1705–79 (pronounced Tolliver, as it was sometimes spelled in documents of the period), seems to have been responsible for the first significant group of Virginia plantation houses, of which the best known is Westover (*Ill. 27*), built about 1730–34 by William Byrd II, whose famous diary records the daily life of the owner of a large plantation with the self-revealing completeness, though without the humor, of the famous Samuel Pepys. Byrd was educated in London where he was a member of the Inner Temple, and inherited broad lands and a large fortune made from trade in various commodities and in Indian and Negro slaves. He had the largest library in Virginia, and furnished his house with portraits of his highly-placed friends and acquaintances in London. Though the house he built is spacious and dignified to a degree which suggests a life of ease, he was a hard-working, hard-driving business man always on the lookout for a money-making scheme.

Rich but always short of funds, Byrd knew Greek, Hebrew, and Latin, and was a correspondent of the Royal Society, yet he actually lived a life close to the frontier in its incessant activity. Somewhat primitive patterns of life were the rule in even the largest Southern

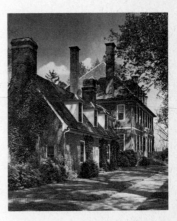

27 RICHARD TALIAFERRO (1705–79) *Westover, Charles City County, Virginia, c. 1730–34*

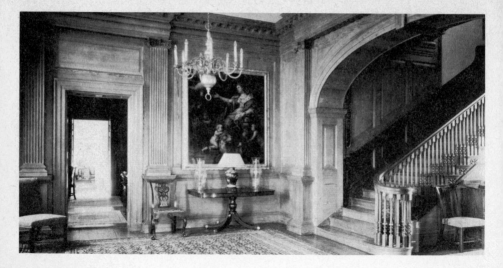

houses. Because of the demanding realities of existence
remote from any urban center, everything needed had to
be improvised or else ordered from abroad. Constant
travel through rough country, by boat, on horseback, and
on foot, was necessary to attend to all the responsibilities
which went with a various enterprise carried on without
adequate skilled assistance. The planters found themselves
increasingly unable to operate without the system of
slavery, yet were increasingly the victims of the system
which demanded a crippling outlay of capital and
constant supervision. Taliaferro was a third-generation
Virginian of landed background, who was a Justice of the
Peace in Williamsburg and sheriff of the county. By
1749 he was sufficiently established as an architect to be
commissioned to design the ballroom wing of the
Governor's Palace, and in 1755 he built his town house
in Williamsburg, which he later turned over to his
son-in-law George Wythe, first professor of law in an
American college, friend of Jefferson, and a signer of the
Declaration of Independence.

The Wythe House has the simplicity and formal dignity
of earlier Georgian at its robust best. Similar qualities
may be seen at Westover, but are more apparent still at
Carter's Grove (*Ill. 28*) in James City County, built
from 1750 to 1753 a few miles below Williamsburg on
the James River by Carter Burwell, grandson of the
arrogant and powerful King Carter. The master builder
was David Minitree of Williamsburg, and the interior
woodwork, among the best of its kind in the colonies,

was carried out with unerring taste and craftsmanship by an English carpenter, Richard Bayliss, who came to Virginia for this specific commission. Originally Carter's Grove had a low-pitched hip roof without dormers, and was much more impressive in its restrained simplicity than in its present form, the result of extensive alterations during which the pitch of the roof was raised and rows of dormers added, on the model of Westover. But its interiors are examples of early Georgian of superlative quality. In its completeness, simplicity, and perfection of proportion, however, his own house in Williamsburg is still the finest untouched example of Taliaferro's work.

John Ariss (c. 1725–99), about twenty years Taliaferro's junior, is known to have traveled in England as a young man. It was doubtless there that he learned the Palladian style so enthusiastically promoted during the first half of the century by the Earl of Burlington, for in the *Maryland Gazette* in the Spring of 1751 he advertised that he was 'lately from great Britain'. He assured his potential patrons that he was prepared to undertake and perform 'Buildings of all Sorts and Dimensions . . . in the neatest Manner (and at cheaper rates),' and that anyone interested might apply 'to the Subscriber at Major John Bushrods at Westmoreland County, Va., where may be seen a great variety and sundry Draughts of Buildings in Miniature, and some buildings near finished after the Modern Taste.'

In Newport, Rhode Island, colonial architecture reached its climax. There Richard Munday (act. c. 1713–39), innkeeper and carpenter, designed Trinity Church (1725–6) with fitting elegance to be the fashionable place of worship for the wealthy shipowning families who were the leaders of Newport society. His Old Colony House (1739–42) was worthy of its setting, rivalled only by Williamsburg, situated at the end of a mile-long axis formed by a tree-lined avenue leading straight as a die, from Newport's busy waterfront. With Boston's Old State House, and Andrew Hamilton's Independence Hall, Newport's Colony House is the sole public building of consequence remaining from the colonial period. Carried out in mellow brick, its façade, topped by a clipped gable and surmounted by a tall cupola, has a central feature of a doorway beneath a balcony which seems derived from that of the Hancock House in Boston completed two years earlier (*Ills. 22, 29*).

29 RICHARD MUNDAY (act. *c.* 1713–39) *Central section of the façade of Old Colony House, Newport, Rhode Island, 1739–42*

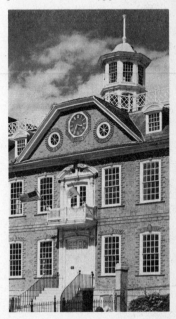

30 PETER HARRISON (1723–1805)
Redwood Library, Newport, Rhode
Island, 1748

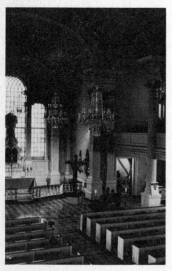

31 THOMAS McBEAN (act. 1764)
St Paul's Chapel, New York,
1764–6

Richard Munday died in 1739 before the Colony House was finished, and within the year there arrived in Newport the young Quaker whose architectural career was strictly a sideline, but who was destined to provide the climax of colonial architecture. Peter Harrison (1723–1805) was a Yorkshireman who came to the New World to seek his fortune, and he indubitably found it. He was only seventeen when he first saw Newport, but six years later, aged twenty-three, he was captain of one of the largest vessels in the transatlantic trade. At thirty he was a successful merchant who had mastered half a dozen trades ranging from shipbuilding and engineering to cartography. He turned to the more fashionable Anglican congregation, and had an affair with one of the richest heiresses in town which resulted in pregnancy and a highly advantageous marriage. With his new-found freedom from the drudgery of money making, he had the leisure to turn to architecture as an avocation. Harrison's Redwood Library, completed in 1748, was in the latest Palladian mode and an example of the first monumental temple-fronted structure in the colonies (Ill. 30). His design of 1749 for King's Chapel in Boston, though the spire was never completed and the handsome simplicity of his concept of the exterior is therefore seriously flawed, has one of the finest Georgian interiors of the period, equaled only by that of St Paul's Chapel (Ill. 31) in New York – the work of Thomas McBean, a Scottish pupil of James Gibbs, the architect of St Martin's-in-the-Fields in London – built from 1764 to 1766.

Harrison's most interesting building is the Touro Synagogue (Ill. 32), constructed between 1759 and 1763 in Newport, for the congregation Jeshuat Israel, made up of Sephardic Jews. Rabbi Isaac Touro, a distinguished scholar, determined the ritual necessities of the building which Harrison carried out with brilliant virtuosity. The exterior, simple to the point of barrenness, provides a dramatic contrast to the richness of the interior, which is a display piece of Harrison's command of the full range of the Palladian manner.

Touro Synagogue is not only the oldest in the United States but a fitting finale to colonial architecture. By the time of its completion in 1763, James Otis of Boston and Patrick Henry of Virginia had openly challenged the crown in its regulation of colonial affairs, and within the decade the Massachusetts Great and General Court had

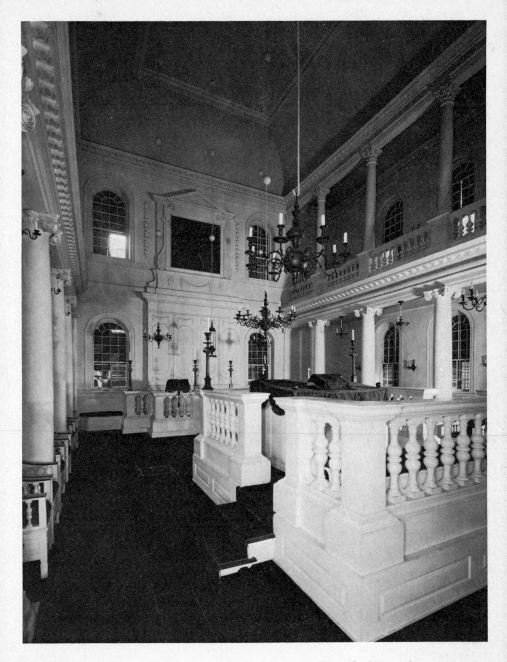

32 PETER HARRISON (1723–1805) *Touro Synagogue, Newport, Rhode Island, 1759–63*

defied the royal government. Sam Adams' Committee of Correspondence in Massachusetts led to the formation of others throughout the colonies, and the Boston Tea Party, carried out by Adams' Liberty Boys, lit sparks which were soon to break into the flame of open rebellion. The secure and orderly world of Peter Harrison and the other Loyalists was shattered by the gathering momentum of forces which, with hindsight, can be seen to have been long at work. Thomas Hancock's prospect, spacious though it was, included more than he, like the great majority of others of his times, had ever dreamed of.

Imported skills and native genius

Throughout the 18th century, as earlier in America, most painting continued to be the work of artisans rather than of artists. Though one occasionally finds examples by rank amateurs, the generally workmanlike way the paint is handled shows the competence of a housepainter or painter-decorator. Without art schools, men learned to paint as they learned other crafts, by assisting and watching more experienced artists at work, and by studying the pictures of those more proficient than they. There were such craftsmen-artists in all the colonies from the later 17th century on. Their advertisements appeared in local newspapers or on handbills offering a variety of services, from gilding, painting on glass, and the decoration of signs, coaches, and furniture to giving drawing, music, and dancing lessons. Though their work was influenced by the academic through engravings made after the works of European-trained masters, they lacked the knowledge of anatomy, perspective, and formal design to be gained through academic study. For the most part they were nonetheless professionals, and represent the vernacular tradition usually referred to as primitive or folk art.

Both the vigor and the other direct qualities of that tradition appear in such examples as the *Portrait of Anne Pollard* (*Ill. 33*), produced in Boston by an unknown hand in 1721, and that of the *Reverend Ebenezer Devotion* (1770, *Ill. 34*), painted by Winthrop Chandler (1747–90) of Woodstock, Connecticut, almost fifty years later. Though they differ in style as well as in date, both share the primary characteristics of the primitive painter in their

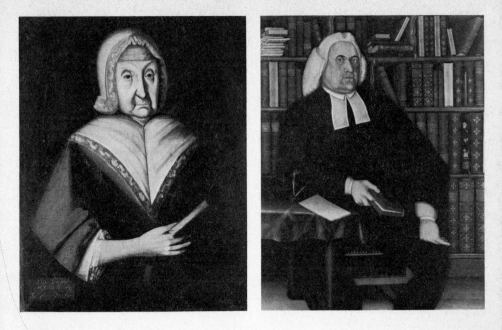

emphatic design, an essentially flat treatment, and in their stress, by a process of abstraction, of those details and elements which most strongly convey the sitter's individuality. By these simple means the Pollard Limner has created, not only a memorable portrait, but also an expression of the isolation and experience of age, painted when the sitter was, by her own reckoning, a hundred years old, and liked to tell how, as a child, she was the first to jump ashore from the first boat to land John Winthrop's group of settlers at Salem more than ninety years before. Chandler's *Portrait of Ebeneazer Devotion* is equally expressive of individuality and also suggests the unyielding integrity of the Puritan tradition in New England, whose dedication to learning is symbolized by the books in the background (which are also an important component of the picture's strong and simple design).

The vigorous vernacular tradition forms a background and a continuity for American painting from its earliest beginnings until it was finally so weakened by the introduction of the daguerreotype in the 1830s, that, within a generation, the village artist and the itinerant limner, formerly existent in generous numbers in relation to the population, had virtually disappeared. But in the meantime, this tradition produced the works of the Hudson River Valley painters mentioned earlier, and of

33 (above, left) UNKNOWN ARTIST *Anne Pollard, 1721. Oil, 27¾" × 22¼" (70.4 × 57.7). Massachusetts Historical Society, Boston*

34 (above) WINTHROP CHANDLER (1747–90) *Reverend Ebenezer Devotion, 1770. Oil, 4'5" × 3'7" (135 × 110). Preserved by the Brookline Historical Society at the Edward Devotion House, Brookline, Massachusetts*

such artists as are represented by the Pollard Limner and Winthrop Chandler. And from it, through the influence of visiting painters of greater formal training and experience than it was possible to gain in the New World, emerged a number of native-born artists who rose far above its limitations, foremost among them being John Singleton Copley, whose extraordinary work is the crowning achievement of colonial painting.

The idealistic dream of a new future for man in the New World brought the first academically competent painter to America. That painter was John Smibert (1688–1751), a Scot whose parents, intending him for the ministry, had hoped for better things for him. But he persisted in the pursuit of art under considerable difficulty, rising from the menial status of housepainter to study in Italy and then a studio in Covent Garden in London and a modest clientele for his portraiture. The dream was not Smibert's, however; it was George Berkeley's. Berkeley was a lively and intelligent Irish cleric, who conceived the idea of founding a college in Bermuda for the Christian education of Indians. With the promise of a parliamentary grant, he assembled a small faculty, including Smibert as professor of art, and, with his wife and children, sailed for America in 1728. The group landed at Newport where they stayed, waiting for the promised financial support. The money was not forth-coming, however, and Berkeley returned to Britain to become Bishop of Cloyne and win fame as a philosopher with his *New Theory of Vision* and other writings, while Smibert moved on to Boston.

Because he was the first artist of any genuine talent and training to visit that city, he immediately received portrait commissions from several of the leading citizens. In 1730 he opened a studio with an exhibition of his copies after old masters, casts from the antique, and a group of newly completed portraits of Boston worthies. It was the first art exhibition in America and established his repu-tation at once, especially as his work – solid, craftsmanlike, and competent – appealed to the taste of the practical New Englanders.

One of Smibert's earliest paintings, and the most ambitious work produced to that date in America, was a life-size group portrait commemorating the abortive Bermuda project (*Ill. 35*). Painted in 1729, it shows Berkeley standing on the right dictating a letter to Richard

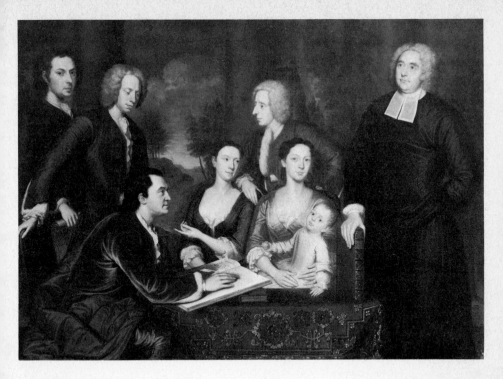

Dalton, seated, pen in hand, to the near left. Berkeley's wife is next to her husband holding their little son, Henry, while John James leans attentively on the back of the chair of Mrs Berkeley's sister. Beside Dalton stands the painter's nephew, Dr Thomas Moffatt of Edinburgh, who was later to bring Gilbert Stuart's ne'er-do-well father to Rhode Island to run a snuff mill. Smibert looks out at us from the far left, just as he scrutinized himself in the mirror used for this self-portrait – serious, sensible, observant. The group is a little self-conscious and stiff, but the composition – standard Baroque in the fashion of Sir Godfrey Kneller whose style dominated British painting during the earlier part of the century – is dignified, the color rich, and the personalities convincingly portrayed.

Until his death in 1751, Smibert was the leading artist in America. Other European-trained painters – like the Swedenborgian Gustavus Hesselius (1682–1755), who worked in Philadelphia and the Middle Colonies – had preceded Smibert, but none approached him in artistic quality. There was no reason for really good artists to chance the uncertainties of the raw New World, because

35 JOHN SMIBERT (1688–1751) *The Bermuda Group, 1729. Oil on canvas, 5' 9½" × 7' 9" (176 × 241). Yale University Art Gallery, Gift of Isaac Lothrop of Plymouth, Massachusetts, 1808*

there was work enough for all at home. Smibert would undoubtedly have continued painting in London, a satisfactorily successful minor portraitist, if Berkeley had not persuaded him to undertake the venture. As a result, the course of painting in America was given a strong impetus in a sound direction. Smibert's sober likenesses of his characterful New England sitters became stronger and more direct under the influence of the Boston environment which brought out unexpected capacities for development. Although his admirable example profoundly influenced the future of American painting, curiously his most important work in this respect was not one of his own portraits but a copy after van Dyck's *Cardinal Bentivoglio* which he had made years earlier in Italy. More than any other single work, it was studied by generations of young colonials who caught in its painterly handling and subtle modelling a glimpse of the richness of the great tradition of which they were so anxious to become a part.

Smibert's death at mid-century left two New England artists to share the leadership, Joseph Badger (1708–65), who started out as a housepainter and glazier, and John Greenwood (1727–92), whose father was a Boston shipbuilder and merchant. The former's *Jonathan Edwards* (1760, *Ill. 36*), with its stiff pose and silvery tones, suggests something of the personal remoteness of New England's leading Puritan philosopher, while his doll-like portraits of children have a nostalgic charm. Greenwood painted a fair number of vigorous and fairly competent likenesses before going to London to become a successful art dealer. On the way he spent some time in Dutch Guiana where he painted his liveliest and most amusing picture, perhaps as a joke for a tavern club, entitled *Sea Captains Carousing in Surinam* (1757–8, *Ill. 37*). Many of the subjects have been traditionally identified as among New England's leading citizens, but they are scarcely behaving in the fashion which later generations were led to believe was customary among their ancestors. Captain Ambrose Page, unaware that his coattails are afire from bumping into a candle flame, is vomiting into the pocket of Joseph Wanton, one of Newport's leading merchants, who has fallen into a drunken stupor. At the round table to the left, Captain Nicholas Cook, a future governor of Rhode Island, holds forth to companions who are too busy imbibing to pay much attention, while to the right,

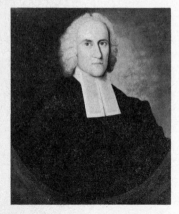

36 JOSEPH BADGER (1708–65) *Reverend Jonathan Edwards, 1760. Oil on canvas, 30½" × 25½" (77.4 × 64.7). Yale University Art Gallery, Bequest of Eugene Phelps Edwards*

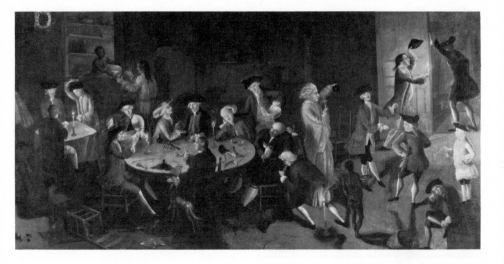

Captain Esek Hopkins, the future commander-in-chief of the Continental Navy, unsteadily raises an admiring glass to the dance being performed with more verve than assurance by Godfrey Malbone and Captain Nicholas Powers. Greenwood is said to have included himself as the distinctly uncomfortable figure staggering out the door! Six feet long, and painted with lively assurance in a cool palette on a length of bed ticking, it is the first genre painting in American art and a vivid reminder of the more Hogarthian aspects of 18th-century life.

In the meantime a mysterious and far more gifted artist had appeared on the scene. Despite intensive research, very little is known of the life and career of Robert Feke (c. 1705–50?). He was probably born in Oyster Bay, Long Island, the son of a minister and a member of a large family associated with Newport. A brief notice after his death refers to him as a mariner, which may explain what appears to be the influence on his work of the then fashionable London portrait style as practiced by such artists of the generation before Reynolds and Gainsborough as Ramsay, Hudson, and Highmore. In 1742 Feke married and settled in Newport, and there is evidence that he painted in Philadelphia also. In 1744 a visitor to Newport reported that he 'had exactly the phiz of a painter, with a long pale face, large eyes, – with which he looked at you steadfastly,' and an early self-portrait fits this description precisely. Whatever brief training he

37 JOHN GREENWOOD (1727–92) *Sea Captains Carousing in Surinam, 1757–8. Oil on bed ticking, 3′ 1¾″ × 6′ 3¼″ (95.9 × 191). The St. Louis Art Museum*

65

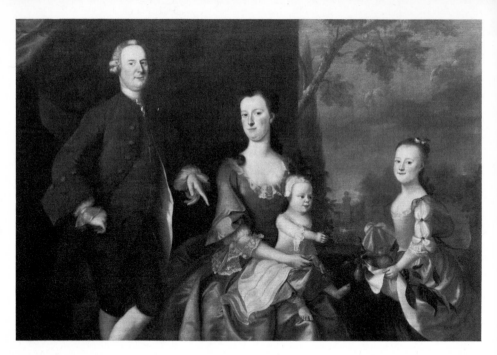

received and wherever he received it, his works show
him to have been an artist of most unusual gifts, which
were appreciated by his contemporaries. Otherwise the
all too brief list of his portraits would not include the
names of so many colonial notables.

Feke's group *Portrait of Isaac Royall and Family* (1741,
Harvard University Law School) is clearly based on
Smibert's *Bermuda Group*, but is at once less formulated
and more intensely observed. His colors are lighter and
fresher, and his figures have none of Smibert's often
heavy-handed literalness. His full-length, life-size *Portrait
of Brigadier General Samuel Waldo* (1748–50?, *Ill. 39*) is
one of the few really outstanding works of art of colonial
America. Waldo stands, silhouetted against a landscape
whose spacious distance includes a scene of the bombard-
ment, beneath a dramatic sky, of the citadel of Louisburg,
an action in which Waldo played a major part. The figure
has elegance without pomposity, formality without
colonial awkwardness. When Feke inexplicably dis-
appeared from the scene at the age of about forty-four, the
American colonies were deprived of a rare talent which
was to be matched only by that of Copley.

Copley's development was much influenced by Feke's
work, but it was equally influenced by that of Joseph

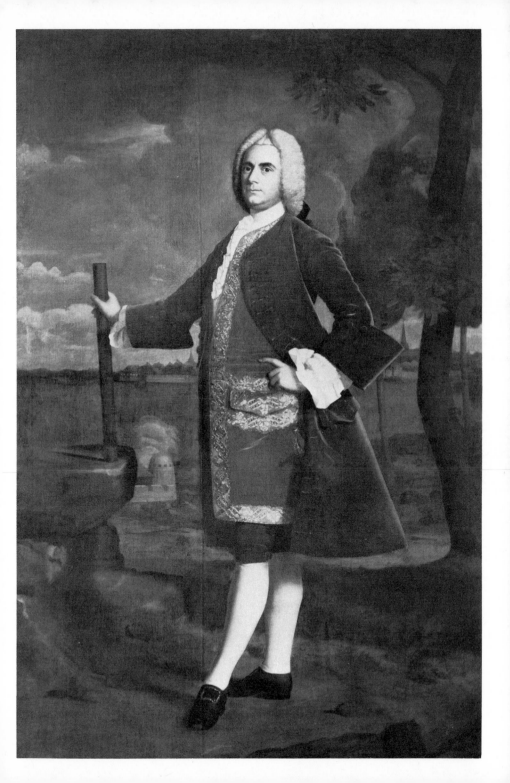

Blackburn (act. in America 1754–63), who arrived from Bermuda in 1754 to spend nearly a decade in New England. He brought with him the rococo style of contemporary London, and was a typical drapery painter such as were employed in major portrait painters' studios to paint costumes, since he was obviously far more interested in the stylishness of his sitters' dress, in the sheen of satin and the richness of velvet, than in personality. One has only to compare his treatment of *Isaac Winslow and his family* (*Ill. 38*) to Smibert's *Bermuda Group* (*Ill. 35*) or Feke's *Royall Family Portrait* to see the difference.

Blackburn's contemporary John Wollaston (act. in America *c.* 1749–58, 1766–7) was the other major artistic visitor of the period, who ranged from New York southward to Virginia from 1749 till 1758, went to India as an official of the East India Company, and returned briefly to Charleston, South Carolina, in 1767 before retiring to England. Also clearly trained as a drapery painter, Wollaston turned out literally hundreds of portraits of almond-eyed individuals, fashionably clad.

John Singleton Copley (1738–1815) was an artist of another stamp. When he was ten his mother, a widow, married Peter Pelham, an English-trained painter and printmaker, and the family moved from the little house and tobacco shop on Long Wharf in Boston to more comfortable quarters near the Old State House, where Mrs Pelham continued to sell tobacco while her husband sold artist's colors, made mezzotints, and taught drawing, penmanship, dancing, and needlework, and apparently painted a few portraits. Pelham died when Copley was still only thirteen, yet his influence on the boy must have been great. His stock of prints after the best English portraits and his knowledge of design and technique were undoubtedly very helpful in enabling Copley to become a respected professional portraitist by the time he was seventeen, turning out stiff, solid likenesses based on his studies of prints for composition, and the works of Smibert, Greenwood, Badger, and Blackburn for color and handling. But by the time he was in his early twenties he had surpassed them all.

An intense, introspective individual of immense determination and strength of character, Copley worked with single-minded dedication. As he turned out one portrait after another we can see him developing from the primitive limner of his teens into the assured artist of his

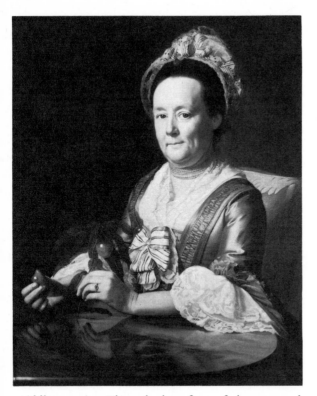

40 JOHN SINGLETON COPLEY
(1738–1815) *Mrs John Winthrop*,
*1773. Oil on canvas, 35½″ × 28¾″
(90.2 × 72.9). The Metropolitan
Museum of Art, New York, Morris
K. Jesup Fund, 1931*

middle twenties. Through sheer force of character and intelligent and unremitting application, he forged a style of power and subtlety, and painted far better pictures than any he had ever seen, to become one of the out⁄standing artists of his period both in America and in England, and a portraitist unrivaled in America until the appearance of Thomas Eakins a century later.

From the 1760s on, came the memorable series of portraits which irrefutably establish Copley's reputation. These include such admirable portraits of women as *Mrs John Winthrop* (1773, *Ill. 40*), and the famous series of the likenesses of the leaders of the Revolution. Among the latter are the elegant and self⁄conscious young *John Hancock* (1765, City of Boston); the tense and combative *Samuel Adams* (*c.* 1770, City of Boston), painted as he re⁄enacted his historic confrontation with the Royal Governor, Thomas Hutchinson, the day after the Boston Massacre; and *Joseph Warren* (1772–4, Boston), the brilliant young physician who died at Bunker Hill.

Between 1765 and 1770 Copley also portrayed Paul Revere (*Ill. 41*), silversmith and patriot, who often made gold and silver frames for the painter's miniatures, in a picture of extraordinary intensity. There is no back-ground, and though the sitter was a leading citizen, no parade of dress. Revere wears no wig and his brown hair is unpowdered. His immaculate white shirt, open at the throat, is reflected in the polished mahogany table top on which are scattered engravers' tools momentarily to be used in the chasing of the silver teapot that Revere holds in his left hand, lightly resting on the sand cushion. The hands have the blunt, capable fingers of the expert craftsman. But it is the glance that holds one's attention. One notes the mobile mouth, the straight nose, and the broad forehead, but the look of the eyes and the slightly raised right eyebrow suggest, despite the immobility of the pose, the quick intelligence and spirit of the man of action who played such an important part in those exciting and disquieting times leading up to the Revolu-tion. It is in such portraits as these that Copley combines the objectivity of vision, the closest possible scrutiny of the externals of his subject – the power which enabled him to grow from a near-primitive provincial to an accomplished professional with an academician's technical competence – with an emphatic identification with his subject. The resulting tension gives his portraits the powerful sense of presence which is an expression not only of the strong individualism of his subjects but of the artist himself.

Copley had as much work as he could handle, and his reputation as the leading artist in the colonies spread far beyond Boston. He married the charming daughter of one of Boston's leading families, Susanna Clarke – Suky, he called her – whose father was the merchant Richard Clarke. Copley bought a farm on Beacon Hill next to Thomas Hancock's handsome mansion. Secure and respected, he had come a long way from the little house and shop on Long Wharf. Yet he found himself in-creasingly discontented. Ever since his early teens, when he studied his stepfather's prints after paintings by great European masters, he had cherished the dream of embarking on what he, like the rest of his period, believed the highest branch of art, that of history painting. He longed to go to Europe and to immerse himself in what seemed to him the main stream of art, flowing out of the remote classical past, enriched by the genius of generation

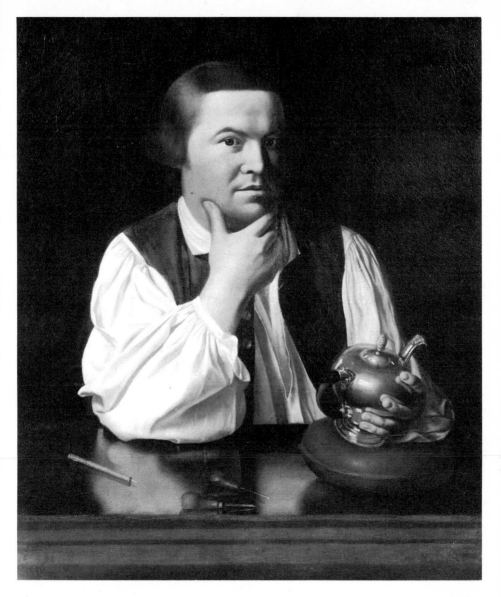

after generation of artists. His exact contemporary, Benjamin West, had done it; a Pennsylvania country boy, he had taken the giant step early in life, and with European study and his own innate gifts had become Painter to the King, and a member of the exalted Royal Academy of which he was to be elected second president in succession to Sir Joshua Reynolds. But Copley had a

41 JOHN SINGLETON COPLEY (1738–1815) *Paul Revere, 1765–70. Oil on canvas, 35″ × 28″ (88.9 × 71.2). Courtesy, Museum of Fine Arts, Boston, Gift of Joseph W., William B. and Edward H. R. Revere*

family to support and was beset by doubts. His sym-
pathetic portrait of his half-brother, Henry Pelham, *The
Boy with the Squirrel*, (c. 1765, Boston), had been shown
in London and won great praise from both West and
Reynolds.

While he hesitated, circumstances made the decision
for him. The growing opposition to the Stamp Act and
the increasing activities of Sam Adams and the Liberty
Boys, so many of them craftsmen like himself, and among
them many personal friends, created a rising tension.
British troops, billeted on the Common, drilled and
marched to show the might of the crown, while Sam
Adams and his followers met by night in the back room
of the tavern called the Bunch of Grapes. They had made
hay with the Boston Massacre of 1770, but the furor had
died down. The Boston Tea Party of December 1773
gave Adams the excuse he needed. Despite the eloquent
pleas of Burke and Pitt and the support of London
merchants, Parliament voted reprisals, and conflict was
inevitable.

Among the merchants to whom the hated tea had been
consigned was Richard Clarke, Copley's father-in-law,
while many of the artist's good friends were Sons of
Liberty. The merchants took refuge in Castle William
in the harbor from the mobs roaming the streets looking
for trouble. Copley tried to be a mediator, but the
Loyalists were stubborn and the populace aroused.
There was no work for a portrait painter in the midst
of such civil disorder, so Copley, not dreaming that the
events in which he had endeavored to play a constructive
part would actually lead to open conflict, set sail for
Europe, leaving Suky and the children to await his return
to Boston. He went to Italy and France and reveled in the
wonders which he had so longed to see. He traveled and
sketched and painted avidly. But the news was ever more
alarming, with the battles of Concord and Lexington,
and a citizenry in arms, and personally tragic as well
because of the death of a baby born after his departure,
whom consequently he had never seen. Suky hurriedly
packed what she could, took the children, and managed
to get passage on a ship for England. The family was
reunited in London, which, though they had no idea of
it at the time, was to be their permanent home.

III THE REVOLUTION TO THE AGE OF JACKSON

'The glories of Greece in the woods of America'

The period between the winning of Independence and
the election of Andrew Jackson as the seventh president
of the United States in 1829 was one of transition in the
arts as in politics. During these years the Federalist style
dominated architecture, though the Classical Revival
had already begun with Thomas Jefferson's design for the
Virginia State Capitol at Richmond (*Ill. 42*), completed
in 1798, which was derived from the Roman temple
known as the Maison Carrée at Nîmes, in southern
France. Ancient republican Rome with its devoted
citizens and Spartan virtues appealed to the citizens of the
struggling new republic in America. There was in-
creasing interest in the arts of the classical past, and the
growing Romantic Movement and the struggle of the
Greeks for independence from the Turks made anything
Greek universally popular, so that the Classical Revival
tended to become more exclusively a Greek Revival.
During the 1820s it gained momentum and by about
1830 had become the first national architectural style.

In the meantime the Federalist style had produced two
of the nation's leading architects and a considerable
number of distinguished buildings. The publications
reflecting the manner of the British architect, Robert
Adam, with its more delicate proportions, so readily
translated into the native American material of wood,
were strongly influential, and replaced the heavier
Palladian manner, which was the dominant architectural
influence in the colonies during the previous period. The
Federalist style reached its height in the works of two
outstanding individuals, Charles Bulfinch (1763–1844)
of Boston and Samuel McIntire (1737–1811) of Salem.
Though Bulfinch was the elder, he outlived McIntire by
thirty-three years, and his style, always tending toward
greater classicism and simplicity, was influential across
the country through one edition after another of the useful

42 THOMAS JEFFERSON (1743–
1826) *Virginia State Capitol, Rich-
mond, Virginia, 1786–98*

73

43 SAMUEL MCINTIRE (1737–1811) *Entrance of the Peirce-Nichols House, Salem, Massachusetts, 1782. Courtesy, Essex Institute, Salem, Massachusetts*

44 SAMUEL MCINTIRE (1737–1811) *Gardner-White-Pingree House, Salem, Massachusetts, 1805. Courtesy, Essex Institute, Salem, Massachusetts*

and practical builders' handbooks produced by his pupil and follower, Asher Benjamin (1773–1845). For Bulfinch, then, Federalism was but a phase in a long and significant career as the nation's first professional architect. McIntire's achievement, on the other hand, was to create a very model of the style at its best in his native town of Salem, Massachusetts.

While Jefferson initiated the classical style which was spread by his own practice and example and by Bulfinch's pupils and followers to dominate the nation, Samuel McIntire transformed Salem from a mixture of the medieval and the colonial into a Federalist townscape. The sudden prosperity of the East India and China trade was expressed in the handsome brick, wood-trimmed mansions, many of which still line its wide, tree-bordered streets. McIntire's touch is almost everywhere. His early Peirce-Nichols House (1782, *Ill. 43*) on Federal Street still shows a Palladian heaviness in the proportions of its white clapboarded façade, but the gateposts with their flame-carved finials were already a McIntire trademark, and the interior woodwork, especially in the east drawing room, already shows the delicate, fine-drawn style of McIntire's mature manner. The Gardner-White-Pingree House of 1805 (*Ill. 44*) is typical throughout of his developed style. The simplicity of its brick façade is relieved by the gracefully curving entrance with slender columns and delicately patterned fanlight and mouldings, and the slender balustered parapet crowning the façade.

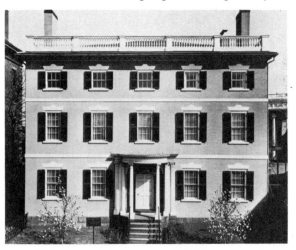

Its interior design is consistent in the fineness of scale of decorative elements and their subtle relation to flat surfaces.

He also designed the handsome Customs House where, generations later, Nathaniel Hawthorne dreamed of an earlier and more austere Salem, but McIntire's most ambitious plan to be carried out was that for the house he created for the East India merchant, Elias Haskett Derby (*Ill. 45*). Though McIntire's friend Bulfinch may have had a hand in the façade with its colossal order of Corinthian pilasters and balustraded roofline, the style is characteristically McIntire's, inside and out, from the fireplaces with reeded pilasters, the delicate cornices, and much of the furniture, embellished with the crisply carved baskets of flowers and overflowing cornucopias, to the delightful garden house with its frivolously attired figures, sculptured by John and Simeon Skillin of Boston, who, like McIntire himself, carved figureheads for Derby ships. From the domed lantern atop the pyramidal roof of his house, Derby could look down the harbour for the Salem-owned vessels, so many of them his own, which brought the wealth of the Indies to the little New England town.

McIntire's greatest project, however, was never carried out. Along with Thomas Jefferson, Dr William Thornton, and others, he submitted drawings for the national Capitol in 1792 (*Ill. 46*). Large in concept and in scale, sure in its handling of detail, elegant yet vigorous,

45 SAMUEL MCINTIRE (1737–1811) *Study for the front elevation of the Derby House, Salem, Massachusetts, completed 1799. Courtesy, Essex Institute, Salem, Massachusetts*

46 SAMUEL MCINTIRE (1737–1811) *Competition drawing for the United States Capitol, 1792. Maryland Historical Society, Baltimore*

75

it remains his finest concept. As Talbot Hamlin, the distinguished authority on the Classical Revival in America, observed, however, the classical was the modern of the day, and McIntire's scheme retains all the aspects of his mastery of the Federalist style. The award went to the entry of the crotchety West Indian Quaker, Dr William Thornton, which though far less professional was in the columnar style then coming into vogue.

McIntire died in 1811 at the age of fifty-four. The qualities of his Capitol design suggest something of the potential achievements which time denied him and his country. Trained as a woodcarver and cabinetmaker, he became an architect of distinction and also, as his friend, the indefatigable diarist William Bentley, observed, one of Salem's most congenial and ingenious citizens, and a capital performer on the flute.

Though McIntire left his mark on Salem, the influence of Charles Bulfinch was far more widespread. The son and grandson of prominent physicians, he graduated from Harvard College in the class of 1781, and three years later took the Grand Tour, a less unusual aspect of a young American's education then than one might today suspect. He visited friends and relatives in England, saw Jefferson and Lafayette in Paris, traveled extensively in France and Italy, and had his portrait painted by Mather Brown, another young American then working in London, before returning home. After his European adventures, Boston looked to him still medieval in many ways, with its narrow, winding streets, its houses with overhanging second stories, its cows grazing on the Common, and its generally provincial air.

The government of the Commonwealth had outgrown the Old State House, formerly used by the Royal Governors, and in 1787 the Great and General Court decided to build a new State House (*Ill. 47*). On the basis of his own sketches of buildings seen on his recent travels and architectural books brought home from abroad – the beginnings of the most extensive architectural library of the period in the New World except perhaps for that of Jefferson – Bulfinch set to work. In four months he made plans and elevations, along with detailed estimates of costs and of structural methods, which were accepted by the committee appointed for the purpose. It was a notable achievement for a young man of twenty-four without any formal training whatsoever. Because of

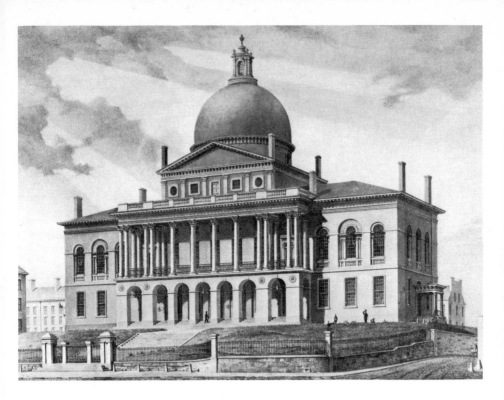

delays customary with legislative bodies, construction was not begun until 1795 when the committee's recommendations were formally accepted. In the meantime he had designed the state of Connecticut's handsome new Capitol in Hartford (completed in 1796), several churches, and Boston's first theater, and had embarked on the first example of group planning in the country, the Tontine Buildings forming Franklin Place. It was the last venture which made Bulfinch turn to the practice of architecture as a livelihood. The unnecessary default of his brotherinlaw on a debt forced him into bankruptcy, and what had before been an avocation became a profession.

In the next few years Boston was transformed into a city of handsome redbrick houses, largely in Bulfinch's style if not all of his own creation. He designed most of Boston's churches, including the Roman Catholic cathedral, drawings for which he contributed; the only one of his churches which remains in the city, however, is New North, now St Stephen's, admirably restored in recent years. Bulfinch's finest church was not built in

47 CHARLES BULFINCH (1763–1844) *State House, Boston, Massachusetts, designed 1787, built 1795–8. Lithograph after Alexander Jackson Davis. The Boston Athenaeum*

77

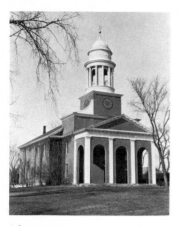

48 CHARLES BULFINCH (1763–1844) *First Church of Christ, Lancaster, Massachusetts, 1817*

Boston and still exists, the Meeting House (now First Church of Christ) in Lancaster, Massachusetts (*Ill. 48*), dedicated in 1817. In its perfection of proportion of cupola and façade, in the classic dignity of its white‑painted interior, and in the balance of brick structure and wood detailing, it is one of the most notable buildings of its period in America.

He also designed half‑a‑dozen banks, school and college buildings in Boston, Andover, and elsewhere, almshouses, the Massachusetts General Hospital, the Courthouse and new City Hall, India Wharf, prisons, and docks. Furthermore, he presided as chief selectman over the city's growth for more than twenty years. He acted as chief of police, regulated traffic, which even then was a problem, lighted the city's streets, and planned the orderly future development of the Back Bay. During these years Bulfinch's Boston was transformed from a small provincial town into one of the leading cities of the New World. Probably no other city in America has ever owed more to the dedication and genius of one man.

Given his reputation, it was natural that President Monroe, in 1818, should have appointed Bulfinch architect of the public buildings in Washington. The national Capitol, still incomplete, had not only been burnt by British forces in 1814, but had also passed through the hands of four previous architects: William Thornton, who had made the original design but lacked the experience to carry it out; Stephen Hallet and George Hadfield, who were both more experienced but unable, like the admirably trained Benjamin H. Latrobe, to cope with the political problems involved in the skirmishes among numerous congressional committees and the various Commissioners of Public Buildings. Bulfinch found an incomplete building bearing the evidence of the innumerable changes of preceding regimes. At fifty‑five he was an acknowledged leader of his profession, yet it needed all his experience, both as an architect and in the political life of Boston, to complete the job. 'I shall not have credit for invention,' he wrote his family in Boston, yet somehow, with a minimum of basic change, he unified the various parts and created a whole of such distinction that even Mrs Trollope approved (*Ill. 49*). He designed and laid out the grounds, superintending grading, planting, and approaches, properly to relate the whole to Major L'Enfant's grand plan, a task no other

American architect but Jefferson could have undertaken successfully. His last, and in many ways finest, public building, the State House at Augusta, Maine, was unfortunately so drastically and unnecessarily altered early in the present century that virtually nothing of its original distinction remains.

When in 1830 Bulfinch moved back to Boston, an era in American architecture was over. The younger men who had been his pupils inherited and carried on the tradition in which he had so admirably led the way. Among them were Isaiah Rogers (1800–69), who designed the first modern hotel in the world in the famous Tremont House in Boston (1829); Alexander Parris (1780–1852), who had superintended the completion of Massachusetts General Hospital, and is best remembered as the architect of Quincy Market (*Ill. 50*) and its handsome surrounding buildings similarly constructed of that

49 CHARLES BULFINCH (1763–1844), AND OTHERS *United States Capitol, Washington, D.C. Aquatint after Bulfinch by H. & J. Stone, 1826. Library of Congress, Washington, D.C.*

50 ALEXANDER PARRIS (1780–1852) *Quincy Market, Boston, 1825–6. Behind the market on the left is Faneuil Hall by* JOHN SMIBERT (1688–1751). *Engraving after Hammett Billings, 1852. Courtesy of The Bostonian Society, Old State House, Boston*

particularly New England material – granite – in the use of which Bulfinch had pioneered; Solomon Willard (1783–1861), the architect and engineer who designed and built the Bunker Hill Monument and who invented methods and machines for handling larger blocks of stone than had been used since the days of ancient Rome; and Asher Benjamin (1773–1845), whose architectural publications became standard handbooks for American builders and spread Bulfinch's simple, dignified, and essentially classical style throughout the country.

In the Boston State House and the Lancaster Meeting House, Bulfinch had created prototypes. In his inter-pretation of the role of architect as that of a citizen dedicated to public service rather than as merely a designer, he set a standard for the profession which has remained as an ideal in the lives and careers of such later and various figures as H. H. Richardson, Louis Sullivan, Frank Lloyd Wright, and Buckminster Fuller.

Jefferson had initiated the Classical Revival with his design for the Capitol at Richmond in 1786 (*Ill. 42*), yet the evolution of his own house, Monticello (*Ill. 51*), and his monumental concept for the University of Virginia at

51 THOMAS JEFFERSON (1743–1826) *Monticello, Virginia, 1772, 1789–1809*

Charlottesville (*Ill. 54*) display more of his own idio-
syncratic approach. 'Architecture is my delight,' he once
remarked, 'and putting up and pulling down one of my
favorite amusements.' The history of Monticello proves it.
He was only twenty-four when he started work on his
mountain-top villa, essentially Palladian in concept.
After trips abroad and studying both classical buildings
and contemporary French houses, with their new ideas
of privacy and increased intimacy of scale, the design
underwent successive changes. He kept adding to his
already large library of architectural books, and borrowed
interiors from them freely.

The first version of the house dates from 1772, shortly
before the Revolution, but after the death of his young
wife ten years later he turned to the Richmond Capitol
project on which he continued to work during several
years abroad. On his return in 1789 he completely
redesigned and rebuilt the house, and, though it was never
really finished – one suspects he could not have borne the
thought of its final completion – in its present form it
represents to an extraordinary degree the man: indivi-

*52 WILLIAM STRICKLAND (1788–
1854) Second Bank of the United
States, Philadelphia, 1818. Lithograph
after W. H. Bartlett. Courtesy, The
Historical Society of Pennsylvania*

81

dualistic, classically minded, imaginative and idealistic, yet intensely practical, by nature an experimenter with an indefatigable curiosity, always open to new ideas.

The University of Virginia (1817–26), on the other hand, reveals a consistency and completeness of concept one would scarcely expect after Monticello. It is the expression in terms of architecture of Jefferson's theories of education, his conviction that classicism represents the rationality toward which man must aspire for the good life, and the necessity of his constant intimate relation with the natural world for spiritual and moral health. He intended to 'make the establishment the most eminent in the United States.' At the northern end of the Lawn stands the Rotunda, temple-fronted and reminiscent of the Pantheon in Rome. On each side, extending south-ward, are matching series of pavilions, displaying in classic perfection the various orders of architecture, connected by covered passageways, with dormitories and dining halls for students, generous housing, with private gardens, for the professors, the whole leading outward with a carefully calculated perspective to what was, before the view was unforgivably closed by Stanford White's Cabell Hall (1898–1902), a magnificent panor-ama of richly wooded hills, stretching to the distant horizon. The grandeur of the concept far exceeds the scale of the execution and is an expression of the extra-ordinary qualities of mind and imagination of its creator.

Though Jefferson initiated the Classical Revival, it was Bulfinch's followers who largely carried on the classical tradition. Though the Boston School comprised the leading group of architects of the following generation, there were many others as well, men like William Strickland (1788–1854) whose Second Bank of the United States (*Ill. 52*) is today a landmark in the recent urban renewal plans for Philadelphia. And Robert Mills (1781–1855), who designed the United States Mint and countless customs houses and other buildings for the government, experimenting with the use of cast-iron and maintaining a consistent standard of quality despite the uninspiring nature of his commissions. And also Thomas U. Walter (1804–87), whose temple front for Andalusia, Nicholas Biddle's lovely house outside Philadelphia, remains a perfect example of its kind, and whose ingenuity was equally expressed in the classical perfection of Girard College (*c.* 1833–47) and in the

53 THOMAS U. WALTER (1804–87) *Dome of the United States Capitol, Washington, D.C., 1855–65*

present dome of the enlarged Capitol of the United States (1855–65, *Ill. 53*).

Propagated by the books of Asher Benjamin, classicism became the first national architectural style in the United States. Temple-fronted houses appeared everywhere – from Maine farms to the plantations of the deep South, and from the Atlantic to the frontier. But in the meantime other forces were at work. The underlying idea of the Classical Revival, to recreate, in the words of B. H. Latrobe, 'the glories of the Greece of Pericles in the woods of America,' was essentially a romantic notion. And romanticism was to express itself in other and quite different terms, not only in architecture, but in the other arts as well.

54 THOMAS JEFFERSON (1743– 1826) *University of Virginia, Char- lottesville, Virginia, 1817–26*

55 BENJAMIN WEST (1738–1820) *Treaty of William Penn with the Indians, 1771. Oil on canvas, 6′ 3½″ × 9′ ¾″ (191 × 276). Courtesy of the Pennsylvania Academy of the Fine Arts, Philadelphia*

56 JOHN SINGLETON COPLEY (1738–1815) *The Copley Family, 1776–7. Oil on canvas, 6′ ½″ × 7′ 6⅜″ (184 × 230). National Gallery of Art, Washington, D.C., Andrew Mellon Fund*

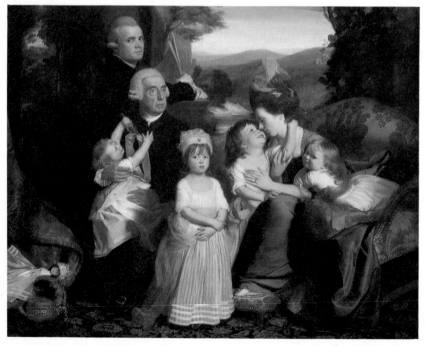

When the Copley family was reunited in London, the artist found his contemporary American, Benjamin West (1738–1820), one of the leading painters in England, whose appointment by George III as Painter to the King gave him an influential position in the world of art. Lacking Copley's genius, West was an artist of genuine talent though uneven production, and also a person of great generosity whose studio in London became the school and the refuge for more than a generation of young Americans endeavoring to pursue artistic careers by foreign study. His instruction in the studio and in lectures at the Royal Academy was practical and effective. His naturally serene temperament, so different from Copley's intense introspection, made his handling of dramatic themes inevitably unsuccessful. Yet he was, like Copley, a significant innovator. His *Death of General Wolfe* (1770, Ill. 57) is the first important painting to treat a contemporary event in contemporary terms. Instead of being clad in the togas of ancient Greece or Rome, as had before been customary, the participants

57 BENJAMIN WEST (1738–1820) *The Death of General Wolfe, 1770. Oil on canvas, 4′11½″ × 7′ (151.1 × 213.4). The National Gallery of Canada, Ottawa, Gift of the Duke of Westminster, 1918*

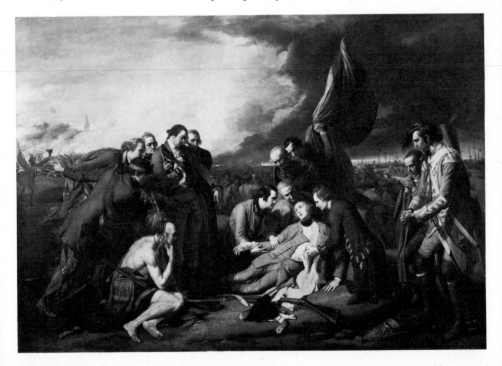

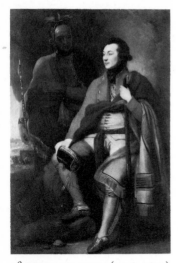

58 BENJAMIN WEST (1738–1820) *Colonel Sir Guy Johnson, 1776. Oil on canvas, 6'7¾" × 4'6½" (203 × 138). National Gallery of Art, Washington, D.C., Andrew Mellon Collection, 1940*

in the tragic episode are clad in the uniforms they actually wore. They are shown against a stormy sky stained with the smoke of battle, while an Indian brave sits in silent contemplation, an effective and dramatic symbol of the remoteness and power of the New World.

As a Quaker, West was particularly interested in the fortunes of Pennsylvania, and celebrated its founding in his large *Treaty of William Penn with the Indians* (1771, *Ill. 55*) in which, again, the stoic dignity of the native chieftains, resplendent in savage ornament, is contrasted with the gray-clad Penn and his followers as they discuss what has been called the only treaty made between white men and Indians that was ever maintained.

West's romantic manner was well developed before the end of the 18th century. It appears even in his portraiture, as in the painting of *Colonel Sir Guy Johnson* (1776, *Ill. 58*), who is shown accompanied by an Indian brave, perhaps Johnson's friend and secretary the famous Mohawk, Joseph Brant, who points to the scene of an Indian family group in the background, a Rousseauistic idyll of the joys of man in a state of nature. West's *Death on a Pale Horse* was so popular that it was repeated in several versions, vastly impressing audiences both in America and in Europe by their Wagerian theatricality. His little-known designs for the decoration of the tremendous false-Gothic country house, Fonthill Abbey, constructed by the eccentric millionaire author William Beckford, are as wildly romantic as Beckford's book, *Vathek, An Arabian Tale*, which is as unreadable today as any other once-famous Gothic novel, and yet was a best seller in its day.

That Copley shared West's romanticism is shown by one of the first important pictures he painted shortly after his arrival in London, *Watson and the Shark* (1778, *Ill. 59*; other versions Detroit and Washington), which became so popular that it, too, was repeated in several versions. When first exhibited, however, it was shocking to some because it dealt with people of neither historical nor social importance; it was the record of an actual event that took place some years before, in which Brook Watson had had a leg bitten off by a shark while swimming in Havana Harbor, his friends in a boat trying to fend off the shark's attack and rescue the swimmer. The episode is recreated in all its horror and drama by Copley. The waterfront types in the boat are accurately

portrayed, the whole realized to a degree, yet there are tension and conviction in the representation of which West was quite incapable.

In the following year Copley embarked on a far more ambitious project, *The Collapse of the Earl of Chatham in the House of Lords* (1779–80, *Ill. 60*). It included more than fifty portraits, every one of which was studied, when possible, from life. The drama of the event is suggested not only by the representation of the scene at the precise moment when, during his passionate plea on behalf of the American colonies, Chatham was stricken, but also by the arrested poses of the participants and the powerful unifying force of a strong abstract design of both figural elements and of light and shade. When exhibited independently in 1781 with admission charged, it sabotaged the Royal Academy exhibition of that year because so many of the public flocked to see Copley's spectacular performance rather than the Gainsboroughs, Reynoldses, and works by other members of the Academy. It gained him many portrait commissions from the

59 JOHN SINGLETON COPLEY (1738–1815) *Watson and the Shark, 1778. Oil on canvas, 6′½″ × 7′6¼″ (184 × 229). Courtesy, Museum of Fine Arts, Boston, Gift of Mrs George von Lengerke Meyer*

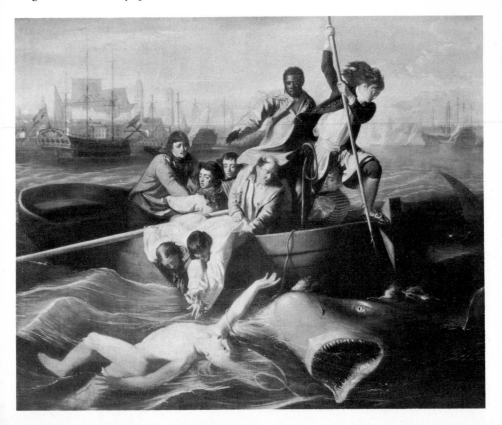

London merchants and businessmen who had been Chatham's enthusiastic admirers.

Copley's reputation was dramatically established, but at the cost of acquiring powerful enemies at the Academy. In the meantime he achieved his most successful history picture, *The Death of Major Peirson* (1782–4, Tate), memorializing the death at the very moment of victory of a young British officer in an engagement with a superior French force on the Isle of Jersey. *The Repulse of the Floating Batteries at Gibraltar*, commissioned by the Corporation of London, was completed in 1791. It is a gigantic picture more than 20 feet long and 20 feet high, whose exhibition in a tent in Green Park near Buckingham Palace again ruined the Royal Academy's annual exhibition. *The Copley Family* (1776–7, *Ill. 56*), a more sympathetic work to modern taste, was completed somewhat earlier. It shows his mastery of composition, of the psychology of portraiture, and of the handling of paint. It includes his wife Suky, his father-in-law Richard Clarke, himself, and his four children, two of whom were dead by the time the painting was finished, and one of whom was to become Lord Lyndhurst, Lord Chancellor of England.

Not only was Copley established as one of the leading artists of his day, but he had achieved a success he could scarcely have dreamt of in the bygone days in Boston which he came to miss with increasing keenness. Never satisfied by present achievement, he drove himself, his health suffered and his powers began to fail, until, after years of increasing melancholy during which he could paint no more, he died of a stroke at seventy-seven, forgotten by a world of art which had long since passed him by in a direction that he himself had pioneered.

West, on the other hand, lived on to a serene old age. He died at eighty-two and was buried with great honors in Westminster Abbey next to Sir Joshua Reynolds whom he had succeeded as second President of the Royal Academy. In such classical history paintings as *Agrippina Landing at Brundisium with the Ashes of Germanicus* (1768, Yale), he anticipated Jacques-Louis David's famous *Oath of the Horatii*, long famous as an initial work of romantic classicism, by almost twenty years. In romanticism's more dramatic mode, the work of both West and Copley foreshadowed by more than thirty years the advent of romanticism in painting with the works of Géricault

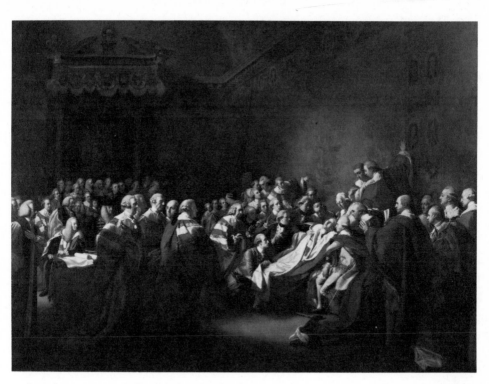

and Delacroix. Not only did these and other French artists visit England, but works of British artists were shown in France. As a result, West and Copley share leadership in the direction in which European painting as a whole was to evolve. There were others in America who saw their successes and shared their dreams, men like Samuel F. B. Morse and John Vanderlyn, for example. But American painting was to grow along other lines, less idealistic, perhaps, but more appropriate to a bustling, burgeoning, practical new nation.

The Rhode Island-born Gilbert Stuart (1755–1828) returned from study with West and outstanding British successes – and a mountain of debts accumulated by dressing as fashionably as the Prince Regent and generally living far beyond the generous means provided by his extremely popular portraiture – to become the leading portraitist of America. His extraordinary range is shown by such works as his delightful *Mrs Perez Morton* (*c.* 1802, *Ill. 61*) and the picturesque yet psychologically convincing *Chief Joseph Brant* (1786, Cooperstown). Stuart's

61 GILBERT STUART (1755–1828)
*Mrs Perez Morton, c. 1802. Oil on
canvas, 29⅛" × 24⅛" (73.9 × 61.2).
Worcester Art Museum, Worcester,
Massachusetts*

most famous picture and, indeed, one of the best-known paintings in American art, is his Athenaeum portrait of *Washington* (1796, *Ill. 62*), the basic model for the several other versions of Washington portraits which were in such demand. As his style evolved, though he proved himself on occasion a master of the portrait in the grand manner, he increasingly placed the emphasis on the head of the sitter, often dissolving the background into shadow. His brushwork loosened also until it became a brilliant personal manner capable of expressing the translucency of flesh and its subtle shifts of texture and tone, with a transparency of light and shade which is uniquely his own. Even in his old age, when suffering from gout and a palsied hand, he never lost the touch, vibrant and vital, which gives his portraits a timeless immediacy and reveals the essential human sympathy underlying all his work.

Stuart was one of the wittiest and most charming personalities in American art, whose humor and endless fund of amusing anecdotes made sitting for a portrait by him a delightful experience. His only rival as a per-

62 GILBERT STUART (1755–1828) *Athenaeum Portrait of George Washington, 1796. Oil on canvas, 4' × 3' 1" (122 × 94). Courtesy, Museum of Fine Arts, Boston, Purchased by Washington Association, Boston, The Boston Athenaeum 1831*

sonality, though not in the virtuoso handling of paint, was his contemporary, Charles Willson Peale (1741–1827), who occupied a similar position as leading portraitist in Philadelphia to Stuart's in Boston. The son of a well-born English remittance man who died when Peale was still a child, the boy learned several trades, among them those of shoemaker and saddler, until at twenty-one he decided to teach himself to paint. Though Copley was only three years older, he was the leading artist in the colonies, so Peale studied briefly with him and showed such promise that friends made it possible for him to go to London for two years of study with West. Until Stuart's return in 1793, Peale dominated American portraiture with competent, rather matter-of-fact likenesses. A man of lively imagination and enthusiastic temperament, he named his children after artists – Rubens, Rembrandt, and Raphaelle, among them – and founded a dynasty of painters whose descendants still carry on his artistic tradition. His once-famous museum in Philadelphia was the first to be established on scientific

91

63 CHARLES WILLSON PEALE
(1741–1827) *The Artist in his
Museum, 1822. Oil on canvas, 8′7½″
×6′8″ (263 × 204). Courtesy of
the Pennsylvania Academy of the Fine
Arts, Philadelphia

64 SAMUEL F. B. MORSE (1791–
1872) *Lafayette, 1825–6. Oil on
canvas, 8′×5′4″ (244 × 163). Art
Commission of the City of New York

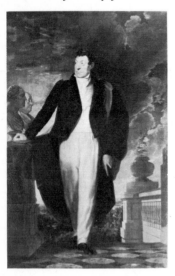

principles to present the life and history of America with
likenesses of its leading citizens and all its variety of flora
and fauna. It also included habitat groups, Indian
artifacts, and fossils, including the bones of the mastodon
he himself excavated.

A *Self-portrait* (1822, *Ill. 63*) in his old age shows him,
a vigorous and sturdy figure, full of character, holding
back a curtain to invite us to enter his beloved museum.
At once practical and idealistic, he had served in the
Revolution, and in camp often mended his companions'
boots or sketched their likenesses. He was a scientist, a
naturalist, and an inventor, and for years was a member
of the Pennsylvania Assembly. In the variety of his
interests and the success with which he carried them out,
he resembles a number of other leading creative person-
alities in the history of American art, such as Samuel
F. B. Morse, the artist who invented the telegraph,
Robert Fulton, the painter who developed the steam boat,
and, in the more recent past, Frank Lloyd Wright, and,
today, the brilliant architect-engineer Buckminster Fuller.

The careers of John Vanderlyn (1775–1852) and
Samuel F. B. Morse (1791–1872), though one ended in
tragedy and the other in triumph, illustrate the differences
in the direction of painting between America and
Europe. Both studied with West and traveled in Europe
where Vanderlyn painted the best American nude for
many a decade, his *Ariadne Asleep on the Island of Naxos*
(1812, *Ill. 65*), and was awarded a gold medal by
Napoleon himself for his *Marius amid the Ruins of Carthage*
(1807, San Francisco). Both he and Morse returned to
America to continue their artistic careers with works on
similarly ambitious and grandiose themes. But somehow
their fellow Americans were more interested in portraiture
than in past European grandeur, which seemed remote
and irrelevant in a fast-growing America. Though
Morse despised portrait painting as 'a mechanical art',
he produced one of the finest examples of the century in
his monumental *Lafayette* (*Ill. 64*), a full-length, life-
sized canvas painted in 1825–6 during the triumphal
return to America of the last survivor among the leaders
of the Revolution. Morse portrayed the ancient hero in a
pose of immense dignity, silhouetted against a sunset sky,
with the busts of his beloved friends, Washington and
Franklin, already passed into history, at his right hand.
Morse did other good portraits, notably that of his

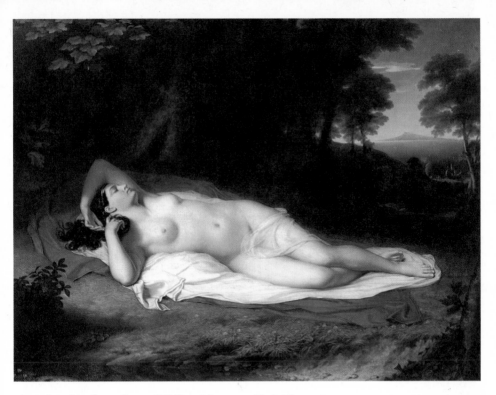

charming daughter, Susan Walker Morse, entitled *The Muse* (*c.* 1835–7, Metropolitan). But he was discouraged by the complete lack of interest in the history painting he so wanted to pursue, and turned from art to science. The dramatic result was the invention of the telegraph and an entirely new career.

Vanderlyn was far less fortunate. After years of trying to make a success of a panorama of Versailles (Metropolitan) and an exhibition of his paintings, to which he charged a modest admission fee, he finally failed, and retreated to his native Kingston on the Hudson, his undoubted powers corroded by despair and defeat, and died bitter and forgotten.

The success which portraiture could bring is illustrated in the career of Thomas Sully (1783–1872), a pupil of Stuart much influenced by Sir Thomas Lawrence, who succeeded Charles Wilson Peale as the leading artist of Philadelphia. His mastery of the romantic portrait is illustrated by such works as the chic and classically dressed *Lady with a Harp: Eliza Ridgely* (1818, *Ill. 66*), standing in a handsome Empire-style interior with a hand

65 JOHN VANDERLYN (1775–1852) *Ariadne Asleep on the Island of Naxos, 1812. Oil on canvas, 5′8″ × 7′3″ (177 × 221). Courtesy of the Pennsylvania Academy of the Fine Arts, Philadelphia*

66 THOMAS SULLY (1783–1872) *Lady with a Harp: Eliza Ridgely, 1818.* Oil on canvas, 7'3⅜" × 4'8⅛" (214 × 143). *National Gallery of Art, Washington, D.C., Gift of Maude Monell Vetlesen*

languidly touching the harp at her side. But he was capable of more vivacity as well, as in the charming *Fanny Kemble as Bianca* (1833, Pennsylvania Academy). He traveled abroad and in 1838 painted a widely acclaimed portrait of the young Queen Victoria (a half-length version is in The Wallace Collection, London). In his international success as a fashionable portraitist, Sully anticipated the later career of John Singer Sargent.

There were other forces at work, however, to influence American creative expression besides the insatiable appetite for portraiture and the increasing prevalence of romantic elements in the Classical Revival in architecture. Americans were interested in historical painting as long as it dealt with their own history, and consequently admired the brilliant sketches of episodes of the Revolution (*Ill. 67*), so much better than his oversized *Signing of the Declaration of Independence* (1816, U.S. Capitol), executed by the irascible former aide-de-camp of Washington, John Trumbull (1756–1843).

The paintings by the Philadelphian, Thomas Birch (1779–1851), of American naval victories during the War of 1812, which made national heroes of Stephen Decatur, Oliver H. Perry, John Paul Jones, Isaac Hull, and William Bainbridge, were also welcomed with enthusiasm. His *Constitution and the Guerrière* (*Ill. 68*) and *The United States and the Macedonian* (1813, Pennsylvania Historical Society) are among his best. Engravings were made after the whole series, as of Trumbull's episodes from the Revolution, to add to the popularity of both subjects and artists.

Thomas Sully made his contribution in this genre with such impressive large-scale pictures as his *Washington at the Passage of the Delaware* (1819, *Ill. 69*), so much better observed and convincingly recreated than the far more famous later work by Emmanuel Leutze, *Washington Crossing the Delaware* (1851, State Park Museum, Washington Crossing, Pa.), which shows the general standing in a boat in an ice-filled river, something his own prudence, as well as that of the Gloucester fishermen – the original American Coast Guard – who were in charge of the operation, would never have allowed.

Birch also treated other subjects, such as landscapes with figures engaged in the homely pursuits of sleigh-riding, skating, and other rural activities, his contributions to the development of genre painting which was to

67 JOHN TRUMBULL (1756–
1843) *The Surrender of Corn-
wallis at Yorktown. Oil on can-
vas, 13⅞″ × 21″(35.1 × 53.4).
Courtesy, The Detroit Institute
of Arts, Gift of Dexter M.
Ferry Jr. Fund*

68 *After* THOMAS BIRCH
(1779–1851) *Constitution and
the Guerrière, 1812. Stipple
engraving by C. Tiebout. Yale
University Art Gallery, Mabel
Brady Garvan Collection*

69 THOMAS SULLY (1783–
1872) *Washington at the Pas-
sage of the Delaware, 1819. Oil
on canvas, 12′2½″ × 17′3″
(372 × 526). Courtesy, Mu-
seum of Fine Arts, Boston, Gift
of the owners of the Old Boston
Museum*

flower in the following period. Thomas Doughty (1793–
1856) was trained as a tanner, but turned to painting
instead, and, because of his love of the countryside,
became one of the earliest of Americans to devote himself
to the painting of landscape, a pioneer, like Birch, in
another artistic category which was to flourish later.

The awakening consciousness to the appearance of the
American scene, as shown by the works of Birch and
Doughty, was an aspect of America's increasing national
pride which was also reflected in the continuing pre-
valence of naturalistic portraiture to record the likenesses
of her own citizens, and in the interest in her own history,
as in the works of Trumbull, Birch, and Sully. This
awareness also appears in the still-life paintings of the
Peales, especially those of James (1749–1831) and
Raphaelle (1774–1825), whose representations of field
flowers in a pitcher, of the fruits and vegetables from the
neighboring farm, and of the wild grapes and nuts from
the nearby wood-lot, are apparently simple and informal,
yet the result of knowing craftsmanship and intense
observation (*Ill. 71*). Unlike the formally arranged still-
lifes of European origin and inspiration – with their
mountains of wild game and profusion of artfully
composed fruits, fish, and vegetables – the works of the
Peales celebrate the rewards of the clearing of the forest

and conquest by the plough of the wilderness, and establish an American school of still-life painting which was also to reach a climax at a later time.

Another aspect of this growing awareness in America is represented by the extraordinary achievements of John James Audubon (1785–1851), who devoted a lifetime to the recording of the bird and animal life in America, not only with fidelity, but with a sense of wonder at its variety and richness that expresses his own passionate dedication and sympathy, and raises his work far above mere factual observation and into the realm of art (*Ill. 70*).

Therefore, in painting as in the other arts, the period between the Revolution and the Age of Jackson, to borrow Arthur Schlesinger's phrase, was one of transition and development. The remainder of the 19th century was to be shattered and revolutionized by the fearful conflict of the Civil War. Despite this fact, however, and the drastic social and economic changes which it brought about, the following decades of the century and the earliest years of the next were to see a further development of the tendencies and trends established during the transitional earlier years from the winning of Independence to the 1830s.

71 RAPHAELLE PEALE (1774–1825) *Lemons and sugar, c. 1822. Oil on wood, 12″ × 15″ (30.5 × 38.1). The Reading Public Museum and Art Gallery, Reading, Pennsylvania*

Every man his own artist

Like the sculptors of an earlier era, most of those of the post-Revolutionary period through the first three decades or so of the 19th century were artisans and craftsmen rather than sculptors in a formal sense. They were, for example, shipcarvers and cabinetmakers, like the members of the Skillin family of Boston who made figureheads for sailing vessels of the New England merchant fleet, and figures of the seasons for Elias Haskett Derby's summer house following designs by Samuel McIntire. There were also inn- and trade-signs which were carved as well as painted by anonymous hands. The second quarter of the 19th century was to see some of the most impressive of works of art produced within this popular tradition, but during the period under consideration there were only a few whose sculpture rose above a level of awkward expressiveness.

William Rush (1756–1833) was the first and by far the most important of these. Though Solomon Willard, the

72 WILLIAM RUSH (1756–1833)
*Pocahontas, first quarter of the 19th C.
Painted wood figurehead, h. 4′8½″
(143). Courtesy, Kendall Whaling
Museum, Sharon, Massachusetts*

architect of the Bunker Hill Monument, is known to have made a few figureheads, such as a *Washington* which is perhaps the one preserved in the collections of the United States Naval Academy at Annapolis, Maryland – a vigorous and forthright work – none could equal Rush in this category. And he went on to other achievements which justify the high regard of his contemporaries.

Rush was the son of a shipwright and grew up in the shipyards of Philadelphia where his father worked. Apprenticed as a youth to a British-trained shipcarver, he gained a reputation as the leader in his profession at as youthful an age as had Copley as a painter not many years before. During the Revolutionary period he saw two French frigates up for repairs in the yard of Joshua Humphreys, builder and designer of the famous American frigate U.S.S. *Constitution*, 'Old Ironsides'. For generations the French Navy had employed academically trained sculptors as instructors in government schools of shipcarving. The style they taught was strongly dependent upon the work of Pierre Puget, the greatest of French Baroque sculptors, who had been associated for years with the French Navy Yard at Toulon more than a half-century earlier. What the youthful Rush saw, therefore, was a far cry from the usual awkward if vigorous performance of the artisan shipcarver – something much closer to the great European sculptural tradition. It not only gave him an entirely new notion of what a figurehead could be, but a new concept of sculpture as a whole. Translating his new ideas into his own terms, he designed and carved figureheads which, within a matter of months, made him a reputation that rapidly became international in scope as American vessels bearing his work sailed the seas of the world.

Rush's figureheads are full of motion, male figures thrusting forward in dynamic energy and female figures with flowing draperies; that of *Pocahontas* (Ill. 72), sculptured for an unknown vessel, exemplifies the liveliness and assurance of Rush's work. As an admiring contemporary remarked, they 'seem rather to draw the ship after them than be impelled by the vessel.' Soon orders for 'Philadelphia style' figureheads began to come from all parts of the world, from European shipowners as well as American. Rush even carved one for the Bey of Algiers which included a lively conflict of lions and tigers, 'painted to the Life'. As a result, in 1794 he

73 WILLIAM RUSH (1756–1833)
*Benjamin Franklin, c. 1785. Wood,
h. 21" (53.4). Yale University Art
Gallery*

received the commission to design all the heads for the six frigates of the original United States Navy.

The same vigor pervaded all his work, from the amusing figures of *Comedy* and *Tragedy* which once occupied a pair of niches on the façade of Philadelphia's Chestnut Street Theatre and the *Water Nymph and Bittern* (all now in the Philadelphia Museum) sculptured for the fountain in front of the Pump House designed and engineered by his friend, the architect Latrobe, to the life-sized *Washington* in Independence Hall. In the latter, based on Houdon's masterful figure in Richmond, Rush turned the French sculptor's smoothly modelled marble forms into the forceful expressionism of his own wood-carving style. The same intense vigor informs his portraits, also in wood, of *Lafayette* (Pennsylvania Academy) and of *Franklin* (*Ill. 73*), the latter perhaps the most revealing of all likenesses of the great American philosopher and diplomat.

Though Samuel F. B. Morse was a painter before turning to a scientific career, like many artists of his day

and earlier, he sometimes made three-dimensional figure sketches which later became models for elements in paintings. One of these, his *Dying Hercules* of 1812 (*Ill. 74*), was exhibited at the Adelphi Society in London where it received a gold medal, and won immediate recognition for its twenty-two-year-old creator. It also served to inspire three of Morse's contemporaries to undertake careers as sculptors. Two of these were friends of his, John Frazee (1790–1852) and Hezekiah Augur (1791–1858); the third was John Henri Isaac Browere (1792?–1834). None of the three had had the advantages of the academic training enjoyed by Morse, but each rose, as had the greater number of American artists until after mid-century, through the artisan tradition of the folk artist to positions of respect in the artistic world. Frazee, for example, was one of the group of artists and architects who founded the National Academy of Design in 1826, of which Morse was the first president.

Frazee started out in his youth as a tombstone cutter. Dissatisfied with the dully repetitious designs copied from antiquated European pattern books, he turned to the natural forms of leaves, flowers, and vines, familiar from the days of his boyhood in the country, which he carved with naturalistic fidelity and accomplished craftsmanship in stone for all sorts of projects, from tombstones to

74 SAMUEL F. B. MORSE (1791–1872) *Dying Hercules, 1812. Plaster, 20″ × 22½″ × 9″ (50.8 × 57.2 × 22.9). Yale University Art Gallery*

architectural decorations for interiors and exteriors alike and, in wood, decorations for cabinetmakers and architects. From 1818 on, when he established his own independent studio, he enjoyed a great success. His portrait busts are characterized by the same intense and searching realism which had been the almost universal aim of American artists from earliest times to the early years of the present century. Several such busts of leading New Englanders, commissioned by the Boston Athenaeum, are relentlessly convincing portrayals set off by incongruous classical draperies, and represent the outstanding characteristics of his style.

Augur's career almost exactly paralleled Frazee's. A New Haven carpenter, he, too, won success as a practical carver, though he worked almost entirely in wood, often

75 HEZEKIAH AUGUR (1791–1858) *Jephtha Meeting his Daughter, 1828 and 1832. Marble, h. 36½ " (92.6). Yale University Art Gallery, Gift of a group of subscribers, 'the Citizens of New Haven', 1837*

76 *Thomas Jefferson, aged 82, from the life mask by* JOHN HENRI ISAAC BROWERE (1792?–1834). *Bronze. New York State Historical Association, Cooperstown*

producing architectural details and decorations for cabinetmakers. When he carved in stone, however, his results display the same totally realistic aim of his other work and that of Frazee. His small figures of *Jephtha Meeting his Daughter* (1828, 1832, *Ill. 75*) in marble, though only about three feet high, are carried out to the most minute detail and display the completeness and control of his craftsmanship.

The search for total realism was carried a step further by Browere. Somewhere, perhaps in Paris under the tutelage of Houdon, he learned the technique of making life-masks. With an aim similar to that of Charles Willson Peale with his museum, Browere conceived the idea of making likenesses of all the outstanding Americans of the day – to preserve their appearance for posterity; in fact, a national portrait gallery for the United States such as has been realized only in our own times. With some promise of official support, Browere made a series of plaster busts, toga-draped like those of Frazee, but based upon life-masks, of such worthies as Jefferson, John Adams, De Witt Clinton, and many others, only to be refused final government support for his project by President Madison on the grounds that, since a mechan-ical process was involved, they were not genuine works of art. Many years after Browere was dead and forgotten, the plasters were discovered in the barn of a remote farm in upstate New York. Today, finally cast in bronze (*Ill. 76*) as originally intended, and exhibited in a special gallery in the New York State Historical Association at Cooperstown, they form an impressive display of the founders and early leaders of the Republic.

The climax of American sculpture, in its first phase in the 19th century, was to be reached in the period from the 1830s to the Civil War. It was expressed in both the folk tradition of Rush, Frazee, and Augur, and the academic tradition of Neo-Classicism. But another category of folk art which flowered in this period includes the arts of the Protestant German groups which settled in Pennsylvania and the Middle Colonies and came to be known as the Pennsylvania Dutch, and the arts of the sect known as the Shakers.

The Pennsylvania Germans lovingly illuminated manuscripts, everything from school diplomas to birth certificates, in a still almost medieval but particularly distinctive fashion. An anonymous house blessing (*Ill.*

77), written and illuminated in the earlier 19th century, and now in the Karolik Collection in the Boston Museum, may serve as a typical example of *fraktur*, as this art of the Pennsylvania Dutch is properly called. Whimsical urns of stylized tulips flank a neat brick house from whose balustraded roof sprout another pair of fanciful bouquets; the blessing is inscribed above, while a heart and still more flowers decorate the top of the arcading which frames the whole.

In the utterly austere architecture of their carefully planned settlements, such as Hancock Village and Harvard, both in Massachusetts, the Shakers constructed buildings of such functional simplicity that they still serve as resources for contemporary designers. (Shaker furniture was, in fact, the model for what is known as Danish Modern.) The round barn constructed of stone at Hancock in 1826 and other buildings of the Shaker settlement there are examples of the sect's devout sim-

77 UNKNOWN ARTIST Pennsylvania Dutch house blessing, early 19th C. Pen and watercolor, 11¹¹⁄₁₆″ × 14½″ (29.7 × 36.8). Courtesy, Museum of Fine Arts, Boston, M. and M. Karolik Collection

103

plicity. With their inspirational paintings – records in watercolor of mystical visions, often of trees blazing with celestial light or symbols of divine harmony and love – their architecture reflects their belief that anything which 'has in itself the highest use possesses the greatest beauty'. Their Utopian dream, like that reflected earlier at Ephrata, recalls to a disturbed modern world the beauty and dignity of anti-materialistic devotion to a spiritual ideal.

The folk artist, who became particularly active during this period from the days of recovery from the War of 1812 into the 1830s, has already been mentioned as a significant factor in American art. Virtually every American painter from Copley on found his beginnings in this tradition, either as a village artist or as an itinerant, showing how general was the American desire for likenesses. Even Morse earned a living for a while as a wandering portraitist before turning to science. Audubon similarly supported himself while carrying out his great project of recording the birds and animals of America, and Thomas Cole, the founder of the Hudson River School, had also begun as a youthful itinerant. Though the academic tradition was always strong in America from the earlier 19th century onward, the vernacular tradition was the basis on which all American arts were founded from the first days of settlement until after the middle of the 19th century. Then the combination of the disruption of the Civil War and the advent of photography in the form of the daguerreotype, which was introduced toward the end of the 1830s, within a generation almost eliminated the respected professions of the itinerant and village artist, and changed the course of American art.

IV THE AGE OF JACKSON TO THE CIVIL WAR

From classic temples to Gothic fancies

This period saw the flowering of Romanticism in the arts anticipated earlier in the paintings of Copley and West. In architecture, the prevalent classicism of the Greek Revival, introduced by Jefferson before the end of the 18th century in his Capitol at Richmond (*Ill. 42*), and interpreted by the numerous editions of Asher Benjamin based on the style and practice of Charles Bulfinch of Boston, gradually gave way to an even more obviously Romantic Revival of medieval form. Finally, the increasing popularity of more exotic styles derived from the Near East and elsewhere caused architecture to degenerate, after the Civil War, into an indiscriminate melange of styles. From this situation emerged the towering figure of Henry Hobson Richardson as the inaugurator of a renewed architectural tradition which led into the developments of our own century.

The writings as well as the designs of Andrew Jackson Downing (1815–52) were influential in the change of taste in architecture which took place shortly before the middle of the 19th century. Starting as a landscape gardener, he published during the early 1840s his best-selling *Cottage Residences*, a work which went through several editions. It was followed by other architectural books in which he deplored the misuse of the form of the Greek temple for everything from houses to banks, churches, and government buildings. He advocated instead the choice of a design in architecture which represented 'a happy union between the locality or site and the style chosen', and particularly preferred the Gothic Cottage and the Italian Villa. He built a charming example of the former for himself at Newburgh overlooking the Hudson. He was actually responsible for the popular romantic style of domestic architecture known as Hudson River Bracketted which was so successfully employed by his contemporary, Alexander Jackson

Davis. His practicality is attested by his having published the design for an odor-free indoor toilet.

Downing had achieved an international reputation by the time of his unfortunate death at the age of thirty-seven aboard a Hudson River steamer, the *Henry Clay*, which sank after an explosion while racing a rival vessel. He had influenced the taste of fast-growing post-Jacksonian America, introduced the works of Ruskin to his countrymen, and taken on as a partner a young English architect, Calvert Vaux (1824–95), who was to carry on his ideas, not only in architecture, but also, as a partner of Frederick Law Olmsted (1822–1903), in landscape design. Before his death, Downing had landscaped the grounds of the Capitol in Washington, and, with his friend, the poet William Cullen Bryant, had embarked upon the plan for Central Park in New York City. The first project of its kind, it was ably carried out by his successors Vaux and Olmsted, and was an ideal expression of Downing's belief in the integrity of the character of a place, and in the idea that man should work with nature rather than impose, as in the Renaissance and Baroque traditions, his own grand plan, based upon an arbitrary geometry of crossing axes.

The house that Calvert Vaux designed for the popular writer and journalist, Nathaniel Parker Willis, perfectly expressed Downing's philosophy (*Ill. 78*). It was built without cutting down a tree, and its windows revealed views of the Hudson and surrounding countryside which were composed according to the principles of the land-scapes of the Hudson River School. It is therefore Downing whom we must credit with the foundation of the American school of landscape design. It remained for Olmsted, however, to give full expression to Downing's ideas, adding many of his own, during a long career in both the United States and Canada. He was a pioneer in the establishment of the United States Forest Service and national parks, and designed college campuses, park systems for many cities, and whole communities like Riverside, Illinois. Sharing the feeling for nature of Emerson, Thoreau, Bryant, and the Hudson River painters, Olmsted believed that the health of a democracy lay in the availability to all its citizens of decent housing, fresh air and water, and natural green spaces, and of the opportunity for recreation and indivi-dual development through the study of history, art, and

science in institutions functioning rather like free public universities. Therefore he was one of the founders in 1870 of the Metropolitan Museum of Art, whose original building was designed by Vaux, and of the American Museum of Natural History, established to show the complex relation of man and nature.

Influenced by the Utilitarian ideals of Jeremy Bentham, so important to the British reform movement of the earlier 19th century, and the planning principles of Sir Humphry Repton, England's great landscapist, Olmsted's practice was so broad and various and his influence so great that he has been correctly called 'America's foremost environmental designer'. Today's ecologists, conservationists, and urban and community planners carry on his tradition, as do many architects. Wright's 'Falling Water' (*Ill. 144*), a house built in 1936 over the stream and among the water-washed boulders of Bear Run, Pennsylvania, is a particularly distinguished example. Others may be found among the works of such outstanding contemporary architects as Philip Johnson, William W. Wurster, Harwell H. Harris, and Eliot Noyes, to name but a few among many.

There is no telling what Downing might have achieved if he had lived. As fate would have it, his friend and contemporary, Alexander Jackson Davis (1803–92), became the leading Romantic architect of the period before the Civil War. Taken into partnership by the older Greek Revivalist, Ithiel Town, Davis turned out some highly distinguished designs of his own in the

classical manner before turning to the more congenial medieval revivalism so beautifully represented by the charming country house, Glen Ellen, which he executed for Robert Gilmore of Baltimore, in 1832. An imagin, ative designer, Davis could also make some of the finest renderings in the history of American architecture. Carried out in line and watercolor, they not only accurately convey the form and the spatial relationships of a design, but also express its atmospheric quality. Gimore's lovely house has disappeared; it was partially destroyed by fire, then, still beautiful as a ruin, was inundated by the waters of a reservoir. But Davis' renderings and contemporary descriptions make clear what an appropriate setting he had conceived for one of the most generous patrons the arts have known in America, and a man who numbered among his most treasured possessions a walking stick given him at Abbotsford by Sir Walter Scott. The classically simple arrangement of rooms, allowing free circulation, carries on the development which Bulfinch had pioneered in his later work, and leads to the organic conception of interior space of Wright.

Though Glen Ellen has gone, one of Davis's greatest houses, Lyndhurst (*Ill. 79*), still exists, its future secured

79 ALEXANDER JACKSON DAVIS
(1803–92) *Lyndhurst, Tarrytown,
New York, 1838 and 1864*

by the National Trust for Historic Preservation. It was built in 1838 at Tarrytown, New York, for a former mayor of New York, William Paulding, and was then enlarged by Davis in 1864 when it was acquired by George Merritt. Davis designed the house, inside and out, including the furniture and other furnishings, as was the custom later of Frank Lloyd Wright. Richard Byrnes executed Davis' designs for panelling and furniture with superlative craftsmanship. House and setting, including outbuildings, are combined in a harmonious whole just as Davis intended, making one of the outstanding achievements of picturesque design, and perhaps the finest one remaining, in America.

Through the quality of Davis' renderings, which were regularly exhibited and served as models for other architects, and because of the distinction and extent of the architectural library assembled by his partner, Ithiel Town, and available to any aspiring student at the firm's offices in New York and in Town's handsome Grecian villa in New Haven, the influence of the partners, and especially of Davis, was very strong on the subsequent development of American architecture. It was because of Davis that Gothic became the standard collegiate style for so many years, and also that of so many churches.

The outstanding ecclesiastical architect of the period, however, was a young Englishman, Richard Upjohn (1802–78). Trained as a cabinetmaker, he came to America in 1829. Of a decidedly high-church Anglican turn of mind, he designed literally dozens of churches for congregations from Bangor, Maine, and Utica, New York, to the South, many of which reflect the picturesque medievalism of the distinguished English Revivalist, A. W. N. Pugin (1812–52). Upjohn's finest work, fortunately still existing, is Trinity Church (Ill. 80) at the corner of Broadway and Wall Street in downtown New York. Begun in 1840 and finished within the decade, it is a perfect example of the completeness and consistency of Upjohn's concept, not a reproduction of some European prototype, but an original creation in an understood, knowingly interpreted, Gothic idiom. Standing among trees and shrubs, surrounded by the ancient graveyard which dates back to the 17th century and the first Trinity Church to occupy the site, it is an island of timeless peace among the towering skyscrapers and bustling business world which surround it.

80 RICHARD UPJOHN (1802–78) *Trinity Church, New York, begun 1840. Lithograph after the architect's drawing. Museum of the City of New York, J. Clarence Davies Collection*

109

81 JAMES RENWICK, JR. (1818–95) *St Patrick's Cathedral, New York, 1858–88. From a photograph taken in 1894. Museum of the City of New York*

Upjohn had had the benefit of study and work with several leading Boston architects before embarking upon his own practice. His published designs, many of small buildings such as could be constructed by local carpenters in small communities, resulted in the building of churches in an Upjohn manner in towns and cities across the country.

In the meantime the most monumental example of Gothic Revivalism in America was rising in what was then far uptown New York, St Patrick's Roman Catholic cathedral on Fifth Avenue between Fiftieth and Fifty-First Streets (*Ill. 81*); for the remoteness of the site Archbishop John Hughes was much criticized. It was the design of a whimsical and imaginative individual who had begun the practice of architecture as a rank amateur. Rich enough to own two steam yachts, James Renwick, Jr. (1818–95) began his architectural career with Grace Church on Broadway and Tenth Street, a decidedly unacademic exercise in the Gothic style interpreted with a lively imagination and a feeling for

the picturesque. On the strength of his performance with Grace Church, Renwick was commissioned to design St Patrick's. Though construction was begun in 1858, its progress was interrupted by the Civil War, and its spires were not completed until 1888. Because of its vast size, Renwick could not indulge the sense of fancy which enlivened the design of Grace Church, and other architects, of a more studious mind, were involved in its later phases.

Renwick indulged all his feeling for the picturesque, however, in the original building of the Smithsonian Institution in Washington, D.C., begun in 1846 (*Ill. 82*). Its style is pure Renwick, otherwise unclassifiable, though it has been called everything from Anglo-Norman to Byzantine. In its uninhibited richness of invention it rivals the best works of A. J. Davis, and today is a most welcome relief to the eye – with its rich, red sandstone bulk softened by ivy, and its fascinating liveliness of silhouette – amid the ever-increasing mass of surrounding official buildings whose mediocrity and monotony seem an unfortunate if accurate expression of the bureaucratic mind.

Just like the delightfully unlikely confrontation of Renwick's St Patrick's cathedral with Harrison and Fouilhoux's vast Rockefeller Center (*Ill. 149*) across Fifth Avenue, and the Smithsonian's constant reproach to the conformity of officialdom in Washington, the works of the revivalist architects, in the few cases where progress has allowed them to remain, often lend a welcome liveliness and contrast to the cityscape. They stand as monuments to the ebullient individualism of a

From classic temples to Gothic fancies

82 JAMES RENWICK, JR. (1818–95) *Smithsonian Institution, Washington, D.C., 1846–55*

nation in a period of rapid expansion. They carried an aura of romance into increasingly workaday lives, and in their implications of another era suggested the in‑evitability of the passage of time, a theme so popular that it occurs again and again in the painting and literature of the period.

Beneath the superficially picturesque elements of the Romantic style, other and more significant developments were taking place. It was probably a housewright named Augustus Deodat Taylor who invented the new form of wood construction called the balloon frame because of the rapidity of execution it made possible. Taylor was the builder of the first Roman Catholic cathedral in Chicago in 1833, and completed the modest building with amazing speed by the use of thin wooden plates and studs, generally 2×4 inches in section, instead of the heavy‑timbered, morticed and tenoned method, time‑consuming and requiring special tools and skills, until then tra‑ditional. With the machine production of nails and the standardization of parts, it was possible to build a house, as a contemporary architect observed, with no more technical skill than was needed to use a hammer and a saw. By using the balloon frame, cities could rise in a matter of weeks when gold was discovered in California and oil in Pennsylvania. Chicago and San Francisco grew from villages to great cities in little more than a year.

In 1830 John Haviland (1792–1852) constructed the first building to have a cast‑iron front, the Farmers' and Merchants' Bank in Pottsville, Pennsylvania, and in 1848 James Bogardus (1800–74), a Rochester watch‑maker, built the first completely cast‑iron structure, a factory in New York City. Soon thereafter, cast‑iron buildings were not only shipped, knocked‑down, to all parts of the world – just as wooden buildings had been in colonial times – but were rising in cities all across America. From the practical point of view, they were comparatively fireproof and easy and economical to erect. From an esthetic point of view, many of them, often in an Italianate style, were handsome, like a number which still stand in downtown New York, those which, until their recent destruction, lined the waterfront in St Louis, and the Z.C.M.I. Department Store in Salt Lake City, Utah.

In 1849 a young architect named William L. Johnston (act. c. 1850) and Thomas U. Walter (1804–87), the

83 WILLIAM L. JOHNSTON (act. c. 1850) and THOMAS U. WALTER (1804–87) Jayne Building, Phil‑adelphia, 1849. Courtesy, The Old Print Shop, Inc., New York

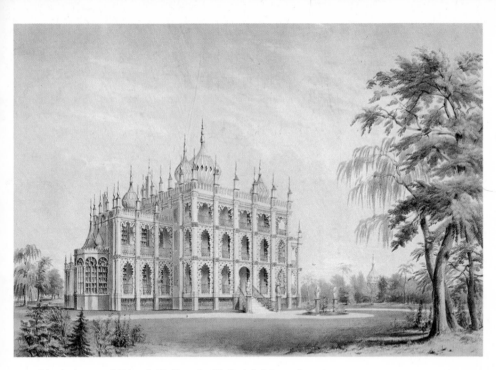

capable designer of Girard College in Philadelphia and
the new dome of the national Capitol (*Ill. 53*), collab-
orated on the Jayne Building in Philadelphia (*Ill. 83*).
Eight stories high, and in a simplified and freely inter-
preted Venetian Gothic style, it shares with the late
designs of A. J. Davis' utilitarian city structures a strong
verticality which anticipates the development of the
skyscraper almost a half-century later. In 1857 the first
practical passenger elevator was installed in the Haugh-
wout Building in New York, and another step was taken
towards that end.

Ithiel Town's lattice truss, the simple wood construction
which had made possible bridges of great length,
essential for the westward expanding railroads as well as
for highways, had been superseded by truss-systems
carried out in iron. Others were experimenting with
concrete and with other new materials and methods.

Yet the external appearance of America's architecture
became more and more elaborate, reaching unbelievable
heights of fancy in such buildings as Iranistan (1848) in
Bridgeport, Connecticut (*Ill. 84*). A miniature Taj
Mahal with echoes of the Prince Regent's pavilion at
Brighton, it was designed by Leopold Eidlitz for the

84 LEOPOLD EIDLITZ (1823–
1908) *Iranistan, Bridgeport, Con-
necticut, 1848. Lithograph by Sarony
and Major. Library of Congress,
Washington, D.C.*

113

original master-showman, Phineas T. Barnum of circus fame. But beneath the surface the creative mind and imagination were at work in areas less picturesque but more important for the future. The same capacity which had earlier created the American ax, the Kentucky rifle, the Conestoga wagon, and the Concord coach, was still at work. Donald McKay's clipper ship, the American locomotive, Henry Ford's Tin Lizzie, the Brooklyn Bridge, the skyscraper, the invention of the Wright Brothers – all were to emerge in their own time from the same combination, the result ultimately of the conditions and necessities of life in the New World, which so demanded practicality and ingenuity. Bulfinch had been both architect and engineer, and, until late in the 19th century, it was traditional for both professions to be combined. The architecture of the period before the Civil War contains the promise of later and present-day achievements. The ingredients were there. It only remained for gifted individuals to assemble them for new purposes.

The sculptor Horatio Greenough perceived this by mid-century when he recognized the sailing ship as a work of art. When the Greek Revival was still strong, having continued long after other stylistic revivals had appeared, Greenough wrote that 'The men who have reduced locomotion to its simplest elements, in the trotting wagon and the yacht *America*, are nearer to Athens at this moment than they who would bend the Greek temple to everyday use.' When he defined beauty as 'the promise of function', his was the voice of the future, a voice of our own times.

'Our own bright land'

From the 1830s to the Civil War there was a rediscovery of America in visual terms, through the eyes of a group of her painters. A renewed view of the landscape, though tentatively anticipated by others, was really initiated by Thomas Cole and continued by his followers to become the Hudson River School, though in subject and approach they ranged far more widely than that originally not very flattering identification suggests. There was also an awakening of interest in the everyday life of America, given added impetus by the rapidity of urban growth and

an accompanying nostalgia for the simpler world of the farm and countryside in the mood of so many of the songs of Stephen Foster and the popular lithographs of Currier and Ives. There was an awareness of the drama of the frontier, recorded by artists whose interests ranged from the vanishing folkways of the Indians to frontier politics. The popular arts flourished in such forms as the panorama, which reached its highest development in America and is a progenitor of the motion picture, and in a final flowering of the itinerant and village artist in the ultimate expression of the folk tradition. The search for a total realism of expression continued, balanced by a yearning for the ideal which often led far afield from naturalism and into the realm of fantasy and dream, the two poles between which the arts of America have continued to fluctuate. A prevailingly romantic attitude provides the common denominator among the great diversity which has been so constant a factor in American art.

The first artist fully to represent the romantic spirit in America in the period was Washington Allston (1779–1843). Born in the South but raised in New England, he became as famous an international figure in painting as were his contemporaries, Washington Irving and James Fenimore Cooper, in literature. When a student at Harvard he studied Smibert's expert copy of the head of van Dyck's portrait of *Cardinal Bentivoglio*. Like many other young Americans, he was not only encouraged to an artistic career by it as well as by his own natural bent, but through it he became aware of the great tradition of Western painting. With his fellow student, Edward Malbone (1777–1807), who was to become America's leading miniature painter, he went to London to study with Benjamin West.

Brought up, like the architect Alexander Jackson Davis, on extravagantly romantic Gothic novels, such as Mrs Radcliffe's *Mysteries of Udolpho* – works full of mysterious characters, haunted castles, ghosts, bandits, beleaguered heroines, and fated heroes – Allston much admired the landscapes of Salvator Rosa, and even attempted to write a novel in the Gothic vein, *Monaldi*. But, far more important, he discovered the paintings of the great masters of the European past, such as Titian, Tintoretto, and Michelangelo, and also those of Turner, with their extraordinary effects of atmosphere which

anticipate the work of the Impressionists half a century later.

As a result, in the early years of the 19th century he began to produce the series of pictures of natural scenes which establish his great contribution to art, what his sympathetic biographer, Edgar P. Richardson, has aptly termed the 'landscape of mood'. He developed a theory of color which curiously anticipated modern art. After studying the works of great colorists from the Renaissance to his own day, he became aware of the independent emotional impact of color alone, and recognized that it might form the major subject of a painting rather than 'the ostensible *stories*' of the composition. He likened the effect to that of music, a totally non-objective art, and believed that the great colorists left 'the subject to be made by the spectator, provided he possessed the imaginative faculty . . .'

Allston's own art illustrates his theories of the effectiveness of color in creating mood which becomes the real subject of the painting. His *Coast Scene of the Mediterranean* (1811, Boston), with its luminous sunset glow, is idyllic, while his *Rising of a Thunderstorm at Sea* (1804, *Ill. 85*) has a sinister and almost frightening quality. His

85 WASHINGTON ALLSTON (1779–1843) *Rising of a Thunderstorm at Sea, 1804. Oil on canvas, 3' 2½" × 4' 3" (98 × 130). Courtesy, Museum of Fine Arts, Boston, Everett Fund*

Moonlit Landscape (1819, Boston) has a strangely clouded sky and a sense of enigma that invites the spectator's participation. The great work of his later life, *Belshazzar's Feast* (study in Boston), was a gigantic picture which, despite his years of struggle with it, painting and re-painting, was never finished.

Thus Allston's career ended in defeat. But by introducing the landscape of mood into American art and by the example of the artistic life he led, not only in Europe where he enjoyed considerable reputation, but also in America, where his studio was the meeting place for artists and literary figures as well as for amateurs and those interested in the arts, he lent the cause of the arts in America the same dignity with which he pursued his own artistic career, and, like West in an earlier generation, gave both instruction and encouragement to many an aspiring young American, one of the most important of whom was Samuel F. B. Morse.

It was the function of Thomas Cole (1801–48) during his unhappily short life to direct the vision of his fellow citizens to the particular beauties and qualities of their own landscape. Though Allston and others had painted earlier landscapes, Cole was the first to conceive of

86 THOMAS COLE (1801–48) *The Oxbow, 1846. Oil on canvas, 4′ 3½″ × 6′ 4″ (131 × 193). The Metropolitan Museum of Art, New York, Gift of Mrs Russell Sage, 1908*

landscape painting as a revelation, as it appeared when untouched by man, of the forces of creation and the expression, therefore, of the Creator. He shared this mystically pious attitude with such of his contemporaries as the novelist James Fenimore Cooper, whose Leather-stocking saw 'the hand of God . . . in the wilderness', and the poet William Cullen Bryant, whose verses again and again echo a similar sentiment.

Though Cole studied in Europe and painted several important European subjects, such as his *An Evening in Arcady* (1843, Hartford) – a poetic evocation of a golden age – his finest landscapes are those done in his beloved Catskills and *The Oxbow* (*Ill. 86*), showing a famous curve in the Connecticut River near Northampton, Massachusetts, the most impressive version of which is that of 1846 in the Metropolitan Museum. Light, color, and atmosphere are expertly orchestrated to form a monumental whole, dramatic in depth and clarity of vision, one of the 'scenes of wild grandeur', as Bryant called them, 'peculiar to our own country, . . . with depths of skies . . . through the transparent abysses of which it seemed that you might send an arrow out of sight.'

Like so many of his contemporaries, Cole was obsessed with the passage of time. His *Course of Empire* (1835-6, New-York Historical Society) consisted of five scenes showing the progress of man through *The Savage State, The Arcadian or Pastoral State,* to *The Consummation of Empire,* followed by *The Destruction,* in which the great city is sacked by barbarian hordes; the final scene is *Desolation,* empty ruins, overgrown and forgotten, seen in the vaguely melancholy light of early evening, where, in Bryant's words from *Thanatopsis,* 'the dead reign . . . alone.'

The most popular of Cole's works is the series of four paintings known as *The Voyage of Life* painted in the 1840s. The scenes of *Childhood, Youth, Manhood,* and *Old Age* were engraved for the American Art Union (*Ill. 87*) and circulated among its membership of thousands throughout America and even to Europe and beyond. Though the idea of life as a voyage and the literal though imaginative portrayal of its stages seems today banal beyond belief, its realization so accurately reflected the sentiments of the times that the paintings became probably the most famous in the history of American art.

87 *After* THOMAS COLE (1801–48)
*The Voyage of Life – Youth, 1840.
Engraving by James Smillie, 1850.
Courtesy of Kennedy Galleries Inc.,
New York*

Cole combined in his work the double strains of
realism in his landscapes and of fantasy in such works as
The Course of Empire, *The Voyage of Life*, and the proto-
surrealist *The Titan's Goblet* (1833, Metropolitan): these
are the contrasting objective and subjective attitudes
which appear so emphatically throughout American art.
His short career established landscape as the major area
of artistic expression in American art which had hitherto
been dominated by the portrait, and reflected a continuing
interest in certain historical subjects. Both of the latter
categories continued to be represented, but when Cole's
follower Asher B. Durand (1796–1886), a landscape
painter, was elected president of the National Academy
of Design, it was an acknowledgment of the priority of
that branch of painting. Durand's *Kindred Spirits* (*Ill. 88*),
painted in 1849 after Cole's death, shows the painter
and the poet Bryant standing in a Catskill glen, and is a
reminder of their attitude toward nature which was shared
by so many of their contemporaries.

Cole had many followers, though only one direct
pupil, Frederic E. Church (1826–1900). Inspired by
the writings of the adventurous German naturalist,
Alexander von Humboldt, Church exploited the remote
valleys of the Andes and the desolate coasts of Labrador
as subjects for his epic landscapes. His *Heart of the Andes*
(1859, *Ill. 90*) represents a kind of summary of his
pantheistic view of nature inherited from Cole. It is a
spectacular performance technically, amazingly success-
ful when judged in the terms of its author's intent, to
express in all its wildness and extent the lush beauty and
vast expanse of the Andean highlands.

88 ASHER B. DURAND (1796–1886) *Kindred Spirits, 1849. Oil on canvas, 46″ × 36″ (117 × 92).*
Collection of the New York Public Library, Astor, Lenox and Tilden Foundations

Albert Bierstadt (1830–1902) was another artist-
explorer. He studied in Germany, so his Rocky Mountains
sometimes look Swiss rather than American, yet he
proved himself capable of such impressive renditions of
mountainous solitude as *The Wind River Mountains* (1860,
Ill. 89). His work became so popular that when his
colossal *Rocky Mountains* (1863, Metropolitan) was first
exhibited in New York, banners were strung across
Broadway to announce the showing.

Martin J. Heade (1819–1904) was a friend of Church
and, like him, explored the jungles of South America.
His frequent subjects were the orchids and hummingbirds
he found there, and so expert did he become as a pictorial
ornithologist, that he was honoured by Don Pedro, the
Emperor of Brazil. Despite such interest in subject-

91 MARTIN JOHNSON HEADE
(1819–1904) *Approaching Storm,
Beach near Newport, c. 1860. Oil on
canvas, 2′4″ × 4′10¼″ (71.2 × 149).
Courtesy, Museum of Fine Arts,
Boston, M. and M. Karolik Col-
lection*

matter, Heade's mature paintings show a consistent preoccupation with light until the subtle nuances of the play of light become at least as important as the subject portrayed and sometimes more so. A series of small studies of various effects of light on the Newport marshes, several of which are in the Karolik Collection in the Boston Museum, prove him to be among those artists of the period whom Edgar Richardson in his valuable *Painting in America* has classified, because of their special interest in light, as Luminists. That Heade was the most powerful of these is shown by his intensely dramatic *Approaching Storm, Beach near Newport* (*Ill. 91*) of about 1860, a frightening evocation of the sinister forces of nature.

Luminism in America was an expression of the growing interest in light, both scientifically and artistically, which began during the middle years of the century. In Europe it appears both in the invention of photography and in the painting of Corot in France, and in England in the painting of Constable and Turner, whose work in turn influenced that group of painters who gathered at Barbizon shortly before mid-century and were pre-cursors of Impressionism. The Luminists were less interested in theory than the Europeans. Their attitude was firmly naturalistic, and for them light and the effects of light became an added dimension of expression of their feeling for the American scene with which they felt such identification.

The real leader of this group was John F. Kensett (1816–72). Like Durand, he was trained as an engraver, but on his return from seven years of travel and study

abroad, he was so struck with the special qualities of light and atmosphere in America that he spent the rest of his life painting their effects on landscapes of lakes and mountains in New York and New England and the rocky coast near Newport, Rhode Island. His *Thunderstorm, Lake George* (1870, *Ill. 92*) and *The Old Pine, Darien, Connecticut* (*c.* 1872, Metropolitan) both reveal his benign temperament and exemplify the visual poetry that made him one of the best-known artists of his period, both at home and abroad.

Others of the group were Worthington Whittredge (1820–1910) and Sanford R. Gifford (1823–80), both of whom traveled abroad with Kensett. Whereas the latter's pictures are generally pervaded with a quietude that sometimes has vague suggestions of the slightly melancholy spirit of his friend Bryant's verses, Whittredge's paintings have an atmosphere which unifies the whole in emotional as well as painterly terms, whether a broad panoramic landscape, like his *Deer in the Forest* (*c.* 1850, Metropolitan) or the intense greenness of his broadly painted sketch of *Autumn in the Catskills* (IBM).

Gifford painted in a higher key and loved the effects of back-lighting, of the sun filtered through branches, of the saturated atmosphere of late afternoon and sunset, explored in small studies or in broad landscapes like his *Kaaterskill Falls* (1862, Metropolitan), where the rugged Catskills' steep slopes are seen through a veil of golden light.

92 JOHN F. KENSETT (1816–72) Thunderstorm, Lake George, 1870. Oil on canvas, 14″ × 24″ (35.6 × 61). Courtesy of The Brooklyn Museum, Gift of Mrs W. W. Phelps

Another artist to be classed among the Luminists was
Fitz Hugh Lane (1804–65) of Gloucester, Massachusetts,
who was the first distinguished marine painter in
American art. He was a paraplegic who had been
crippled by polio at the age of two; though he was totally
unable to walk, he got around by means of a wheelchair
and drove a smart rig to various places where he made the
sketches for the paintings of shore and harbor scenes
which won him his reputation. The rigging of his painted
ships passed muster with his nautically experienced
neighbors, and artists and critics acknowledged him as
the leading marine painter in America. From the top
deck, enclosed in glass, of the curious Gothic house he
and his brother-in-law, Ignatius Winters, built of granite
on Duncan Point, he studied the effects of dawn and
dusk, storm and calm, winter and summer, and embodied
his observations in such sensitively realized works as
Owl's Head, Penobscot Bay (1862, *Ill. 93*), with its
silence and crystal clarity and sense of loneliness; here he
treats a subject and mood to reappear again and again in
American art, the solitariness of man in the face of
nature, as vast and impersonal as only those with
experience of the emptiness of the New World and the
limitless extent of the sea can understand. It is a theme
which occurs in the paintings of Winslow Homer and

in the writings of Herman Melville and continues into our own century in the works of such diverse artists as Marsden Hartley and Andrew Wyeth.

Though many of these men came from widely differing backgrounds – Whittredge, for instance, grew up in poverty on a frontier farm in Ohio while his friend Gifford was the son of a wealthy foundry owner on the Hudson – most had their initial training in engraving which led them to construct their compositions on a linear basis. It also led them to think and compose tonally, in terms of subtle relations of value, however strong a coloristic sense they developed. These qualities enhanced the naturalism inherent in their basic concept of nature and made their works as popular with a broad public as were these of their literary counterparts, Irving, Cooper, and Bryant. Never before or since have American artists been so universally admired, understood, and respected as during the height of the landscape painting development around the middle of the 19th century, and which flourished till the disruption of the Civil War.

It was not only the landscapists, however, who enjoyed such wide public acclaim. Just as Cole had discovered

94 WILLIAM SIDNEY MOUNT (1807–68) Cider Making, 1841. Oil on canvas, 27″ × 34⅛″ (68.6 × 86.6). The Metropolitan Museum of Art, New York, Purchase, Charles Allen Munn Bequest

for his countrymen the beauties of the American scene, another group of artists was discovering the charms of everyday life in America and starting a flourishing school of genre painting. Among the most important of these is William Sidney Mount (1807–68) of Stony Brook, Long Island, who loved to play the fiddle for country dances and specialized in painting such homely subjects as horse-trading and farm chores. One of his most attractive works is *Cider Making* (1841, *Ill. 94*), whose lively narrative qualities are pictorially unified by his subtle handling of light.

George Caleb Bingham (1811–79) grew up in Missouri, in a *milieu* similar to that immortalized a generation later by Mark Twain in his tales of Tom Sawyer and Huckleberry Finn. Bingham, like so many others of his day, tried at least half-a-dozen trades and projects before turning to painting, possibly influenced in that direction by the genial giant Chester Harding (1792–1866), the frontiersman turned artist, who had gone through town on his way to paint a portrait of the already legendary Daniel Boone. Bingham managed some desultory study at the Pennsylvania Academy in

95 GEORGE CALEB BINGHAM (1811–79) *The Verdict of the People, 1854–5. Oil on canvas, 3′ 10″ × 5′ 5″ (117 × 165). Collection of the Boatmen's National Bank of St Louis*

Philadelphia, and stayed briefly in Washington where his still wooden style did not deter some of his fellow frontiersmen from commissioning portraits. But in the process he seems suddenly to have become aware that the familiar aspects of frontier life, so natural to him, were, in fact, history in the making.

So Bingham returned to Missouri to paint a memorable series of pictures of the rough-and-ready politics and life of the area in *County Election* (1851–2), *Stump Speaking*, and *The Verdict of the People* (1854–5 *Ill. 95*; all, Boat-men's National Bank of St Louis). Full of lively and earthy observation, they record the imperturbable dignity of local worthies, the activities of drunken riverboatmen, the constant attendance of small boys and dogs, with the verve and immediacy of a man who lived what he painted.

Later study at Düsseldorf in Germany was detrimental to Bingham's art. His later works are cold and hard. With the tensions leading up to the Civil War, Bingham entered politics himself, held various public offices, and then, a passionate advocate of the Union, enlisted when the conflict came. But his paintings remain as a unique record of frontier life.

While Bingham concerned himself with recording the colorful life of the frontier, others, like Church, Bierstadt, and Heade, ventured far beyond the frontier, but for entirely different reasons. Such authors as Cooper and Irving prove that people were conscious at the time of the drama and the epic qualities of the conquest of the West, and were aware of the interest, both scientific and pictur-esque, of the life and customs of the American Indian.

George Catlin (1796–1872) and Seth Eastman (1805–1875) were leaders among those painters who set them-selves the task of recording the manners and costumes of the various Indian tribes, many of whom were soon to vanish as the white man drove relentlessly westward, carrying with him the means of unbelievable material success but also inevitably the forces which were not only to destroy entire nations but also to create a world in which their ancient ways of life could no longer exist. Catlin's portraits of Indian chiefs are particularly memorable in their portrayal of the immense dignity and ceremonial aspect of these leaders, as in his unfinished equestrian portrait of *Keokuk*, the Mandan chief *Four Bears* (1832, Smithsonian) and *The White Cloud* (*Ill. 96*). Eastman was most successful in recording such activities as appear

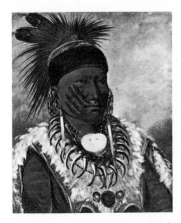

96 GEORGE CATLIN (1796–1872) *The White Cloud, Head Chief of the Iowas. Oil, 27¾" × 22¼" (70.4 × 57.8). National Gallery of Art, Washington, D.C., Paul Mellon Collection*

127

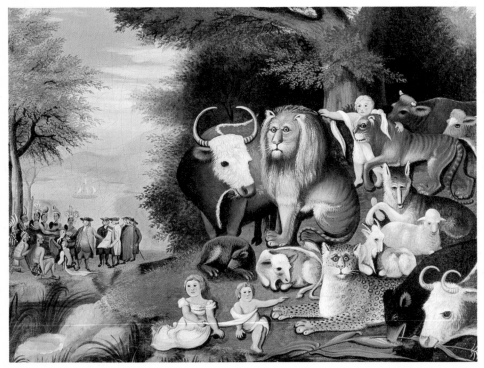

in his famous painting of *Lacrosse Playing* (1857, Corcoran), and *Sioux Indians Breaking Camp* (c. 1848, Boston).

In a way, the works of such painters are an aspect of genre painting, but the most talented American to devote a major part of his efforts – because he was also a leading portraitist – to genre painting in its truest sense, without overtones of scientific record, was Eastman Johnson (1824–1906) of Maine. Study in Europe seems to have had no influence on his vision or point of view, though it undoubtedly gave him the mastery of technique which enabled him to become the leading artist in this field. Starting out as a portraitist, he never abandoned that primary area of American art, and turned out distinguished examples such as his *Hatch Family Group* (1871, *Ill. 100*), a fascinating record of the life and surroundings of wealthy New Yorkers of the period, and his *Two Men* (1881, Metropolitan) which rivals Thomas Eakins' painting in its rich but sober tonality and psychological insight. But his many treatments of such simple themes as sugaring⁄off in the woods of Fryeburg, Maine, of corn⁄husking bees, of blueberrying at Kennebunkport and cranberrying on Nantucket, scenes of figures unified in atmosphere and light, some⁄times sun⁄drenched and sometimes with strong patterns of light and shade, and always devoid of sentiment, show his mastery of genre. In his feeling for paint combined with his personal vision, an often broad handling, and a system of composition based upon the transitory, he anticipates the art of a later period.

Only Winslow Homer (1836–1910) equaled and, in his best works, surpassed Johnson as a painter of genre, because during his earlier period, from the time he worked as an illustrator for such periodicals as *Ballou's Pictorial* and *Harper's Weekly* until his visit to Tynemouth, England, in 1881, Homer was primarily a genre painter. Today, highly as we regard these earlier works, we value most the late epic series of Adirondack and coastal scenes which provide one of the highest achievements of American art and belong to another period. Thomas Eakins (1844–1916) also occasionally turned to genre subjects, but he, like Homer, was to do his greatest work in other fields.

Meanwhile portrait painting was flourishing, not only by virtue of the distinguished contributions of Eastman

'Our own bright land'

97 *(opposite, above)* ERASTUS SALISBURY FIELD (1805–1900) *Historical Monument of the American Republic, c. 1876. Oil on canvas, 9′3″ × 13′1″ (282 × 399). Museum of Fine Arts, Springfield, Mass⁄achusetts, The Morgan Wesson Memorial Collection*

98 *(opposite)* EDWARD HICKS (1780–1849) *The Peaceable King⁄dom, 1830–40. Oil on canvas, 17½″ × 23½″ (44.5 × 59.7). Abby Aldrich Rockefeller Folk Art Collection, Williamsburg, Virginia*

Johnson, and the work of the long-lived and active Thomas Sully of Philadelphia, but also of Rembrandt Peale and a number of others, including the most prolific and famous of his generation, George Peter Alexander Healy (1813–94). Healy had studied abroad and became a professional at almost as early an age as had Copley. Totally lacking Copley's extraordinary powers, he nevertheless painted countless portraits of notables at home and abroad, rivaling the later John Singer Sargent as an international artistic personality.

Perhaps more interesting from a modern point of view was the flourishing of the academically untrained professionals, many of them portraitists, whose paintings have a robust vigor and a freshness so often lacking in the work of those who sought to accommodate their styles to a European ideal. William M. Prior (1806–73), for example, was the son of a Bath, Maine, shipwright, and became a highly successful itinerant who ranged far afield from his headquarters in a loft in East Boston, painting single and group portraits, from heads 'without shades or shadows', framed and glazed, for $2.95 to 'fancy portraits', complete not only with shades and shadows but often with nosegays and the family cat or dog included as well, all for the sum of $25. His brother-in-law Sturtevant Hamblin and other members of the family assisted him, and so consistent is their style that, without signatures, one hand cannot be told from another. Yet the results – for instance *Three Sisters of the Coplan Family* (*Ill. 99*) – are always lively, well painted, and freshly observed, and have a vividness and directness of vision which put the works of his more pretentious contemporaries to shame.

Erastus Salisbury Field (1805–1900) was another folk artist whose work stands up over the years. During a lifetime as long and as productive as Titian's – and there the comparison must end – he turned out numerous colorful portraits of friends and neighbors of several generations, and such Biblical subjects as *The Garden of Eden*, a charming example of which is in the Karolik Collection of the Boston Museum, showing Eve discreetly waist-deep in a cluster of peonies like those that undoubtedly grew in the artist's own garden, reaching for an apple of a variety more likely to have gone into one of Mrs Field's pies than to have caused the downfall of man. His most important work, in size and purpose if not

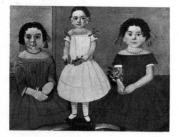

99 WILLIAM MATTHEW PRIOR (1806–73) *Three Sisters of the Coplan Family. Oil on canvas, 26¾″ × 36¼″ (67.8 × 92). Courtesy, Museum of Fine Arts, Boston, M. and M. Karolik Collection*

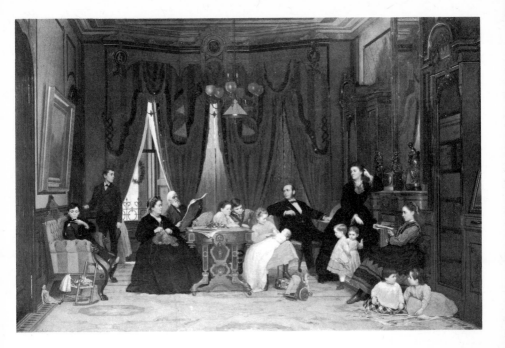

in artistic qualities, is his *Historical Monument of the American Republic* (*Ill. 97*), an architectural fantasy of vast proportion symbolizing the history, structure, and future of America.

Another visionary whose paintings embody a similar but even simpler and more moving expression of idealism is the Quaker, Edward Hicks (1780–1849). Trained as a sign and wagon painter, he was also a convincing preacher who occasionally underwent deep soul-searchings because of his facile eloquence, and turned to visual allegory instead. He had just one subject, particularly appealing in today's world. He had a vision of the 'peaceable kingdom', sometimes expressed in idyllic scenes of Jacob Twining's Farm, where he had been taken in as a child and spent his boyhood, and sometimes as a literal translation into visual terms of the prophecy in the eleventh chapter of *Isaiah*, showing domestic and wild animals in a happy group with the little child who was to lead them. Particularly attractive is the worried, human-faced lion in the various versions of the *Peaceable Kingdom* (*Ill. 98*), with which Hicks seems to have identified himself.

100 EASTMAN JOHNSON (1824–1906) *The Hatch Family Group, 1871. Oil on canvas, 4′ × 6′ 1⅜″ (122 × 187). The Metropolitan Museum of Art, New York, Gift of Frederick A. Hatch, 1926*

Shaker inspirational painting often embodies just such simple and moving allegory, as do the *fraktur* paintings of the Pennsylvania Dutch. Such works represent that strain of the visionary which runs through American art, from the soul symbols on Puritan gravestones to the work of certain artists of today, such as Burchfield (*Ill. 165*), Graves, Baskin, and many others. It represents the opposite pole from the relentless search for the real which is such a strongly contrasting factor in our artistic history.

Neo-Greeks and ingenious mechanics

101 HIRAM POWERS (1805–73) *The Greek Slave, 1843. Marble, h. 5'6" (168). In the collection of the Corcoran Gallery of Art, Washington, D.C.*

In sculpture as in painting, there is a curious mixture of the academic and the vernacular during the 19th century. American academic sculptors gained international fame, and inherited the Neo-classic mantle of the European leaders in the field of a previous generation, the Italian Canova, and the Dane Thorvaldsen. Hiram Powers (1805–73) of Vermont, for example, after settling in Florence in 1837 and producing portrait busts which, in the opinion of the aging Thorvaldsen, established him as without a rival in this field, became known as the Yankee Canova. Ingenious enough to have invented a method of laying a transatlantic cable far more efficiently than that first attempted, and to have planned and organized a joint stock company to transport marble from the quarries at Carrara to Florence, Powers is best known for his *Greek Slave* (1843, *Ill. 101*) the most famous sculpture of the period, and the hit of the Great Exhibition of 1851 at the Crystal Palace in London. Such diverse art lovers as Prince Diminoff and A. T. Stewart, the New York department store magnate, ordered copies. There are versions in several American museums including the Corcoran Gallery in Washington and the Newark, New Jersey, Museum. Elizabeth Barrett Browning wrote a poem about the *Slave*, and a committee of Cincinnati clergymen endorsed her propriety by unanimously agreeing that she was not really nude but 'clothed in her own virtue', since, as she was, according to the sculptor, represented as being offered for sale in a slave market to a lot of 'eastern barbarians', she could scarcely be blamed for her unfortunately undressed condition.

It was through such dubious arguments that 19th-century prudery was circumvented and the nude again

102 HORATIO GREENOUGH
(1805–52) *George Washington,*
1832–9. Marble, h. 10'6" (320).
Courtesy of National Collection of
Fine Arts, Smithsonian Institution,
Washington, D.C.

entered the domain of art. *The Greek Slave* was exhibited
in cities across America to capacity crowds, the com⁄
bination of nudity and morality proving irresistible. She
was followed by many other such figures, similarly titled
to justify their otherwise unforgivable lack of clothing.

Powers went on to other successes, including many
portrait busts, one of the best of which (*c.* 1850, Boston),
is of his friend and contemporary, Horatio Greenough
(1805–52), who, with Thomas Crawford (1814–57),
shared his dominance in the field of sculpture, both at
home and abroad. Greenough's famous *Washington*
(1832–9, *Ill.* 102), one of the very few major commissions
ever accorded an American artist by the United States
government, has shortcomings so obvious that they do not
need to be pointed out, but they are to a considerable
extent the shortcomings of Neo⁄classicism, rather than

133

of Greenough himself. In a period when nothing which was not classical could be considered serious or proper, it was inevitable that he should try to suggest the timeless/ ness of Washington's contribution to his country's history by the classical means which were the accepted artistic vocabulary of the period. Despite its failure, the passage of time has given sufficient perspective so that we can credit Greenough with both the largeness of the concept and dignity of the idea which he tried to express. Despite its awkwardness, the *Washington*, as the first attempt at genuinely monumental sculpture by an American, deserves respect.

Greenough was overwhelmed with portrait and other commissions despite the mixed greetings accorded his *Washington*. He was appointed professor of sculpture at the Grand Ducal Academy of the Fine Arts in Florence, and his house there was a meeting place for visiting Americans and for the famous and not so famous from many distant parts. He was considered a latter/day Donatello and his husky and handsome figure was universally recognized as he took his daily walk ac/ companied by his greyhound Arno, named after the river flowing through the city he made his home. Greenough's place in art is assured, however, less by the sculptures that his contemporaries so admired, than by the extraordinary perceptions expressed in his essays on the arts, written with masculine directness in a sinewy style, and containing ideas which far transcend the limitations of his epoch. With his keenness and creative intelligence, one wonders what he might have accom/ plished had his life not been suddenly cut off at forty/seven.

Greenough's other famous contemporary, Thomas Crawford (1814–57), died at an even earlier age. After learning something of the handling of stone and wood from Frazee, he went to Rome. There he, too, carried out commissions for the government, among them the colossal mourning *Indian Warrior* now in the New/York Historical Society, for which, somehow, a place was never found in Washington; a pair of bronze doors to the Senate Wing of the Capitol; and, crowning the Capitol dome, the colossal figure of *Armed Freedom*, whose silhouette Oliver Larkin, in his excellent book, *Art and Life in America*, amusingly compares to that of a pregnant squaw. A far more successful work, Crawford's equestrian *Washington* reached its destination in Richmond, Virginia, the same

day as the news of his untimely death in London. Much admired in its day, it is a respectable example of its type, though it lacks the spirit of the awkward but vital *Andrew Jackson* for Lafayette Square in Washington, D.C., the work of a self-trained sculptor named Clark Mills (1810–83), and the first bronze equestrian statue to be wholly produced in the United States (*Ill. 103*). Another cast of Mills's work occupies the center of Jackson Square in New Orleans.

Though by way of international reputation Hiram Powers ruled supreme in the domain of sculpture until his death in 1873, he never, even in his best work, approached the vigorous expression of Clark Mills and other sculptors of the vernacular tradition. Mills's *Jackson* shows Old Hickory on a rearing horse, a feat rarely attempted by the greatest of sculptors in the entire history of art. Mills not only designed the figure, but cast it himself, no mean accomplishment for a young man who, an orphan, had lived on his own from the age of thirteen, and had had little formal or technical education. A similar liveliness informs others of the artists who shared Mills's lack of academic and European experience.

The same vitality appears in the extraordinary primitive portrait, executed in wood in about 1840, by someone perhaps named Corbin, of the famous minister *Henry Ward Beecher* (*Ill. 105*), whose rapturous upward gaze suggests something of the effect on his hearers of his far-famed eloquence as a preacher. The same vigor is a common quality too of the birds and animals (*Ill. 104*) carved and painted by a morose old wanderer of German

106 DAVID GILMOUR BLYTHE
(1815–65) *Lafayette, 1847. Painted
poplar wood, h. 9' (275). Fayette
County Court House, Uniontown,
Pennsylvania*

descent in the beautiful Cumberland Valley area of
Pennsylvania, Wilhelm Schimmel (1817–90), who died
penniless in an almshouse in Carlisle. But there was
scarcely a tavern, house, or restaurant throughout the
area which did not possess at least one of his birds, lions,
roosters, squirrels, or other animals, whittled with a
jack-knife from pine and painted, and traded by him
for a night's lodging, a meal, or a drink of whiskey.

There were craftsmen who continued the shipcarving
tradition to which William Rush had so generously
contributed. Though not his equal, John H. Bellamy
(1824–1914), the last of the shipcarvers, deserves
recognition for having created a distinctive type of eagle
simplified into an almost abstract symbol that has since
been known by his name. With a wingspread of more
than 18 feet, the most spectacular example (Newport
News) was carved in 1875 at the Navy Yard in Ports-
mouth, New Hampshire, as the figurehead of the U.S.S.
Lancaster, for many years flagship of the Pacific fleet. The
ubiquitous cigar-store Indian and other such shop signs,
so common in 19th-century America, and the elaborately
carved and colored circus wagons and carousels, seem
mostly to have been produced by but a handful of shops,
staffed later in the century largely by imported German
and Swiss craftsmen.

One of the most impressive examples of folk sculpture
is the work of a cantankerous individualist far better
known as the painter of some of the earliest pictures of
social and political satire, David Gilmour Blythe (1815–
65). Born on a frontier farm in Ohio, he was apprenticed
to a Pittsburgh woodcarver, worked briefly in Baltimore
as a shipcarver, and did a stint in the Navy before return-
ing to the Pittsburgh area where he traveled about as a
jack-of-all-trades. The early death of his wife left him
with a bitterness which is reflected in such paintings as
Art Versus Law (*c.* 1860, Brooklyn), showing an
impoverished artist, a self-portrait, locked out of his
studio because he could not pay the rent. Yet there is
nothing but compassion in his painting of *Libby Prison*
(*c.* 1863–4, *Ill. 107*), the notorious Confederate military
compound where so many captured Union soldiers died.
By the use of words, signs, and gestures, devices taken
from his painted political cartoons, Blythe made his
picture a moving statement of deeply felt humanitarianism.
His only known sculpture is the 9-foot-tall figure of

Lafayette (*Ill. 106*), carved in 1847 out of a block made of poplar planks spiked together, for the top of the dome of the Fayette County Court House in Uniontown, Pennsylvania. Based, according to tradition, on the sculptor's boyhood remembrance of the General's appearance during his triumphal tour of the United States in 1824–5, it is boldly simplified in form, as is appropriate to the high site for which it was designed, and it has the great seriousness and dignity befitting the representation of an ancient hero who had already become a subject of legend and the symbol of a bygone age.

The greatest body of sculpture of the period, however, was the work of another profound individualist, William Rimmer (1816–79), who, except for the painter Thomas Eakins, was the greatest anatomist among American artists. A tragic and gifted person, because of certain mysterious circumstances of his birth he believed himself the son of the lost Dauphin of France, and suffered from extremes of poverty and misunderstanding. With tremendous determination he taught himself painting, sculpture, etching, lithography, music, and anatomy, and managed to earn a medical degree. Like Thomas Eakins later, he

107 DAVID GILMOUR BLYTHE (1815–65) *Libby Prison, c. 1863–4. Oil on canvas, 24″×36″ (61 × 91.5). Courtesy, Museum of Fine Arts, Boston, M. and M. Karolik Collection*

137

108 WILLIAM RIMMER (1816–79)
Evening, or the Fall of Day. Oil on
canvas, 3′ 4″ × 4′ 2″ (101.6 × 127).
Courtesy, Museum of Fine Arts,
Boston

109 WILLIAM RIMMER (1816–79)
Dying Centaur, 1871. Plaster, h.
about 24″ (61). Courtesy, Museum
of Fine Arts, Boston, Bequest of Miss
Caroline H. Rimmer

was a brilliant teacher of anatomy and of drawing, numbering among his students not only those destined for a medical career, but also such later outstanding artists as the painters John LaFarge and William Morris Hunt, and the sculptor Daniel Chester French.

Rimmer's paintings are strange, disturbing visions full of curious emotional and psychological overtones, like his *Flight and Pursuit* (1872, Boston). He illustrated his lectures on anatomy with swiftly drawn chalk figures in swirling masses in violent motion, with charging horse, men and winged demons. A sense of tragedy pervades his superb sketch *Evening, or the Fall of Day* (*Ill. 108*), a doomed winged figure.

Rimmer's most impressive and most tragic works are his sculptures, which anticipate Rodin in personal expressiveness. There is a heroic quality which far transcends the usual narrative content of most sculpture of the period in his *Dying Centaur* (original plaster 1871, *Ill. 109*; bronze, Metropolitan). But in his *Falling Gladiator* (Boston) of 1861 he transformed the personal suffering and tragedy of his own life into a larger expression of the nation's tragedy as it found itself suddenly plunged into the unthinkable horrors of the Civil War.

V THE CIVIL WAR TO THE TURN OF THE CENTURY

From palaces to skyscrapers

There was a continuation of revivalism in architecture after the Civil War, but with a marked difference. The necessities of war had suddenly transformed an agricultural and trading nation into an industrial one. Along with this financial revolution went a social one, as fortunes were made and the necessary labor force was enlarged by an increased flow of immigrants from famine-struck Ireland, from Italy, and from Central Europe. There was a tremendous growth in urban development, and spectacular corruption in government and in big business as the tycoons fought ruthless battles for financial domination of the railroads and industrial complexes which grew out of the production demanded by the War. The leading political cartoonist of the period, Thomas Nast (1840–1902), fearlessly exposed the rampant corruption as personified by Boss Tweed of New York, and the unholy alliance of financial greed with political chicanery.

The newly rich demanded appropriate palaces for the display of their wealth in an ostentatious fashion of which Andrew Jackson Downing would never have approved. The results were some highly picturesque and pretentious buildings which seem far more remote from today than the works of Bulfinch and Davis. Richard Morris Hunt (1827–95), the younger brother of the painter, William Morris Hunt, having been the first American to study architecture at the École des Beaux-Arts in Paris, was prepared to indulge the millionaire ego with a series of buildings of architectural extravagance, such as the French Renaissance château he designed for William Kissing Vanderbilt on Fifth Avenue in 1881. Constructed of stone imported from Caen in France, it presented a challenge which could not be long denied, for the robber barons were as competitive in all other aspects of life as in business. In Newport, Rhode Island,

he built Ogden Goelet's late Gothic château called Ochre Court seven years later. Then came Genoese palaces like The Breakers, also in Newport, in 1893, for Cornelius Vanderbilt II, the Belmonts' scarcely modest Belcourt in the manner of Henri IV; and a number of other similarly spectacular piles, several of which are preserved in Newport – though they have disappeared from Fifth Avenue – as relics of the Golden Age.

The one that outdid them all, however, is Biltmore (*Ill. 110*) in Asheville, North Carolina, a Loire Valley château whose ground plan covers nearly six acres, a cosy country retreat for George W. Vanderbilt on a site landscaped by Olmsted in the midst of the superb countryside of the Great Smokies. By the time the house was finished in 1895, its genial architect was dead, and the business of millionaire architecture was left to competent successors, prominent among them being the famous firm of McKim, Mead, and White.

In the meantime, however, more important develop‚ ments in architecture were reflected in the outstanding achievements of Henry Hobson Richardson (1838–86). Born on a Louisiana plantation, he went to Harvard where he met Henry Adams, who became a life‚long friend. He studied architecture in Paris; when his income was cut off by the Civil War, he found a job with a good French architectural firm. With this sound background he set out to practice his profession in New York. Things were not easy for a time, since most people did not see the need for an architect, but the commission to do the new Brattle Square Church on Commonwealth Avenue and Clarendon Street in Boston led to his selection in 1872 to

110 RICHARD MORRIS HUNT (1827–95) *Biltmore, Asheville, North Carolina, completed 1895*

design the far more important Trinity Church (*Ill. 111*) on Copley Square nearby. Though it has Romanesque aspects, and its success led to a short-lived Romanesque Revival, it is actually a free interpretation of a number of elements, fused into a monumental whole superbly composed for its triangular site. The Parish House, joined by arcading to the body of the church, provides balance for the rest.

The massive masonry and masculine vigor of its forms exactly express Richardson's own heroic spirit. With a team of painters, led by John LaFarge, to carry out its interior, and a team of sculptors, led by Augustus Saint-Gaudens, it was completed in about five years, a landmark in American architecture; its vitality makes McKim, Mead and White's famous Boston Public Library (*Ill. 112*), built across the Square ten years later, look timid by comparison.

Richardson's later buildings show his amazing capacity for development. Increasingly he stripped them of ornament, letting the forthright roughness of the heavy masonry he loved speak for itself. Like Bulfinch, he

111 HENRY HOBSON RICHARDSON (1838–86) Trinity Church, Boston, 1872–7, before alterations. In the distance on the right is Richardson's Brattle Square Church, 1870

141

designed all sorts of structures, houses in which he freely took advantage of the balloon frame, bridges, stores, railroad stations, public libraries, churches. His Allegheny County Courthouse and Jail (1884–7) in Pittsburgh, Pennsylvania, form an imposing composition and exploit the qualities of masonry which, at the foundation, is megalithic in scale. Knowing that he was the victim of an incurable disease, he nevertheless lived life to the full, and left a vast and varied achievement.

Of all Richardson's works, none was more important for the future than the Wholesale Store (*Ill. 113*), a warehouse he designed for Marshall Field in Chicago (1885–7). A colossal business block seven stories high, which was unfortunately torn down in 1930, this building represents the point of departure for the architecture of the future. Bearing the stamp of Richardson's powerful personality in its extreme simplicity and scale, it looks forward to the revolutionary concepts of Louis Sullivan, for whom it provided a unique inspiration, to the protean career of Frank Lloyd Wright, and to the best of the architecture of our own day. Though Richardson died before he was forty-eight, his comparatively brief career changed the course of American architecture from being largely a matter of stylistic revivals and millionaires' palaces to the living tradition, pioneered by such pre-decessors as Bulfinch and Jefferson, whose essential

character was suggested by Horatio Greenough's definition of beauty as 'the promise of function'.

It is significant that Richardson's Wholesale Store should have been built in Chicago. Despite the active practices of such famous firms as McKim, Mead, and White, and the genuine if not revolutionary quality of their more traditional designs, such as the Italianate Villard Houses (1885) on Madison Avenue in New York, behind St Patrick's Cathedral, the Boston Public Library (*Ill. 112*), with its echoes of the Library of Sainte-Geneviève in Paris by Henri Labrouste, and the grandeur of the Fifth Avenue palace housing New York's University Club (1900), architectural leadership in America was to pass to Chicago. There the skyscraper, anticipated by the late designs of Davis and the Jayne Building in Philadelphia, was born when William Le Baron Jenney (1832–1907), a New Englander trained in Paris in engineering, designed the Home Insurance Building, completed in 1885 on the south-west corner of La Salle and Adams Streets.

The skyscraper was dependent upon two entirely practical elements, the passenger elevator and steel construction. When the first practical passenger elevator was installed in the Haughwout Building in New York

113 HENRY HOBSON RICHARDSON (1838–86) *Marshall Field Whole-sale Store, Chicago, 1885–7*

143

in 1857, cast-iron construction had been in use for many years. Jenney started the Home Insurance Building with a wrought-iron skeleton until the sixth floor was reached, when new developments made it possible to use Bessemer steel from that point on. Though undis-tinguished as design, Jenney's imaginative engineering proved that, with the elevator and the steel frame, there were almost no limits to the heights to which a building might soar. His successors have been dramatically proving the point ever since. William Holabird and Martin Roche, who had worked in Jenney's office, pioneered riveted steel structure in the Tacoma Building completed in 1888 and razed in 1929, while in 1889, John Wellborn Root, trained by Renwick, architect of St Patrick's Cathedral, designed the Monadnock Building (*Ill. 114*), fortunately still standing, whose stark, unadorned simplicity provided a classic example of the new architectural aesthetic.

In the meantime a far richer and more complex talent had appeared, the Boston-born and Paris-trained Louis Sullivan (1856–1924). Though he felt he had benefited from his European experience, he considered that the teaching he had received was essentially superficial and completely missed what he considered the one basic point in architecture, which he enunciated succinctly in the famous statement that 'form follows function', a fundamental tenet of modern architecture. In partnership with the able engineer, Dankmar Adler (1844–1900), Sullivan early showed his remarkable capacities in the Auditorium Building (*Ill. 117*) on Michigan Avenue in Chicago, also still standing. Begun in 1886, while Richardson's Wholesale Store was nearing completion nearby in the Loop, it is at once a tribute to Richardson and a demonstration of Sullivan's understanding of Richardson's contribution to architecture. Completed in 1889, the Auditorium Building not only established the firm in Chicago but also reinforced the leadership of the Chicago School.

Sullivan next tackled the skyscraper and designed several, the most impressive of which is the Guaranty Building in Buffalo (1894–5, *Ill. 119*), which completely realizes the emphatic verticality anticipated by Davis and by Johnson and Walters in the Jayne Building. It also shows Sullivan's personal style in decoration and its or-ganic relation to the overall design concept. He believed

115 World's Columbian Exposition, Chicago, 1893. Oil by L. E. Hickmott. Courtesy Chicago Historical Society

116 THOMAS COLE (1801–48) *The Architect's Dream, 1840. Oil on canvas, 4′6″ × 7′ (138 × 214). The Toledo Museum of Art, Toledo, Ohio, Gift of Florence Scott Libbey*

117 ADLER AND SULLIVAN *Audi-torium Building, Chicago, 1886-9*

118 LOUIS H. SULLIVAN (1856-1924) *Corner of the Carson, Pirie, Scott store, Chicago, 1899-1904*

that 'ornament is a mental luxury, not a necessity', and went on to prove it with perhaps his finest work, the Schlesinger and Meyer Department Store (*Ill. 118*) in Chicago (now Carson, Pirie, Scott & Company), designed in 1899 and completed in 1904. The cast-iron panels of rich decoration of the lower two stories merely serve to emphasize the austerity and purist geometry of the whole, a remarkable anticipation of the direction architecture was to take in later years.

In spite of the leadership in architecture established by Sullivan and Adler and other Chicago firms, when the World's Columbian Exposition was launched in 1893, Richard Morris Hunt and McKim, Mead and White were put in charge. The result was the Great White City (*Ill. 115*), a vast panorama of columnar vistas like the realization of that vision of the future painted by Thomas Cole in *The Architect's Dream* (*Ill. 116*) 53 years earlier. It was a triumph of eclecticism and conservatism, a colossal, impermanent pageant of the familiar past presented as a vision of the future. Its tremendous perspectives, colossal statues by Augustus Saint-Gaudens, Daniel Chester French, and others, and the involvement of an army of painters, including both the great and the now properly forgotten, its lath-and-plaster splendors aping the im-mortality of marble, especially when illuminated at night with innumerable electric lights, made it, for the public in general, the Magic City. Unfortunately, for the United

119 ADLER AND SULLIVAN *Guaranty (now Prudential) Building, Buffalo, New York, 1894–5*

States government it provided a model which Washington has followed slavishly ever since, for our official architec/ ture and monumental sculpture still remain in the death/like grip of an outworn classicism.

But there were redeeming features. The grand plan by Frederick Law Olmsted and his able assistant, Henry Sargent Codman, turned empty acres of lake/shore frontage into a series of lagoons, waterways, avenues, groves, and areas of green. As a result of the Exposition, Daniel Burnham was able to launch the much/needed grand plan for Chicago's own development, and because of it he and McKim were able to revive L'Enfant's long/ neglected plan for Washington. Otherwise, except for two individual structures, the Great White City was an exercise in nostalgia, an anachronism.

The two exceptions were the Fisheries Building in Richardsonian Romanesque by the Chicago architect Henry Ives Cobb, and Sullivan's own Transportation Building, whose round/arched façade, enlivened with orange, red, yellow, and gold, stood out like a shout of Hallelujah at a Quaker meeting. But its voice, which sounded so raucous amidst the genteel classicism, was the voice of individualism and of the future. And a young man then working in Sullivan's office, Frank Lloyd Wright, was to have a great deal to say and even more to do with the directions architecture would take.

Expatriates and independents

The political corruption and grubby materialism of the post/war years, combined with the social and financial revolution, had a profound influence on the arts. Many of the new rich, insecure in their tastes and seeking the status to bolster their newly acquired social eminence, spent large sums on the works of the old masters or of the latest winners of gold medals in the French *salons*, neglecting alike the artists of their own land and those Europeans like Manet, Courbet, and others, whose works, exhibited in the *Salon des Refusés*, showed by contrast the depths to which official art had sunk. No longer, as in the days of Cole, Kensett, Bierstadt, and Church, were American artists generally respected and collected. No longer did they seem to speak the same language and share the same ideals as their fellow citizens.

120 JAMES ABBOTT MCNEILL WHISTLER (1834–1903) *Nocturne in Black and Gold – The Falling Rocket, c. 1874. Oil on panel, 23¾″ × 18⅜″ (60.3 × 46.6). Courtesy, The Detroit Institute of Arts*

The result was to drive many, like the painters James Abbott McNeill Whistler and Mary Cassatt and the novelist Henry James, to seek the more sympathetic artistic climate of Europe. Some, like Albert Pinkham Ryder, George Inness, and Ralph Albert Blakelock, turned inward to the resources of the private life of the imagination and the expression of a more personal vision. Others, like Winslow Homer and Thomas Eakins, remained aloof and concentrated on the timeless aspects of man and of nature in America.

Since it was a period during which European art was not only more respected but also more collected than American art, young Americans, aspiring for a career in the arts, turned increasingly to study in Europe as essential to success. They flooded the art schools of Munich and especially the crowded studios of the leading French masters, hoping there to learn the secrets of success.

Whistler (1834–1903) was a natural expatriate. Born in the New England mill town of Lowell, Massachusetts, a fact he preferred to forget, he was brought up largely in Europe because his father was a successful engineer whose accomplishments included planning the railroad from Moscow to St Petersburg. The young Whistler studied art in the latter city and then was entered in West Point, as unlikely a candidate for the United States Army as one could imagine, being spoiled, imaginative, sophisticated, and absolutely immune to discipline. After being expelled in 1854, he put in a year's stint as a draftsman with the Coast and Geodetic Survey. Then, obviously feeling he had paid his due to bourgeois respectability, he went to Paris and settled gratefully into the bohemian life of the Left Bank. He studied in the then-famous atelier of Charles Gleyre, made friends with such outstanding artists as the leading realist Gustave Courbet, and found a lively young milliner, nicknamed La Tigresse, to pose for and to live with him.

In 1860, when one of his pictures was accepted for exhibition by the Royal Academy in London, he settled there to become a picturesque feature of artist life in the Chelsea district and win fame as a wit and dandy at the same time that he was seriously pursuing his artistic career.

One of the first to discover the aesthetic qualities of Japanese prints, he developed under their influence an apparently informal type of composition which is actually

carefully studied. Like Allston, he believed that, 'As music is the poetry of sound, so painting is the poetry of sight, and the subject matter has nothing to do with the harmony of sound or of color.' Yet he was too much of an American in his basic attitudes totally to disregard the subject. Well aware of the revolutionary developments going on in French painting, he evolved his own personal style – like Allston's, evocative rather than explicit – which he applied equally to portraits such as that of his mother, which he titled *Arrangement in Gray and Black, No. 1* (1871, Louvre), and to the remarkable series of paintings he called *Nocturnes*, which include the studies of the Thames and Battersea Bridge, and an essay into the almost non-objective, his *Nocturne in Black and Gold – The Falling Rocket (c. 1874, Ill. 120)*.

Mary Cassatt (1844–1926) was another natural expatriate, having from her early years spent a great deal of time abroad with her wealthy Philadelphia family. In 1868 she settled in Paris to become an accepted member of the art community which included her friend Degas and a number of leading Impressionists. Though un-doubtedly influenced by Impressionism, and especially by the work of Manet, she developed a style of her own. She was at her best in the sensitive figure pieces, often on the theme of the mother and child, like *The Bath (Ill. 122)* of about 1891–2, and *The Loge* (Metropolitan).

John Singer Sargent (1856–1925) was less an expatriate than an international figure, as much at home in London and Paris as in Boston and New York. The leading portrait painter of his period, he was as prolific and as facile as his predecessor in the field, G. P. A. Healy, though far more capable, and, at his best, an artist of power. Like Winslow Homer, he used watercolor as a major means of expression, painting with a controlled freedom and verve which have scarcely been equaled. His dashing sketches in oil – especially Alpine views and Venetian scenes – have a pervasive mood. His mastery of the society portrait and his ability to raise it to the higher realm of serious art is shown by his delightful portraits of the famous Isabella Stewart (Mrs John L.) Gardner *(Ill. 121)*, who made an outstanding and very personal museum of the Venetian palace she built on Boston's Fenway to house her remarkable collection formed with the advice of the scholar Bernard Berenson. Particularly attractive also is Sargent's *Portrait of Mr and Mrs I. N.*

121 JOHN SINGER SARGENT (1856–1925) *Mrs John L. Gardner, 1888. Oil on canvas, 6' 1¾" × 2' 7½" (187 × 80). Isabella Stewart Gard-ner Museum, Boston*

122 MARY CASSATT (1844–1926)
*The Bath, c. 1891–2. Oil on canvas,
39½" × 26" (100.3 × 66.1). Cour-
tesy of the Art Institute of Chicago,
Robert A. Waller Collection*

Phelps Stokes (1897, *Ill. 123*), apparently caught in a
momentary pose, with a resulting effect of immediacy and
freshness, though it was actually the result of long study
and subtle composition.

George Inness (1825–94) was a direct inheritor of the
traditions of the Hudson River School, yet he gradually
changed from the traditional objective realism of that
school to a subjective expression, vague and poeticized,
in which form is dissolved into glowing, light-suffused
atmosphere with results recalling Allston's landscapes of
mood, though they are achieved in an entirely different
manner. Two large canvases in the Metropolitan
Museum, *Peace and Plenty* and *The Delaware Valley* (both
1865) attest the success of his combination of Cole's
panoramic conception with the more personal emotion-

123 JOHN SINGER SAR-
GENT (1856–1925) *Mr
and Mrs Isaac Newton
Phelps Stokes, 1897. Oil
on canvas, 7′¼″ × 3′3¾″
(214 × 101). The Metro-
politan Museum of Art,
New York, Bequest of Edith
Minturn Stokes, 1938*

124 GEORGE INNESS (1825–94) *The Monk, 1873. Oil on canvas, 3'3½" × 5'4" (100 × 163). Addison Gallery of American Art, Phillips Academy, Andover, Massachusetts*

alism achieved through broad brushwork and glowing afternoon light. Perhaps Inness' finest work, however, is *The Monk (Ill. 124)*, painted in Italy in 1873, its sense of mystery and silence conveyed by the contrast of the towering stone pines, silhouetted against a twilit sky, and the tiny figure of the white-habited monk, standing, deep in meditation, in the shadows below.

Like Inness, Ralph Albert Blakelock (1847–1919) was largely self-taught. His deeply subjective landscapes, mostly in evening dimness, though sometimes moonlit, often include an Indian encampment with tepees and the dull glow of campfires, reminiscences of an early trip West, which appear again and again *(Ill. 125)*. His work was instinctive, inner-directed, based on his study of weathered textures of rocks and tree bark and his mystical feeling for nature. The advantage taken by unscrupulous dealers and collectors, who forced him to sell his pictures for paltry sums, driven as he was by the necessity to support his growing family, finally drove him insane. Meanwhile the genuine appreciation of his work led to his election to the American Academy at a time when he no longer could have had any awareness of the honor, and the sale of his pictures at increasingly high prices was of no aid to his destitute family. When a talented daughter turned to painting to try to help, and discovered that a dishonest dealer was forging her

father's signature on her works, she too lapsed into a depth of melancholy from which she never recovered. Blakelock's life is one of the most tragic in American art, yet his paintings show never a touch of the pressures and torments he suffered, but remain visions of a world more ideal and peaceful than he himself could ever have known.

Of all the American painters of vision and dream, the greatest was Albert Pinkham Ryder (1847–1917). The son of a seafaring family in New Bedford, he was a shy, genial, husky man, who developed a personal manner to express the images which crowded his mind. He was inspired by the poetry of Chaucer, Tennyson, Byron, Poe, Scott, Coleridge, and others, Wagner's operas, and other music. But he transmuted everything into personal symbols which have a mood and flavor all his own. Neither narrative nor illustrative, his pictures are evocative expressions of trance-like states, and have the strangeness of a world of dream. He painted in a cluttered room in downtown New York, with his back to the window, listening to the wind in the branches of a gigantic maple in the backyard. He worked slowly and carefully at his small canvases or panels, sometimes for many months, until images gradually began to emerge and take their place in an evolving composition.

Ryder described his approach to art to a friend. 'Have you ever seen an inchworm crawl up a leaf or a twig, and then, clinging to the very end, revolve in the air, feeling

125 RALPH ALBERT BLAKELOCK (1847–1919) *Moonlight, Indian Encampment, c. 1889. Oil on canvas, 26½" × 33¾" (67.3 × 85.8). Courtesy of National Collection of Fine Arts, Smithsonian Institution, Washington, D.C.*

126 ALBERT PINKHAM RYDER (1847–1917) *The Race Track, or Death on a Pale Horse, c. 1890–1910. Oil on canvas, 28¼" × 35¼" (71.6 × 89.4). The Cleveland Museum of Art, Purchase from the J. H. Wade Fund*

for something to reach something? That's like me. I am trying to find something out there beyond the place on which I have a footing.' He undoubtedly succeeded in such compelling visions as *The Race Track* (*c.* 1890–1910, *Ill. 126*), with the skeletal figure of death, bearing a scythe, madly galloping around a race course. Yet he could create the idyllic poetry of midsummer moonlight in *The Forest of Arden* (1897, Matropolitan) and the drama of *Macbeth and the Witches* (1890–1908, Phillips Collection). His most memorable works are his sea-pieces. For him, as for Melville and Whitman, the sea is eternity, forever changing, yet forever the same – whether storm-tossed or calm – endless and timeless. Like Cole he seems to have thought of life as a voyage, and conveys the idea in his moonlit paintings of solitary boats sailing alone across the emptiness of the ocean. *Homeward Bound*

127 ALBERT PINKHAM RYDER (1847–1917) *Toilers of the Sea, c. 1884. Oil on wood, 11½″ × 12″ (29.2 × 30.5). The Metropolitan Museum of Art, New York, George A. Hearn Fund, 1915*

(1893–4, Phillips Collection) and *Toilers of the Sea* (c. 1884, *Ill. 127*) are unforgettable visions.

Ryder was one of the three larger-than-life figures who brought American painting to a climax in the later years of the 19th century and the early part of the 20th. The others were the New Englander, Winslow Homer (1836–1910), and Thomas Eakins (1844–1916) of Philadelphia.

Like so many other artists in America, Homer was apprenticed to a printmaker, the Boston lithographer, John H. Bufford, for whom such diverse talents as A. J. Davis and Fitz Hugh Lane had also worked. He hated the job as the dreariest of drudgery, and swore he would never again tie himself down, so at twenty-one he became a free-lance illustrator for such popular periodicals as *Ballou's Pictorial*. Success led him to New York and work with the leading publication of its kind, *Harper's Weekly*. At the outbreak of the Civil War he accompanied the Union army, sending back many visual reports to *Harper's*, who were so pleased with his work that they offered him a full-time job. He also painted two oils of wartime subjects which he exhibited in New York. If they sold, he decided he would keep on working as a free-lance; if not, he would take the *Harper's* job. His

128 WINSLOW HOMER (1836–1910) *Early Morning after a Storm at Sea, 1902. Oil on canvas, 2' 6¼" × 4' 2" (76.7 × 127). The Cleveland Museum of Art, Gift from J. H. Wade*

157

129 WINSLOW HOMER (1836–1910) *The Country School, 1871. Oil on canvas, 21⅜" × 38⅜" (54.2 × 97.4). The St. Louis Art Museum*

older brother Charles bought the paintings secretly, a fact that Winslow did not discover until years later when he had become an undoubted success. Just the same, he was so incensed that he refused to speak to Charles for weeks.

Another oil of a wartime subject, *Prisoners from the Front* (Metropolitan), dated 1866, attracted widespread attention when it was shown first at the National Academy in that year and then at the Paris Exposition, where its directness of observation and statement impressed European critics. Like all his wartime subjects, it contained no bloodshed, but instead the confrontation of the earnest young Union officer with the ragged but defiant Confederate in a significant psychological contrast.

He went to Europe briefly and traveled much in America, in New England, Virginia, the Adirondacks, and the Bahamas. His watercolors became increasingly masterly, unsentimental visions of farm and shore life, swiftly and largely painted, full of light and atmosphere. In such oils as *The Country School* (1871, *Ill. 129*) and such watercolors as *The Berry Pickers* (1873, Colby), he reached the greatest heights of genre painting. And in his Adirondack and Atlantic coast subjects he found the material for his mature expression. After two summers at the English seaport of Tynemouth in the early 1880s, where he drew and painted the fishermen, their wives and

daughters, and the North Sea coast, he moved to Prout's Neck in Maine. There, among his fishermen neighbors, with the ever-present sound of the surf on the rocks and the crying of the gulls, he began the series of epic sea-pieces which are the culmination of his art.

Homer's essential theme is that which appeared in Copley's painting of *Watson and the Shark*, recurs in Cooper's *Leatherstocking Tales*, in Melville's epic novel *Moby Dick*, in Allston's *Rising of a Thunderstorm at Sea*, Dana's account of his *Two Years before the Mast*, and in the paintings of Thomas Cole, Fitz Hugh Lane, Martin J. Heade, and others. It is the theme of man and nature, of the individual as alone as he can be only when in the midst of the vastness of the New World or the limitless expanse of the empty ocean.

Homer developed the theme with increasing power in such watercolors as *The Adirondack Guide* (1894, *Boston*) and *Adirondacks* (1892, Harvard), and in such oils as *The Fog Warning* (1885, Boston), with a solitary doryman on the Grand Banks rowing toward a schooner which appears hull-down against a horizon obscured by the rising fog. *The Lookout – 'All's Well'* (1896, *Ill. 130*) gives a momentary glimpse of a heroic sou'wester-clad figure on a heaving deck beneath a moonlit sky.

In the later paintings the figures tend to become smaller, as in *Winter Coast* (1890, Philadelphia), a view from the window of the artist's studio. Finally they disappear altogether, as in *Early Morning after a Storm at Sea* (1902, *Ill. 128*), to remain only in terms of the painter's unseen presence and that of the viewer of the picture who thus becomes a part of it. Yet the essential theme remains, a New World theme which has continued in American art into our own times with the paintings of Marsden Hartley, Morris Graves, Andrew Wyeth, and others. Never has it received a more heroic expression than in the late works of Homer, conceived with the awareness of his pioneer ancestors and his fishermen friends of the change of the seasons, the set of the tide, and the shift of the wind.

Thomas Eakins (1844–1916) of Philadelphia was another painter whose work, like Homer's, was matured in solitude, and is the expression also of a profound individualism. Unlike Homer, whose paintings he greatly admired, he studied abroad, spending much time in Paris in the studio of Jean-Léon Gérôme who was

130 WINSLOW HOMER (1836–1910) *The Lookout – 'All's Well'*, 1896. *Oil on canvas, 40″ × 30¼″ (101.6 × 76.9). Courtesy, Museum of Fine Arts, Boston, William Wilkins Warren Fund*

131 THOMAS EAKINS (1844–1916)
Max Schmitt in a Single Scull, 1871.
Oil on canvas, 32¼″ × 46¼″ (81.8 ×
117). The Metropolitan Museum of
Art, New York, Alfred N. Punnett
Fund and Gift of George D. Pratt

generally considered the greatest living French artist because of the minuteness of his detail. Eakins got a thorough training in academic draftsmanship with Gérôme but could not have been less interested in the triviality of his subjects; instead he preferred, as did Sargent, the bigness and boldness of expression of the Spanish masters, expecially Ribera and Velázquez, with their rich contrasts of light and shade, 'so strong, so reasonable, so free from every affectation,' he wrote. Eakins returned to America to use the controlled naturalism of drawing learned from Gérôme, not for that artist's photographic illusionism, but in a relentless search for truth in paintings composed with grand simplicity and breadth, and unified by a subtle control of light – the 'big tool', he called it – learned from 'the good Spanish work'.

He studied anatomy at the Jefferson Medical College and practiced dissection, which he disliked but considered essential to an understanding of the human figure, until he became the only American artist to rival Rimmer in this field. 'Distortion is ugliness,' he declared, and based his idea of beauty, which, like Greenough, he equated with truth, on function. Since most portrait

subjects wish to be flattered, few could face the searching and objective analysis, however sympathetic, which he considered the means to a representation of personality, of both outward appearance and inner life, as in the likeness of his friend, the poet Walt Whitman (1887, *Ill. 132*).

Like Homer, Eakins loved the outdoors, and painted many sculling and sailing scenes, like *Max Schmitt in a Single Scull (Ill. 131)*, and of sporting events such as boxing and wrestling. He painted portraits of his family and friends, many of whom were faculty members of the Medical College, for which in 1876 he undertook one of the two most important paintings of his career, *The Gross Clinic (Ill. 133)*. In it he combined his interest in science with his ideal in art to create a monumental picture, complex in composition, rich in expressive detail, and dramatically orchestrated by light and shade. The concentration and seriousness of the heroic figure of Dr Gross, scalpel in hand, the center of attention of the medical students present in the operating theatre, is

132 THOMAS EAKINS (1844–1916) *Walt Whitman, 1887. Oil on canvas, 30" × 24" (76.2 × 61). Courtesy of The Pennsylvania Academy of the Fine Arts, Philadelphia, General Fund Purchase, 1917*

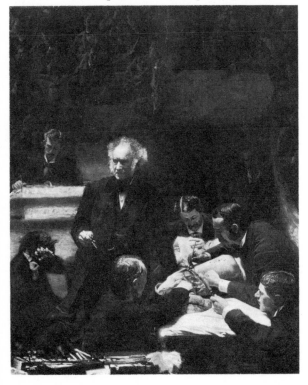

133 THOMAS EAKINS (1844–1916) *The Gross Clinic, 1875. Oil on canvas, 8' ¼" × 6' 6⅝" (244 × 200). Courtesy of The Jefferson Medical College, Thomas Jefferson University, Philadelphia*

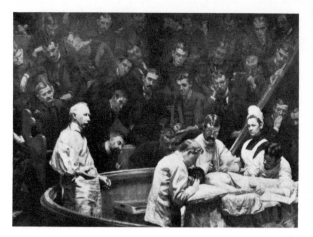

134 THOMAS EAKINS *The Agnew Clinic, 1898. Oil on canvas, 6′ 2½″ × 10′ 10½″ (189 × 331). University of Pennsylvania, School of Medicine*

contrasted with the gesture of horror of the patient's mother as she throws up one arm to cut off from view the incision being made in the patient's leg. Because of the blood on the scalpel and exuding from the incision, Eakins was called a butcher rather than a painter, and the picture was reluctantly included in the medical section of the Centennial Exposition of 1876, rather than among works of art.

The Agnew Clinic, completed almost a quarter-century later (1898, *Ill. 134*), is Eakins' only other work to equal *The Gross Clinic* in scale and complexity. It not only suggests the change in Eakins' own attitude but also the developments in medicine which had taken place in the intervening years. The white, sterile robes, unknown when the earlier picture was painted, produce a lighter tone, but instead of the surgeon being the sole center of attention, as in *The Gross Clinic*, the intense figure of Dr Agnew on the left is balanced with the group surrounding the patient on the right in a more open and horizontal arrangement. The atmosphere is still one of great concentration, but it no longer has the drama of the earlier painting.

Eakins was one of the great teachers in the history of American art. Sparing of praise, he never gave negative criticism, and communicated to his pupils his respect for their individuality and his high standards. His own uncompromising integrity met officialdom head-on when he insisted on the use of a nude male model in his drawing classes for women at the Pennsylvania Academy,

and, after ten years of teaching, he was forced by the board to resign. Almost every one of his students petitioned for his reinstatement, and many left the Academy to found the Philadelphia Art Students League where he con-tinued to teach for several more years. Later he taught in New York at the National Academy of Design, always with the advice to 'peer deeper into the heart of American life', the ultimate source of his own achievement.

At the turn of the century, the most widely accepted American painting was represented by the so-called American Impressionists, foremost among them being John H. Twachtman (1853–1902) and Childe Hassam (1859–1935). But in their basic interest in subject rather than primarily in visual effects – the purpose of the true Impressionist – they are rather heirs to the tradition of Luminism established by such painters as Lane, Kensett, and Gifford. Like Mary Cassatt, they were influenced by that movement toward a lighter palette, toward less apparently formal compositions, and in breadth and manner of brushwork (Ill. 135). But, like her, and like Homer, Eakins, and Whistler, they clung stubbornly to the concept of objective reality as the primary emphasis in painting.

Insistence on reality reached a climax in the work of a group of still-life painters of the later part of the 19th century, outstanding among whom was William M. Harnett (1848–92). These artists continued the tradition established by the Peales, especially James and Raphaelle, who had experimented with the kind of fool-the-eye painting that is called *trompe-l'œil*, from the beginning of the 19th century. Harnett painted carefully composed canvases with a life-like representation of everyday objects. Several years in Europe after study at the Pennsylvania Academy in Philadelphia and the National Academy in New York perfected his technique. After his return to America in 1886, he produced a number of paintings, often large, which carry illusionism to a new degree of realization. In works such as *After the Hunt* (1885, Ill. 136) and *Old Models* (1892, Boston), familiar objects are painted with devoted attention to every distinction of texture and sign of wear, as seen in a softly diffused and gentle illumination. Other painters of the end of the 19th century and the beginning of the 20th shared a similar purpose in forcing still-life to the very limits of painting until the simulated objects not only suggest the

135 CHILDE HASSAM (1859–1935) *Allies Day, May 1917.* Oil on canvas, 36¾″ × 30¼″ (93.2 × 76.7). National Gallery of Art, Washington, D.C., Gift of Ethelyn McKinney in memory of her brother, Glenn Ford McKinney

136 WILLIAM M. HARNETT (1848–92) *After the Hunt, 1885.* Oil on canvas, 5′ 11″ × 4′ (181 × 122). California Palace of the Legion of Honor, San Francisco, Mildred Anna Williams Collection

nostalgia of the commonplace but take on a curious life of their own.

Therefore the century ends with the greatest achieve ments of Homer, Eakins, and Ryder going comparatively unnoticed, with Whistler and Cassatt winning accepted positions in the art world of Europe, and with Harnett's emphatic expression of Americans' proclivities toward realism. The directions in which American art had grown and was further to grow were clear, including the inward looking, imaginative fantasy of Ryder, Inness, and Blakelock, Homer's epic naturalism, Eakins' relentlessly objective though sympathetic and controlled analysis, and the extremes of realization of Harnett and the other painters of trompe-l'œil. Yet the generally accepted and critically acclaimed school of American painting was that of the group called American Impressionists, while the painters whose work was most collected and exhibited were either the old masters or the latest winners of awards in the Salons, the great official exhibits of Europe.

The times were out of joint with the arts. Paris had already seen the Salon des Refusés, made up of works, unacceptable to the academic juries which chose the official show, of the men that later generations were to acclaim as the greatest of their times. In America as in Europe, something was bound to happen, and it did. In the first two decades of the 20th century came a revolution in the arts foretold as early as 1877, when Ryder, whose paintings were regularly refused exhibition in the shows of the National Academy, stated that 'modern art must strike out from the old and assert its individual right to live.'

The real, the ideal, and the classical tradition

The most powerful American sculptor of the 19th century was unquestionably William Rimmer (1816–79), whose Dying Centaur (Ill. 109), one of his last and most impressive works, was done in 1871 and thus falls within the post-war period. The most productive part of Rimmer's career came before the war, however, so that his work has been considered in an earlier chapter. A younger, and much longer-lived contemporary became the most popular sculptor of the post-war period, the Salem-born Yankee, John Rogers (1829–1904).

As the creator of three-dimensional equivalents of the works of such genre painters as Mount and Bingham, Rogers made a name for himself, and a tidy fortune. He turned out casts of small narrative group subjects taken from the writings of Irving and Cooper, from contemporary theatre – he modeled the famous actor, Joseph Jefferson, in such successful roles as Rip van Winkle – and from American history. His *Fugitive's Story* (*Ill. 137*) and other anti-slavery groups were almost as powerful contributions to the abolitionist cause as Harriet Beecher Stowe's *Uncle Tom's Cabin.*

Trained as a mechanical draftsman, Rogers studied in Europe just long enough to reach the canny decision that the frigid confections of Neo-classicism were neither for him nor for Americans in general, who, he believed, shared his interest in narrative and in human situation. He assembled a team of expert workmen who made plaster casts of the small groups he sculptured with great care and detail. He mailed circulars both in America and abroad, pricing his pieces at from $6 to $25, because he wanted them to be available to everyone. Between 1860 and 1890 he sold about 100,000 of them. His work was universally admired, and he was elected a member of the National Academy. Despite the violent shifts in styles and esthetic values which separate his era from our own, there are still those who share his point of view because his sculptures are still collected.

Realism, however interpreted, dominated the arts of the 19th century, as had been the case consistently until our own era. The tendency was especially strong in sculpture, though frequently tempered by idealism, and, in the case of Rogers, by sentimentalism. This was true of the works of the two men considered the leading sculptors of the period, Augustus Saint-Gaudens (1848–1907) and Daniel Chester French (1850–1931). It was not true, however, of the older man with whom French studied briefly, John Quincy Adams Ward (1830–1910), whose sturdy naturalism was expressed in *The Indian Hunter* (1868, *Ill. 138*) in New York's Central Park, a tensely alert figure caught in momentary pose and having the impact of immediate observation, and in the convincing calmness of command in his bronze *Washington* (1883), which stands in front of the columnar façade of the Sub-Treasury Building, designed by Ithiel Town and A. J. Davis, in downtown New York.

137 JOHN ROGERS (1829–1904) *The Fugitive's Story, 1869. Bronze, h. 22" (55.9). Courtesy, The New York Historical Society, New York City*

138 JOHN QUINCY ADAMS WARD (1830–1910) *The Indian Hunter, 1868. Bronze. Central Park, New York*

Ward had never studied or traveled abroad. Born, like the painter Whittredge, on an Ohio farm, he received his entire training in the United States as a pupil of a minor sculptor, Henry Kirke Brown (1814–86), in Brooklyn, New York. Saint-Gaudens, on the other hand, had not only studied at Cooper Union and the National Academy of Design in New York, and then at the École des Beaux-Arts in Paris, but also in Rome and Florence. His work reflects the suavity of his international training, yet at best, as in his admirable *Farragut Monument* (1881, *Ill. 140*) in Madison Square, New York, it remains masculine and direct. His standing *Lincoln* (1887) in Chicago is a tribute not only to a man but to a legend. The *Sherman Monument* (1892–1903), installed just after the turn of the century at Fifty-Ninth Street and Fifth Avenue in New York, was not finished until ten years of work had been invested in it to make it his most famous single achievement.

Daniel Chester French had had the benefit of only a few lessons with Ward in New York and a brief study of anatomy with Rimmer in Boston, yet he won immediate fame at twenty-five, with his *Minute Man* (1875) at Concord, Massachusetts, which had great popular appeal, though it lacks the firm naturalism of Ward and Saint-Gaudens. His was a career which carried him far into the 20th century, and was climaxed by his brooding figure of the seated *Lincoln* (*Ill. 139*) in Georgia marble, commissioned in 1915, enlarged to its final colossal dimension by the Piccirilli brothers (expert pointers and marble cutters, who were responsible for the final form of much of the monumental sculpture of the period), and housed in Henry Bacon's classical shrine at one end of Washington's Mall.

139 DANIEL CHESTER FRENCH (1850–1931) *Abraham Lincoln, 1915. Marble, over life-size. Lincoln Memorial, Washington, D.C.*

French and Saint-Gaudens, and the idealistic naturalism, tinged with classicism, which their work exemplifies, set an eclectic trend which has continued to this day, despite the revolutionary character of recent sculpture, in official commissions of all sorts, paralleling the deadly course of official architecture.

There were, however, a few who continued the more basic realism of Ward and thus produced work of more vitality than most. One of the best was Frederic Remington (1861–1909), who, like the older Ward, actually went west to study the lively figures of cowboys and Indians which he sculptured and painted with such

popular success (*Ill. 141*). Remington was an illustrator of superior qualities, producing crisp pen-and-ink drawings for an edition of Longfellow's *Hiawatha*. His visual record of the Old West has greater vitality than most of the Hollywood westerns which have so distorted the realities of the final stages of frontier life.

In the meantime, a contemporary of Remington's, George Grey Barnard (1863–1938), was moving in a direction which was to prove more significant for the future. Like Saint-Gaudens, he had the advantage of European study, but pursued his own independent course. He was only twenty-one when he started work on his colossal *Struggle of the Two Natures of Man* (completed in 1893, *Ill. 142*), two heroic figures cut from a single block of marble. This was at a time when not even Rodin had begun working on such a scale and there was scarcely a sculptor alive, European or American, who was able to undertake such a task, so used were they to leaving the enlargement and completion of their works to professionals especially trained for the purpose. In its expression of inner conflict and emphasis on the emo-tional, it recalls the works of Rimmer and anticipates much of the content and mood of later sculpture, though its naturalistic style was soon to be entirely abandoned.

142 GEORGE GREY BARNARD (1863–1938) *Struggle of the Two Natures of Man, 1893. Marble, h. 8′ 5½″ (258). The Metropolitan Museum of Art, New York, Gift of Alfred Corning Clark, 1896*

Though Barnard continued the strain of naturalism of Saint-Gaudens and French, and retained aspects of the uncompromising realism of Ward, he was inspired toward an inward-looking art by his enthusiasm, shared with Rodin, for sculpture of the Middle Ages, which led him to assemble in his studio at the northern end of Manhattan the extraordinary collection of medieval art which became the nucleus of The Cloisters, that northern branch of the Metropolitan Museum established in 1925 under the patronage of John D. Rockefeller, Jr. in Fort Tryon Park nearby.

In sculpture as in painting, there was, then, little evidence at the turn of the century of the violent revolution in the arts, so soon to take place, that was to initiate the period of continuing rapid evolution and experiment which is modern art.

'Make no little plans'

When Louis Sullivan proclaimed that 'form follows function', the era of modern architecture had arrived. It remained for his brash and self-assured follower, Frank Lloyd Wright (1869–1959) to carry forward, in a long, stormy, and fruitful career, the ideals toward which Sullivan had striven. With a Jeffersonian belief in individualism and Whitman's faith in the common man, Wright set out to create an 'architecture for democracy'. He inherited many ideas from Sullivan, in whose office he worked and whose basic approach he shared, but he added many of his own. His concept of architecture was one of dynamic space, embodied in what he termed 'organic architecture', in which form not merely follows function, but 'form and function are one.' His stated purpose was to free people from the prison of the box, the rectilinear enclosure of traditional rooms and buildings, and he conceived his houses with free-flowing, inter-penetrating space instead of series or piles of box-like rooms.

Wright shared Downing's awareness of a sense of place, and planned his houses to hug the contours of the land, as in the low-lying, sprawling dwellings he designed, influenced in the geometrical clarity of wall and trim by his interest in the arts of Japan, in what became known as the Prairie Style, and which are ancestors of the ubiquitous ranch house. The first of these was the Winslow House (1893) in River Forest, Illinois, followed by the Willetts House (1902) in nearby Highland Park. Like A. J. Davis, Wright insisted on designing interiors as well as exteriors, and ruled his clients with an iron hand.

One of his most interesting houses was designed in 1908 for Avery Coonley in Riverside, Illinois (*Ill. 143*), the Chicago suburb laid out earlier in picturesque fashion by Olmsted according to principles initiated by Downing. Wright's finest house, however, is 'Falling Water' at

143 FRANK LLOYD WRIGHT (1869–1959) *Avery Coonley house, Riverside, Illinois, 1908*

144 FRANK LLOYD WRIGHT (1869–1959) *'Falling Water', Bear Run, Pennsylvania, 1936*

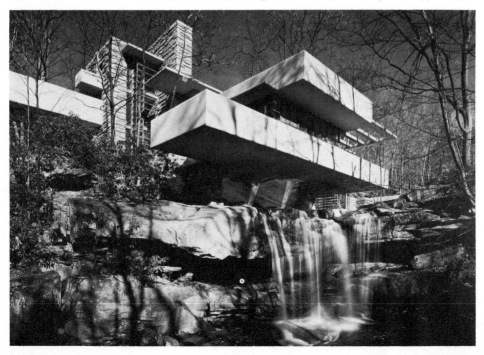

Bear Run, Pennsylvania (*Ill. 144*), built in 1936 for Edgar J. Kaufmann of Pittsburgh, now preserved as part of a public park. It ranks with his own houses, Taliesin East at Spring Green, Wisconsin, and Taliesin West in the desert near Phoenix, Arizona, though neither is as completely integrated with its site as is 'Falling Water', which seems to grow from among the massive boulders and ledges of the mountain stream which gives it its name in an impressive blending of nature and of art.

Wright's eloquence, whether from the speaker's platform on which he was a superb performer, or in his many writings, combined with his practice to attract worldwide attention to his theories. He was much studied abroad where the new architecture was emerging in forms influenced by his thinking. Yet in America others were receiving the major number of big commissions. In 1903, McKim, Mead and White used the Baths of Caracalla in Rome as the basis of their design for Pennsylvania Station in New York (completed in 1906; recently demolished), while in 1909 Cass Gilbert (1859–1934) conceived the Woolworth Building (1911–13, *Ill. 145*) in New York as a gigantic Gothic spire not to be outdone until, in 1924, Raymond Hood and John M. Howells blew up the flamboyant Gothic Butter Tower at Rouen (or, as some architectural historians would have it, the lantern of Ely Cathedral) to even more colossal size in the Tribune Building in Chicago. In the meantime Wright was designing a skyscraper for San Francisco, in the spirit of Sullivan but far surpassing him in scale and grandeur, and so uncompromising in its expression of the functional ideal that no one dared to build it.

In 1932 an exhibition at the Museum of Modern Art in New York was installed by Philip Johnson (1906–), who was to become, under the tutelage of Mies van der Rohe (1886–1969), a leading architect of our own times. It showed the achievements of European modernism, developed during the 1920s, with special emphasis on the works of Walter Gropius (1883–1969) and the Bauhaus, the school of design of which he was director, first at Weimar and then, in a glass-walled building of his own design, at Dessau; of J. J. P. Oud of Holland; of Mies van der Rohe, who had succeeded Gropius as director of the Bauhaus before it was closed by the Nazis; and of Charles-Edouard Jeanneret-Gris, known as Le Corbusier, the leading French modernist.

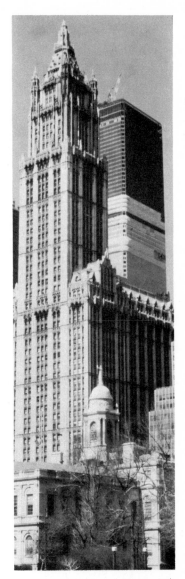

145 CASS GILBERT (1859–1934) *Woolworth Building, New York, 1911–13. Beyond it is one tower of the World Trade Center by* MINORU YAMASAKI (1912–)

171

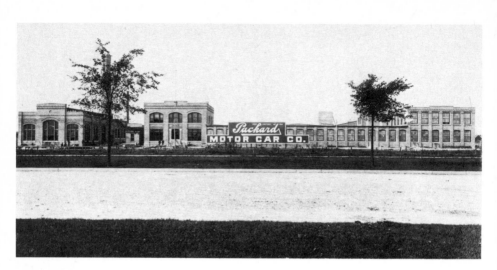

146 ALBERT KAHN (1869–1942)
Packard Motor Car Company factory,
Detroit, Michigan, 1905

In the meantime an Austrian, Richard Neutra
(1892–), had already introduced the International
Style on the West Coast. Marcel Breuer (1902–), an
associate of Gropius in Germany, became a member of the
Faculty of Design at Harvard where Gropius was Chair-
man of the Department of Architecture. The results were
an internationalization in architecture parallel to that
which occurred in other arts. American architectural
students no longer went abroad to study at the Ecole des
Beaux-Arts in Paris, but became increasingly indoc-
trinated with the Bauhaus tradition of collective design
and of working within the discipline of mechanical
production.

Wright's work, well known abroad for more than two
decades, had influenced such developments in European
modernism as the Bauhaus, but he deplored their lack of
regard for human scale and feeling, and their theoretical
purism, so at variance with his own passionate indivi-
dualism. Also of influence were such engineering
achievements as the Brooklyn Bridge and such dramati-
cally simple statements of pure function at colossal scale
as Albert Kahn's (1869–1942) factory buildings for
General Motors, Chrysler, and Ford. Kahn's generously
fenestrated Packard Motor Car Company's plant of
1905 (*Ill. 146*) was apparently the first in a succession of
reinforced concrete industrial structures in America.
Much of the anonymous quality of the pioneer European
modernists entered the stream of American architecture

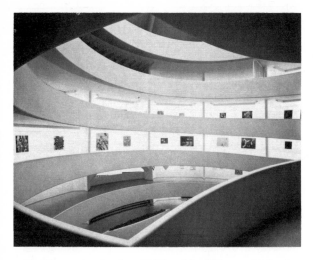

147 FRANK LLOYD WRIGHT
(1869–1959) *Interior of the Solomon
R. Guggenheim Museum, New York,
designed 1943–6, built 1956–9. Photo
by courtesy of the Solomon R. Gug-
genheim Museum*

and still persists in the cliff-faced buildings which rise,
not only in the cities of the United States, but also in
urban centers throughout the world.

In the disillusioned 1930s during the Depression,
Wright undoubtedly seemed old-fashioned to many,
with his flowing tie and Whitmanesque idealism. Yet he
went on to produce such buildings as Falling Water, the
major part of the campus of Florida Southern College,
the complex of buildings in Racine, Wisconsin, for the
Johnson Wax Company, and the much-discussed
Solomon R. Guggenheim Museum in New York, with
its dramatic interior space (*Ill. 147*).

In lending the force of his imagination and conviction
to a more romantic and personal expression, Wright did
much to mitigate the austerities of the new architecture.
He carried forward into our own times the sense of place
and the individualism of such predecessors as Downing,
Davis, Richardson, and Sullivan, and the concept of
architecture as the expression of a philosophy and life-
style held by Bulfinch and Jefferson. Also, in his
experiment with structure and the ease with which he
assimilated new technological developments into his
own concepts, he continued the idea of the architect as
engineer rather than merely as designer, and in his
Broadacre City, an ideal community for the future, he
went yet further in representing the architect as planner.

Wright was not alone, however, in his individualism
and romanticism. As early as 1915 Bernard Maybeck

173

148 BERNARD R. MAYBECK (1862–1957) *Palace of the Fine Arts, Panama-Pacific Exposition, San Francisco, California, 1915*

(1862–1957), a graduate of the École des Beaux-Arts, had contributed his Palace of the Fine Arts to the Panama-Pacific Exposition in San Francisco, whose Piranesian splendors recall, as the architectural historian Wayne Andrews has observed, the romantic melancholy of the sense of time's passing of Thomas Cole's paintings (*Ill. 148*). This more individualistic approach to architecture has continued, and is not limited to the West Coast.

In the depths of the Depression one of the most ambitious architectural projects ever undertaken was started in 1931 in midtown New York, the cluster of towers forming Rockefeller Center (*Ill. 149*), carried out by a team of architects working under the general direction of Harrison and Fouilhoux. Extending from Fifth Avenue west across the Avenue of the Americas, the vast complex forms a city within a city on such a colossal scale that Renwick's St Patrick's Cathedral, diagonally opposite on Fifth Avenue, acts as a welcome contrast. Wallace Harrison (1895–) was also one of the many architects associated with the design of the United Nations Building (1947–50, *Ill. 150*) on the East River in New York, a late monument to the International Style.

Gordon Bunshaft (1909–) of the firm of Skidmore, Owings, and Merrill produced Lever House (1950–52, *Ill. 151*) on Park Avenue in New York with an over-hanging second story to create a pedestrian mall and court at street level, and a terrace garden atop the lower

149 REINHARD AND HOFMEISTER; CORBETT, HARRISON AND MACMURRAY; HOOD AND FOUILHOUX *Rockefeller Center, New York, 1931–40. (Visible bottom right is St Patrick's Cathedral, see Ill. 81.)*

150 *(right)* WALLACE K. HARRISON (1895–), MAX ABRAMOWITZ (1908–) AND OTHERS *United Nations Building, New York, 1947–50*

151 *(below)* GORDON BUNSHAFT (1909–), *of* SKIDMORE, OWINGS AND MERRILL *Lever House, New York, 1950–52*

wing to form an asymmetrical yet balanced whole, using the smooth surfaces of the contemporary skyscraper in a more romantic composition. Nearby, on the other side of the Avenue, opposite McKim, Mead, and White's tra-traditionally handsome version of a Roman palace housing the Racquet Club (1900), Mies van der Rohe and Philip Johnson collaborated to produce the Seagram Building (1956–8, *Ill. 152*). Set back from the street, its bronze austerity is emphasized by its formal plaza, complete with reflecting pools and planting, to create a welcome open space in the increasingly canyon-like avenue. In its sophisticated simplicity, the Seagram Building is an elegant monument to Mies' famous dictum that 'less is more'.

There is nothing anonymous about Eero Saarinen's (1910–61) Wing Building (1956–62, *Ill. 153*) for Trans-World Airlines at John F. Kennedy Airport on Long Island. Having proven his ability to produce buildings as austere as any Bauhaus-inspired architect, as in the General Motors Research Center at Detroit, Michigan (1951), Saarinen here became frankly romantic in the use of forms suggesting flight and in free-flowing

152 LUDWIG MIES VAN DER
ROHE (1886–1969) AND PHILIP
JOHNSON (1906–) *Seagram
Building, New York, 1956–8*

153 EERO SAARINEN (1910–61) *Interior of the Wing Building for TWA, John F. Kennedy Airport. New York, 1956–62*

154 PHILIP JOHNSON (1906–) *Glass House, New Canaan, Connecticut, 1949–50*

interior spaces, changing from the dramatic openness of
the central area to the tube-like corridors, rising in a
gentle curve, which lead to the gates.

Though Philip Johnson's own house in New Canaan,
Connecticut (1949–50, *Ill. 154*) seems in some ways an
ultimate example of internationalism, its all-glass con-
struction reducing it to a crystal box of Miesian perfection,
its individualism and its sensitive relation to its site and
carefully controlled lighting give it another dimension.

Louis I. Kahn (1901–), who is also one of the best
and most influential community planners of today, has
perhaps most effectively carried forward Wright's theories
of organic architecture. In his Richards Medical Research
Building (1957–61, *Ill. 155*), at the University of
Pennsylvania, for example, the logical articulation of
closed and open, public and private, and utilitarian space
is clearly and definitely stated in a spare and forceful
design.

As Horatio Greenough had anticipated so many years
earlier, the creative power of Americans was not to be
limited to the beaux-arts concept of polite design. Today
it may be seen in the laboratory as much as in the studio,
and we must enlarge our ideas of the arts to meet the spirit

of the times. In architecture, engineering has become a vital area of creative expression and modern technology an inviation to imaginative thinking. Some of the results may be seen in achievements such as the geodesic dome, the invention of Buckminster Fuller (1895–), a recent example of which housed the American exhibit at Montreal's Expo '67 (*Ill. 157*), and in such superb arcs as the Verrazano Bridge spanning the Narrows at the entrance to New York harbor, whose chief engineer was O. H. Ammann (1881–1970), and its earlier sister span the Golden Gate Bridge, across San Francisco Bay (Joseph B. Strauss, chief engineer; O. H. Ammann, consultant). It also appears in the gigantic factories, such as the building covering acres in Tacoma, Washington, in which the Boeing Company developed the world's first jumbo-jet plane, and in the yet more colossal structures, the largest ever made by man, at Cape Kennedy for the space program. Though no one has yet built Frank Lloyd Wright's mile-high skyscraper, towers competing with each other in height are rising across the nation. Skidmore, Owings and Merrill have produced several of the best. Their recent John Hancock Center in Chicago combines cross bracing, a functional device with strong visual impact used earlier in their Alcoa Building (1966, *Ill. 156*) in San Francisco, with a tapering silhouette with notable success. In general, however, there tends to be a considerable similarity among tall urban buildings throughout the country, and they often share a kind of anonymity of style that seems to increase with their bulk. Even though designed by Minoru Yamasaki (1912–), who has a flair for decorative quality with a touch of exoticism, the gigantic twin monoliths of the World Trade Center whose 110 stories dominate lower Manhattan are examples of this impersonality of great size (*Ill. 145*).

156 SKIDMORE, OWINGS AND MERRILL *Detail of the Alcoa Building, San Francisco, 1966*

Yet to approach New York or Chicago by air is to experience, as is increasingly true of almost all larger American cities, the visual excitement created by the variety and contrast of tall slabs and towers, which, 'splendidly uprising', in Walt Whitman's phrase, create a complex and dynamic entity. The vigorous expressiveness of the contemporary urban scene, whether the Pop Art vulgarity of Las Vegas or the explosions of towers of Chicago or New York, is, in large measure, the result of those strongly individualistic and romantic attitudes

157 R. BUCKMINSTER FULLER
(1895–) *American Pavilion, Expo*
'67, Montreal

which constantly recur in America. This is reflected in Louis Sullivan's description of the skyscraper as 'a proud and soaring thing, rising in sheer exultation.' With other industrial, commercial, and utilitarian structures – factories, power plants, dams, bridges, grain elevators, and airports – the skyscraper represents what the distinguished critic and theorist Lewis Mumford has called 'the architecture of power' of today.

There is much evidence, however, that we are still far from creating a satisfactory 'architecture for democracy'. Badly conceived urban housing developments in many cities, repetitious groupings of high-rise buildings, all too often have turned into vertical slums as bad as the ancient row houses, tenements, and low-rise apartments they replaced. Ghettoes are still a part of all major cities. An airplane view shows almost every city to be largely surrounded by tracts of monotonous development, identical houses on identical small lots, in a seemingly endless repetition punctuated only occasionally by schools and shopping centers. The air view also reveals the devastation of the landscape for commercial and industrial purposes and other evidences of thoughtless disregard for the environment.

Counterforces, however, are on the increase. The growing strength of the ecological movement is making itself felt. Planned communities are being developed,

181

with a variety of residential building for differing taste and income, including separate houses, rows of town houses, and apartments, and an emphasis on the communal use of open space; interesting examples are Reston in Virginia, Columbia in Maryland, in Mill Valley, California, and in Jonathan, Minnesota. It is too soon to know, however, if they will provide the solutions to the problems that their sponsors hope. There are new directions in urban housing, with an increasing emphasis on variety of unit to include families of different income. Of the many efforts to renew decaying urban centers, those in Boston and Philadelphia display some of the most interesting features in their combination of selective retention of the old with dramatic examples of contemporary style. Of all the new civic centers, that in Chicago, with handsome and austere skyscrapers surrounding a plaza enlivened by a Picasso sculpture on a very large scale, is perhaps the most impressive.

The cause of architectural preservation has also gained strength. Encouraged by the National Trust for Historic Preservation and other interested groups, the imaginative re-use of distinguished older buildings is on the increase, thus enriching the urban scene and retaining the dimension of time in the midst of change. Of many successful examples, two are in Washington, where Robert Mills's handsome Classical Revival Patent Office (1836–42) has been transformed into a museum housing the National Collection of Fine Arts, the National Portrait Gallery, and the National Archive of American Art, and James Renwick's original Corcoran Gallery (1859–71), a picturesque Second Empire design, has been restored as the Smithsonian Institution's museum of decorative arts and appropriately renamed the Renwick Gallery. Another is the transformation by the architect and urban designer Lawrence Halprin of a large brick factory building on San Francisco's waterfront into the delightful complex of shops, terraces, and restaurants known as Ghirardelli Square. For the new generation of architects and planners this sort of intelligent respect for the past is combined with an increased awareness of the visual qualities necessary for successful design. Their competence is shown by the consistently high level, especially of industrial and commercial buildings, both on urban and rural sites, being constructed across the country.

Experiment has increased along with developments in technology. Means have been devised for creating free-form space enclosure in plastic; for the factory production of room units, complete with plumbing, heating, and air conditioning, to be assembled at the site like children's blocks; and for structures to be inflated, suspended, or guyed. Fuller has designed floating cities containing schools, stores, factories, offices, apartments, air and sea ports, recreation areas, communication systems, and utilities. In theory, the principles of his geodesic dome could be used to enclose whole communities, controlling their climate and atmosphere. Paolo Solari (1907–) has envisioned cities underground, on bridges across valleys, inside mountains, in dams, in canyons, a linear city following ground transportation systems snaking across the entire continent, and a city in the form of a man-made asteroid orbiting in space. Others conjecture communities beneath the surface of the sea. Whatever may come of such schemes, they all reflect the conviction now increasingly widespread that architecture can no longer be separated from ecological considerations and that the architect must be an environmental planner as well. Here two significant aspects of the American tradition come together: Jefferson's, Downing's, and Olmsted's belief that close association with nature and the availability of open space are essential to a satisfactory life, and Bulfinch's, Jefferson's and Wright's concept of the architect as the guardian of the nation's ideals to which he gives form in responsible planning for the future.

'Make no little plans,' Daniel Burnham had advised in 1897 when discussing the future development of Chicago, 'they have no magic to stir men's blood.' The course of American architecture so far in the 20th century suggests that his advice has not gone unheeded.

The Eight, the Armory, and modern art

All seemed quiet on the artistic front during the early years of the century. Those few Americans interested in the arts admired the sculpture of Saint-Gaudens and French, the portraits of Sargent, and the landscapes of Twachtman, Hassam, and a few others. But, in general, they far preferred the work of the European masters of the

183

day, the now largely forgotten winners of official recog-
nition which were the favorites of most American
collectors. There were a few exceptions, however. Thanks
to the influence of William Morris Hunt, who had
visited the dedicated group of painters at Barbizon and
knew what was going on in artistic circles in France,
certain Bostonians bought the works of Millet, Corot,
and the Impressionists. And thanks to the sound advice
of Mary Cassatt, certain Philadelphians were also buying
Impressionist paintings. But most of the great American
collections being formed were devoted to the works of the
old masters.

In 1908 there occurred an event that set off a chain-
reaction which catapulted an unsuspecting America
into the world of contemporary art. A year earlier,
paintings by George Luks (1867–1963), John Sloan
(1871–1951), and William Glackens (1870–1938) had
been turned down by the jury for the National Academy
exhibition of that year. All three had been pupils of
Robert Henri (1865–1929) in Philadelphia, and when
their pictures were not accepted, he refused to show his,
though they had been passed by the jury. In the meantime,
William Macbeth, owner of a New York gallery devoted
to American art, convinced that better things were being
done than ever appeared in the Academy shows, asked
his friend, the artist Arthur B. Davies (1862–1928), to
help assemble an exhibition of the work of good con-

158 JOHN SLOAN (1871–1951)
*The Wake of the Ferry, 1907. Oil on
canvas, 26" × 32" (66.1 × 81.3). The
Phillips Collection, Washington,
D.C.*

159 MAURICE PRENDERGAST (1859–1924) *Central Park, 1901.* *Watercolor,* 14⅛″ × 21¾″ (35.8 × 55.1). *Collection of the Whitney Museum of American Art, New York*

temporary Americans. The result was the exhibition officially titled 'Eight American Painters', but known ever since simply as 'The Eight'. They included Henri and his friends and former pupils: Sloan, Luks, Glackens, and Everett Shinn (1876–1953); Ernest Lawson (1873–1939), a friend of Glackens and a pupil of Twachtman, whose style was influenced by Impressionism; Maurice Prendergast (1859–1924), an older painter, originally from Boston, who had developed a personal style related to contemporary European developments but independent of them; and Davies himself.

Henri and his group had studied at the Pennsylvania Academy where the realist tradition of Thomas Eakins still prevailed. All had started as newspaper artists, and many continued as illustrators. Under Henri's inspiration they turned to painting, bringing to it the same involvement with everyday life of the city, recorded vividly and directly (*Ill. 158*).

The rest of The Eight fall into a different category. Lawson painted with a heavy impasto which tends to create a design in itself, so that the landscape and cityscape subjects he loved seem more remote than those of Henri's group. Prendergast had studied abroad as early as 1886, the year his contemporary, Georges Seurat, exhibited his first important Pointillist painting, *Sunday in Summer on the Island of Grand Jatte* (Chicago). Prendergast was familiar with all the European developments of the time, and considerably before the turn of the century had evolved his own mosaic-like manner, both in watercolor and in oil (*Ill. 159*). Davies, who turned out to be the

185

arch-revolutionary of them all, not only because he was an organizer of the showing of The Eight, but also because of his leadership in the Armory Show five years later, painted idyllic fantasies with graceful ethereal nudes in ideal landscapes.

The exhibition at the Macbeth Gallery caused reactions whose violence seems out of all proportion to the works which now appear as happy evocations of a more innocent time before the First World War. Henri and his group were continuers of the best traditions of American genre painting. They were not alone in this. George Bellows (1882–1925) and Walt Kuhn (1880–1949), for example, were others working in the same spirit. Prendergast and Davies belonged to the strain of inward-looking artists in the tradition of Allston, Blakelock, and Ryder, while Lawson's rather poetic pictures seem at least as acceptable as those of Hassam, whose painting was generally respected. Yet the exhibit provoked a general attack from critics who seem to have considered it a part of an anti-American plot to besmirch their country's good name. They called the genre painting deliberately and despicably vulgar, and coined the name 'Ash Can School' to sum up their disapproval and contempt.

There were, however, those who approved. Gertrude Vanderbilt Whitney, always a generous patron of contemporary American art and founder of what was to become the Whitney Museum, bought four paintings. And the Pennsylvania Academy borrowed the entire exhibition and lent it to various other institutions during the following year or so. But the fat was in the fire. More startling revelations were to follow, and they did most dramatically at the Armory Show of 1913. The Eight never showed together again, but out of their exhibition grew the Association of American Painters and Sculptors, of which Davies was elected president. The purpose of the Association was to mount a show to present to the American public a broad survey of contemporary art, both European and American. Davies, with the able assistance of Walt Kuhn, who had earlier been a cartoonist, Walter Pach (1883–1958), a painter and writer who had recently been discovering the exciting developments in Europe, and Alfred Maurer (1868–1932), an American artist who had been living abroad, assembled an extraordinary collection of European art, including

the Dadaist Marcel Duchamp; Matisse, and others of the
the Fauves ('Wild Beasts', as some contemporary critics
called the group); the sculptors Rodin, Maillol, Archi-
penko, Lehmbruck, and Brancusi; Impressionists,
including Monet, Sisley, and Pissarro; and Post-
Impressionists, such as Cézanne, Gauguin, and others;
Picasso, Braques and other Cubists also were represented.
All in all, it was an almost complete Who's Who of
modern European art. In the meantime all American
artists, of whatever persuasion, were invited to participate.

When the show finally opened in the Sixty-ninth
Regiment Armory on Lexington Avenue on 17 February
1913, Kuhn's prediction that it would be a bombshell
fell far short of the mark. It was a triumph of Davies'
organizational powers and didactic purpose. Somehow
he found the necessary assistance, financial and otherwise,
to see it through. The result was not only the largest and
most important art exhibit ever held in America, but
also a visual history of amazing completeness of the
evolution of modern art from such ancestors as Daumier,
Corot, and Goya, through the Impressionists, Post-
Impressionists, Fauves, and other Expressionists, Cubists,
and artists representing the various other major movements
in art to the show's opening date (*Ill. 160*).

Walter Pach estimated that about 1,600 works were
shown, including groups of prints and drawings. Some
70,000 people paid admission to the exhibition, including
a number of important collectors of contemporary art.
Among them were John Quinn, the prominent attorney
who had backed the show from the beginning, Lillie
Bliss, who, with the advice of Davies and Kuhn,
assembled the significant collection which became the
nucleus of that of the Museum of Modern Art, and Dr
Albert C. Barnes of Argyrol fame, whose magnificent
collection is in Merion, Pennsylvania. The Metropolitan
Museum purchased Cézanne's *Poorhouse on the Hill* for
$6,700, the highest price paid for anything sold from the
show, while Duchamp's *Nude Descending a Staircase*,
now in the Arensberg Collection in the Philadelphia
Museum, without question the most famous, not to say
infamous, work of art in the exhibition, was sold for only
$324 to a California dealer.

Though the general public seemed to regard the whole
thing as great fun, the critics were outraged and dismayed.
Things had been going on in Europe, and in America

*160 International Exhibition of Modern
Art, 69th Infantry Regiment Armory,
New York, 1913*

as well, of which they had never dreamed. The broad area within which art was to develop during subsequent decades was in evidence, from the works of the conservative inheritors of the Hudson River School through all the various movements and experiments to the totally non-objective art of Kandinsky. The exhibition was shown at the Art Institute in Chicago, and then, in truncated form, in Boston. Though in all three cities the cries of the outraged critics were shrill and angry, the Armory had accomplished what its backers intended: it had opened the doors to modern art in America and led the way for the internationalization of art later to take place, and prepared for the eventual sharing of leadership in world art by American painters and sculptors.

One immediate effect of the show was to deprive such artists as Henri and his group of their position in the advance guard. Theirs had been a revolution in subject-matter and approach. The Armory Show proved, however, that a much more fundamental revolution was taking place in the arts, nothing less than a basic re-

161 ARTHUR DOVE (1880–1946) definition of aims, forms, and purposes.
Fog Horns, 1929. Oil on canvas, There had already been premonitions of this more
18″ × 26″ (45.8 × 66.1). Collection fundamental revolution in the exhibitions staged by the
of the Colorado Springs Fine Arts photographer and prophet of modern art, Alfred
Center, Gift of Oliver B. James Stieglitz (1864–1946), from 1905 until 1925 at his little

gallery at 290 Fifth Avenue, then for four years at the Intimate Gallery, and finally, from 1929 until his death at An American Place. Fascinated with experiment in the arts, he was a dedicated exponent of all that seemed alarming and disturbing to most Americans about contemporary developments in the arts. He showed the works of pioneer American modernists, such as the painters Alfred Maurer, Max Weber, Marsden Hartley, Arthur Dove (*Ill. 161*), John Marin (*Ill. 162*), Charles Demuth, and Georgia O'Keeffe, and the photographers Edward Steichen, Paul Strand, and Gertrude Kasabier. He showed Rodin watercolors and Picasso paintings and prints, Brancusi's sculptures, and African primitive sculpture to suggest a significant area of exploration by contemporary artists.

The First World War was followed by the gaudy 'twenties, a period, like that following the Civil War, which many artists found so hostile to art that they fled to Europe, generally turning up in Paris to hatch great plans at café tables. But the war also brought European artists to New York, among them Marcel Duchamp.

162 JOHN MARIN (1870–1953) *Movement, Boat off Deer Isle (Maine Series No. 9), 1926. Watercolor, 15⅞″ × 21⅞″ (40.2 × 55.5). Philadelphia Museum of Art: The Alfred Stieglitz Collection, 49-18-22*

189

The international unrest produced all sorts of movements, from the anti-art protest of Dada to the Surrealism which evolved from it, expressing the impact of the explorations of the mind associated with the psychological investigations of Freud and Jung. Though there are isolated cases of non-objective experiment earlier, the first significant developments of abstraction in America occurred during the decade of the Armory Show.

The Depression, which coincided with the end of the 'twenties and lasted well into the next decade, brought the influence of the contemporary Mexicans, Diego Rivera, David Siqueiros, and José Orozco, whose visual protest against political injustice lent power to the art of social protest then developing in the United States. Troubles abroad as well as at home enlisted the consciences of artists who were appalled at the rise of Fascism and Nazism, the Japanese invasion of China, the civil war in Spain. The First Artists' Congress in New York in 1936 proved their awareness of their responsibilities as citizens and associated them with liberal causes.

The 'thirties produced yet another movement in American art, Regionalism. Painters like Thomas Hart Benton (1889–), John Steuart Curry (1897–1946), and Grant Wood (1892–1942), who had fled America for the fairer fields of Europe, returned to the American scene in reaction to war and foreign disruption. All three found their inspiration in the Midwest, in the grain and wheat fields extending to a far horizon, in the life of the farm and of the farming community (*Ill. 163*), and, in the case of Wood, also in fables and stories of America's past.

163 THOMAS HART BENTON (1889–) *Homestead, 1934. Tempera and oil on composition board, 25" × 34" (63.5 × 86.4). Collection, The Museum of Modern Art, New York, Gift of Marshall Field (by exchange)*

At the same time other artists, most of whose work was shown only by Stieglitz, were experimenting in directions more significant for the future. Arthur Dove (1880–1946), a successful illustrator, started working in an abstract vein from about 1907, always maintaining a strong feeling for natural form. He also tried his hand at collage, often with amusing results, such as his *Goin' Fishin'* (1925, Phillips Collection), made up of sections of a bamboo fishing pole, a blue denim shirt, and various items of a fisherman's equipment. He also translated sounds into striking visual images, as in his *Fog Horns* (1929, *Ill. 161*).

John Marin (1870–1953) was trained as an architect and studied at the Pennsylvania Academy. He early struck out on his own, along both abstract and expression-

ist lines, before he was aware of similar developments in Europe. He painted the skyscrapers of New York in a way which shows his sensitivity to the restless pulse of the city. Then he discovered the state of Maine and spent the rest of his life painting lyric appreciations, first in water-color handled with bold directness, then also in oil, of the sea and the rocky shore, the wind-blown pines and firs (*Ill. 162*).

Marsden Hartley (1877–1943) was born in Maine, but it took years abroad, and exposure to the influence of German Expressionism, before he could return to find himself at home, as had Winslow Homer before him, in identification with the rugged lives of the Maine fishermen. Ryder was a great and helpful influence on him; the older man's air of quiet strength appears in the small portrait Hartley painted of him, with the stocking-cap he wore when exploring the city at night. Georgia O'Keeffe (1887–), on the other hand, found her artistic world in the desert of the Southwest, with its tremendous skies and austere and timeless grandeur (*Ill. 164*).

Like his contemporary, John Marin, Charles Burch-field (1893–1967) used watercolor as a major medium, in the tradition established by Homer and Sargent. Brought up in a small town in Ohio, and living the rest of his life in upstate New York, Burchfield sensed an inner animation in the natural world around him and in the weather-beaten old houses, haunted by generations of forgotten inhabitants (*Ill. 165*). He felt the rhythm of life in the sound of insects which he represented in the

164 GEORGIA O'KEEFFE (1887–) *Ram's Skull with Brown Leaves, 1936. Oil on canvas, 30″ × 36″ (76.2 × 91.5). Courtesy of Georgia O'Keeffe, from the collection of the Roswell Museum and Art Center, Roswell, New Mexico, Gift of Mr and Mrs Donald Winston, Mr and Mrs Samuel H. Marshall, and Mr and Mrs Frederick Winston*

165 CHARLES BURCHFIELD (1893–1967) *The False Front. Watercolor. The Metropolitan Mu-seum of Art, New York, Rogers Fund, 1924*

repetitious shapes of dried grasses. He expressed the
mystery of the summer night with stars vibrant in a sky,
beneath which giant sphinx moths explore magic blooms.
With Marin, Hartley, O'Keeffe, and Dove, Burchfield
is representative of the more subjective tradition represented
earlier in the century by Prendergast and Davies.

Edward Hopper (1882–1967), on the other hand,
belongs to the other aspect of the American tradition, that
of Homer and Eakins. Disregarding every frantic shift in
artistic fashion, Hopper's art matured over the years, as he
followed his own vision, and expressed again and again,
in both oil and watercolor, a theme similar to that of
Homer – whom he also resembled in the selective
objectivity of his approach – the theme of modern man
and the loneliness which surrounds him, even in the
midst of the noisy, crowded scene which he has created,

166 EDWARD HOPPER (1882–
1967) *Nighthawks, 1942. Oil on
canvas, 2′9³⁄₁₆″ × 5⅛″ (84.3 ×
153). Courtesy of the Art
Institute of Chicago*

167 (left) CHARLES SHEELER
(1883–1965) *River Rouge Plant,
1932. Oil on canvas, 20⅞″ × 24″
(51 × 61). Collection of the
Whitney Museum of American
Art, New York*

168 (opposite) STUART DAVIS
(1894–1964) *Lucky Strike,
1921. Oil on canvas, 33¼″ × 18″
(84.3 × 45.8) Collection, The
Museum of Modern Art, New
York, Gift of the American
Tobacco Company, Inc.*

whether in suburb or city, an all-night lunch, or a gas station, an empty street, or a motion-picture theater (*Ill. 166*).

In much the same way that Impressionism had influenced many American artists to lighten their palettes and broaden their touch, Cubism reinforced the tendency in some to stress the geometrical structure of their compositions, to clarify and reduce formal elements in a way suggesting the spare simplicity of modern architecture and the machine as seen with a vision almost as impersonal as the camera's. Charles Sheeler (1883–1965) was one of this group of Precisionists, as they have sometimes been called. Significantly, he was an expert photographer, recording the clean lines of Shaker furniture and architecture, and saw a parallel dignity, though on another scale, in modern industrial building. In a group of photographs and paintings made between 1927 and 1930 he gave compelling expression to the new vision anticipated so many years earlier by Horatio Greenough in his conception of beauty as the promise of function. Beneath the cool clarity of Sheeler's painting there lurks a suggestion of the romantic element, so rarely absent from American art, in the heroic vastness of Ford's River Rouge plant, and the aspiring height of skyscrapers and factory chimneys (*Ill. 167*).

Ben Shahn (1898–1969) also started out as a photographer. He recorded feelingly the conditions of those who suffered most from the Depression, the small farmer and the sharecropper, the miner, the factory worker, the immigrant trying to find a place in a new environment. When he turned to painting, it was at first with the same note of passionate social protest, but his attitude mellowed and broadened into a general humanism as suggested by his *Blind Botanist* (1954, *Ill. 169*). His drawings show a personal and often witty use of line, which, like his painting, is essentially expressionistic in character, since, as in the case of a number of other Americans, including Hartley, Expressionism served to strengthen tendencies already innately present in American painting.

Ivan Le Lorraine Albright (1897–) has been called both an expressionist and a magic realist, and certain aspects of his style might fit into either category, but, like so many other American artists he is an individualist rather than a member of any group. Like Shahn, he is essentially a humanist, but with a harsher view of man's

169 BEN SHAHN (1898–1969) Blind Botanist, 1954. Tempera on masonite, 4' 4" × 2' 7" (132 × 79). The Roland P. Murdock Collection, The Wichita Art Museum, Wichita, Kansas

frailties and frequent tragedies as well as his basic dignities. His best known painting, completed in 1941 only after a decade of work, is 'That Which I Should Have Done I Did Not Do' (Ill. 170); it shows an ancient door, scratched and weather-beaten, on which hangs a funeral wreath, while at the left a hand appears, groping for the door knob. Yet the near-surrealistic emphasis on the tortured textures, battered by years of wear and abuse, makes the door a symbolic record of human suffering, disappointment, and disillusionment.

In the meantime, other experiments in various forms and degrees of abstraction were going on. Stuart Davis (1894–1964), like Hopper a pupil of Henri, used the hard, clear, industrial and mechanical forms of Sheeler and the other Precisionists as a point of departure into geometrical abstraction (Ill. 168). He transformed the ordinary and often cheap and vulgar elements of everyday life – gasoline pumps, hardware, billboards, and neon signs – into abstract forms, suggesting Matisse's cut-outs in their angularity, which he assembled in compositions of flat, bright color, with results that are always lively and often witty. In their rhythmic interplay of forms they suggest the tempo of modern city life and the restless beat of the jazz the artist knew so well. From Davis' clean-cut outlines of flat patterns are derived the characteristics of the hard-edged painting and sculpture of mid-century and later, while his use of ordinary objects anticipates something of Pop Art's preoccupation in the '60s with similar aspects of American life.

Before the emergence of the latter two movements, however, came the sudden flowering toward mid-century of what has been called Abstract Expressionism or the New York School. Made up of artists of diverse talents, origins, and attitudes, it represents a coming together at one time and place of a number of the directions in which abstract art had been moving in recent years. European distruption, including the Second World War of 1939 to 1945, caused many artists to flee to America, bringing with them such diverse influences and philosophies as the Constructivism of the Russian brothers known as Gabo and Pevsner and the Surrealism of Duchamp and others. As mid-century approached, the School of Paris was strongly influential, especially Picasso, Miró, Arp, and Braque, whose works were extensively shown by the Museum of Modern Art, which, since its foundation in

170 IVAN LE LORRAINE AL-BRIGHT (1897–) 'That Which I Should Have Done I Did Not Do', 1931–41. Oil on canvas, 8' 1"×3' (246.5×91.5). Courtesy of the Art Institute of Chicago

171 JACKSON POLLOCK (1912–56) *in his studio*

1929, had asserted a growing leadership in the arts. Following the Second World War, as had been the case after the First, there was a tendency to react against realism and other more traditional modes of vision, and toward an increase in experiment in various areas of abstraction. As a result, during the '40s and '50s, the internationalization of the arts seemed suddenly to take place, and a group of younger New York artists emerged to assume a commanding position.

Among the leaders of the New York School were those often called 'action painters'. Influenced by the automatism of Surrealism, they so emphasized the process of creation that the picture became primarily the record of the action that produced it. Here Jackson Pollock (1912–56) is the key figure. His large canvases, covered with spatters and the rhythmic swirls and curving interlacings of dripped paint, are the result and the record of the concentrated, almost ballet-like ritual of their creation (*Ill. 171*). Other action painters are Franz Kline (1910–62) and Willem de Kooning (1904–), born in Holland but long a resident of the United States. Kline's large forms, constructed of slashing strokes,

172 CLYFFORD STILL (1904–) *1957-D no. 1, 1957. Oil on canvas, 9'7" × 13'3" (292 × 406). Albright-Knox Art Gallery, Buffalo, New York, Gift of Seymour H. Knox*

197

crowd the canvas, harsh ideographs for an industrial age.
De Kooning's paintings are savagely brushed evocations
of destructive forces embodied in variations on the theme
of a female figure (*Ill. 173*).

Other artists of the New York School, though not
properly classified as action painters, include Arshile
Gorky (1904–48), who created fluid compositions of
visceral forms with strong overtones of Surrealism; Robert
Motherwell (1915–), a critic and writer as well as a
painter, who uses large, simply formed, dark shapes, not
unrelated to the hard-edge painters and sculptors of the
'60s, to produce totem-like configurations; and Mark
Rothko (1903–70), who painted large blurred rectangles,
glowing with warm tones or melting into cool back-
grounds, whose dominant colors create a contemplative
mood. The large size of most of the paintings by artists of
the New York School – Clyfford Still (1904–) was

among the first dramatically to enlarge his canvases (*Ill. 172*) – relates them to contemporary developments of environmental art; their tendency toward simplification and reduction is akin to Minimal sculpture; while their insistent stress on movement and process as content suggests relations to theatre, cinema, and dance.

Emphasis on surface texture led to the incorporation of paper, fabric, and other materials, and found objects, often junk, to produce an actual rather than a merely illusionistic three-dimensionality through which painting not only becomes sculpture but the two are combined. In this vein Robert Rauschenberg (1925–), a former student of Josef Albers, uses a collage of such ingredients as torn comic strips and pieces of textile, with an assemblage of bottles, automobile tires, stuffed animals, and other objects, with paint applied in an abstract expressionist manner, to produce effects which are partly visual metaphor, partly ironic implication, and are related to both concrete poetry and music (*Ill. 174*).

The process of deliberately mixing artistic categories, by adding an actual third dimension to eliminate the traditional distinction between painting and sculpture, by adding sound with the incorporation of radio, television, and electronic elements, and by adding movement with the development of kinetic sculpture, was momentarily synthesized in the 'happening', originated early in the '60s by Claes Oldenburg, Allan Kaprow, Jim Dine, and others. Not without affinities to the theatre of the absurd, and reflecting aspects of the environmental tendencies then strongly emerging in the arts, the happening is a scheduled, non-recurring event or series of events combining Dadaist meaninglessness and the random principle of aleatory music as practiced by the composer John Cage, and sharing the non-purposiveness of an Andy Warhol film and a ritualistic element reminiscent of Pollock's approach to painting.

The ephemeral aspect of the happening and its frequent inclusion of acts of ritualistic destruction and the use of waste and junk material in the construction of works of art reflect the disposability and transformation which seem inevitable aspects of a society based upon consumption and undergoing constant change. These qualities are related to Pop Art, so named by the English critic Lawrence Alloway, which emerged strongly in the '60s. Pop artists raised the imagery of advertising, brand

174 ROBERT RAUSCHENBERG (1925–) *Odalisk*, 1955–8. Construction, 6′9″ × 2′1″ × 2′1″ (206 × 64 × 64). *From the collection of Mr and Mrs Victor W. Ganz*

175 TOM WESSELMAN (1931–)
*Great American Nude no. 99, 1968.
Oil on canvas, 5' × 6'9"(153 × 206).
Collection: Morton G. Neuman.
Courtesy, Sidney Janis Gallery, New
York*

names and logos, television commercials, moving pic-
tures, road signs, billboards, and other generally
unnoticed yet obvious aspects of the everyday scene, into
icons for the times, often with disturbing implications as
to contemporary values and priorities. There can be
trenchant social comment in their exaggeration of the
banal, as in the gross enlargement of comic strip details,
complete with Ben Day dots, of Roy Lichtenstein
(1923–), and satiric commentary in the series by Tom
Wesselmann (1931–) of *Great American Nudes* (*Ill.
175*). Andy Warhol's (1930–) compulsive repetitions
of multiple reproductions of news photographs of
automobile accidents reflect the violence of the times,
while those of a smiling Marilyn Monroe (*Ill. 177*) have
ambiguous implications of false ideals and the fragility
of human hopes.

Optical or Op Art is another recent movement. It
stems from the work of Piet Mondrian, leader of the
Dutch group known as De Stijl, whose visit to America
in the early '40s during the last years of his life brought,
under the stimulus of jazz, a kinetic element into his
otherwise coolly geometric abstraction, and Josef Albers

176 JOSEF ALBERS (1888–)
*Homage to the Square, 1961.
Oil on masonite, 16"×16"
(40.7 × 40.7). Galerie Tarica,
Paris*

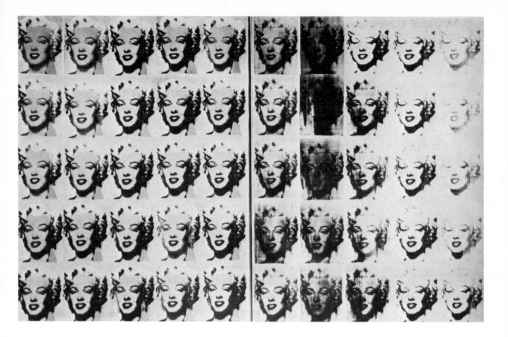

(1888–), a former faculty member at the Bauhaus, and, like his fellow refugee, Hans Hofmann (1880–1966), an influential teacher. Albers' variations on the theme of 'Homage to the Square' (*Ill. 176*) are demonstrations of 'the interactions of color'. Op Art is based on the idea of fooling the eye by visual effects created to suggest that a flat surface is actually distorted; it has curious reminiscences of the *trompe-l'œil* realism of Harnett. In reaction to this are color-field painting, an aspect of hard-edge abstraction, as seen in the paintings and sculptures of Ellsworth Kelly (1923–), and proponents of the shaped canvas, introduced by Frank Stella (1936–), both of which are to a certain degree related to the 'primary structures' industrially created to the specifications of Minimalist sculptors.

But since a basic continuity in American art today seems to lie in the urge to constant innovation, painting, like the rest of the arts, is moving in other and perhaps less fashion-conscious directions as well, both in terms of abstraction and in various other areas within the broad spectrum revealed at the Armory Show so many years earlier. Two other artists of today, both with established reputations, may be arbitrarily selected further to define this diversity. Mark Tobey (1890–), after study in

177 ANDY WARHOL (1930–) Marilyn Monroe Diptych, 1962. Oil on canvas, 6' 10" × 9' 6" (209 × 290). From the collection of Mr and Mrs Burton Tremaine, Meriden, Connecticut. Courtesy, Leo Castelli Gallery, New York

America, Europe, and the Orient, found his spiritual home in the North-west and spiritual sustenance in the arts of the Far East to develop a style of subtlety and distinction. Based in realism, his forms nonetheless are dissolved in a delicate and dynamic linearism derived from automatic writing and Oriental calligraphy. His paintings, often small in scale, have a gossamer-like strength and delicacy, and a purely visual poetry of great complexity and control (*Ill. 178*).

Andrew Wyeth (1917–) stands more obviously toward the realist end of the spectrum, though in the evolution of any of his works a disciplined process of abstraction, in terms of selection, simplification, and interpretation, takes place. With a muted palette, in which earth tones and the colors of late autumn pre-dominate, Wyeth paints landscapes, interiors, still-lifes, and what might be called genre scenes. Though they are pervaded by silence, there is the implication of momentary change, overtones of human association whether figures are present or not, the recurrent theme of solitariness, the inevitability of time, the haunting presence of the past, and the mystery of the future (*Ill. 179*).

Tobey and Wyeth are but two among many artists of stature, along with many more of achievement and yet more of promise, whose work suggests something of the range of contemporary painting, which, through constant change, continues to move forward, all too often in a seeming search for novelty – so obsessed are Americans with the idea that it represents progress and that progress is

178 MARK TOBEY (1890–) *New Life (Resurrection), 1957. Tempera on cardboard, 43⅜″ × 27¼″ (110.1 × 69.1). Collection of the Whitney Museum of American Art, New York. Gift of the Friends of the Whitney Museum of American Art*

179 ANDREW WYETH (1917–) *Christina's World, 1948. Tempera on gesso panel, 32¼″ × 47¾″ (81.8 × 121). Collection, The Museum of Modern Art, New York*

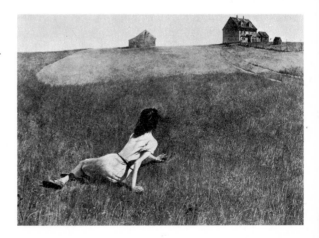

the final purpose – but nonetheless with the variety and continuing experiment which are a measure of the restless vitality of the arts today.

'Seeking what is yet unfound'

Sculptors as well as painters were among the moving spirits of the Armory Show. Gutzon Borglum (1867–1941), for example, a Rodin pupil, is known primarily as the creator of perhaps the most colossal sculptural project yet conceived in America. With dynamite and pneumatic drill, he carved the heads of four outstanding presidents, at a tremendous scale, on the bare rock face of Mount Rushmore in South Dakota. Though the results are undeniably impressive, the project dramatically illustrates the American tendency to equate size with significance. Jo Davidson (1883–1952), several of whose works were included in the exhibition, was another member of the group. He became a specialist in the portrait bust, and a host of celebrities sat for him, among them Gertrude Stein (*Ill. 180*), one of the first important collectors of modern art, whose portrait is one of his best.

The conservative tradition of Saint-Gaudens and French was continued by many sculptors, who became the inevitable winners of official commissions because of the innate conservatism of the official mind. All but a very few maintained a dead level of mediocrity, with results that can be seen in many a city square, courthouse, and state house across the country, with the national capital having the lion's share.

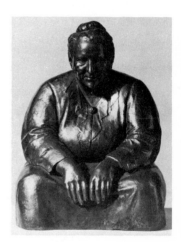

180 JO DAVIDSON (1883–1952) *Gertrude Stein. Bronze, h. 7¾″ (19.7). Yale University Art Gallery, Stein Collection*

As the century progressed, the question as to which artists are to be classified as Americans and which are not suggests the growing internationalization of the scene. Jacob Epstein, for example, was a direct contemporary of Jo Davidson. Born in the Lower East Side of New York, he later settled permanently in England to become honored as the most distinguished sculptor there of his generation. Gaston Lachaise (1882–1935) and Elie Nadelman (1882–1946), on the other hand, were born respectively in France and Poland, yet did their outstanding work in the United States. Both were represented in the Armory Show and also exhibited by Stieglitz. Nadelman had been involved with Cubism and other

181 ELIE NADELMAN (1882–
1946) *Woman at the Piano, c. 1917.
Wood, stained and painted, h. 35⅛"
(89.1). Collection, The Museum of
Modern Art, New York, The Philip
L. Goodwin Collection*

advance-guard developments in Paris before coming to
America in 1914. He handled marble expertly, and his
carved wood figures, such as *Woman at the Piano (Ill. 181),*
and his elegant bronze, *Man in the Open Air* (both
Museum of Modern Art), wittily epitomize the spirit of
the '20s in America. Among the first to interest himself
in American folk art, his collection became the basis of
the Abby Aldrich Rockefeller Collection at Williams-
burg, Virginia.

In sculpture as in painting, European influences were
strong. But none of the Americans had the power of such
Europeans as Brancusi, Picasso, Matisse, or Duchamp-
Villon (the brother of Marcel Duchamp), whose works
in the Armory Show had provoked such alarm. Nor
could they compete with those of Alexander Archipenko
(1887–), or Jacques Lipchitz (1891–), who were
later to move to America and, especially in the latter's
case, reach a zenith of their careers in this country.

Though born in Russia, William Zorach (1887–1966)
was entirely identified with America. After an early
period of abstract experiment primarily in painting,
examples of which were included in the Armory Show,
he turned to the direct carving of the figure in a tradition
in which John Flannagan (1895–1942), was also to
work with a feeling for nature somewhat resembling that
of Arthur Dove and Charles Burchfield. With a
minimum of carving, Flannagan revealed the animal,
and, more rarely, human forms which his imagination
saw in glacial boulders, yet he always retained the
essential shape of the natural rock, expressing his strong
feeling for the unity of the natural world. This tradition
of direct carving was carried on past mid-century by such
younger artists as Leonard Baskin (1922–), whose
work in both sculpture and graphics is pervaded by a
sense of human tragedy and dignity, and whose brooding
figures have great seriousness.

Others pursued abstraction with a parallel feeling for
organic form, like Isamu Noguchi (1904–), a student
of Brancusi in Paris who works in stone to produce
forms with beautifully handled surfaces, which have
some of the qualities of ancient cult images (*Ill. 182*).
Organic abstractions have also appeared in bronze and
other metals in the work of Seymour Lipton (1903–)
and Theodore Roszak (1907–). Where Roszak's forms
seem more open and out-reaching, as in his *Sea Sentinel*

(1956, *Ill. 183*), Lipton's tend to be closed and secretive, as in *Pioneer* (1957, *Ill. 184*).

Among the many sculptors who have turned to metal for its essential material brutality, whether assembled, welded, or cast, none has surpassed David Smith (1906–65) in his harsh and aggressive abstract steel shapes. Their industrial rather than organic reference is strengthened by the inclusion of machine parts and tools as found objects in a number of them, yet they have a strong and spectral personal symbolism. His *Tanktotem* series of the late '50s and *Cubi* (*Ill. 185*) series of the '60s are uncompromisingly severe and have a portentous presence.

Alexander Calder (1898–), whose father and grandfather had also been sculptors, early exploited the possibilities of movement in his mobiles, delicately balanced hanging compositions of forms which may owe something to Matisse, Arp, and Miró, but which he has made essentially his own. His mobiles frequently have the wit of his amusing wire sculptures, while his stabiles,

182 (above, left) ISAMU NOGUCHI (1904–) *Kouros, 1945. Pink Georgia marble, slate base, h. about 9′9″ (298). The Metropolitan Museum of Art, New York, Fletcher Fund, 1953*

183 (above, center) THEODORE ROSZAK (1907–) *Sea Sentinel, 1956. Steel brazed with bronze, h. 8′9″ (267). Collection of the Whitney Museum of American Art, New York*

184 (above) SEYMOUR LIPTON (1903–) *Pioneer, 1957. Nickel-silver on Monel metal, h. 7′10″ (239). The Metropolitan Museum of Art, New York, Gift of Mrs Albert A. List, 1958*

185 (above) DAVID SMITH (1906–65) *Cubi XIX, 1964. Stainless steel, h. 9′ 5⅛″ (287.3). The Tate Gallery, London. Photo by courtesy of the Marlborough Gallery Inc., New York*

stationary pieces composed of riveted steel plates in forms suggesting the organic, often on such a colossal scale as to take on an environmental quality, prove him to be perhaps the most successful monumental sculptor of his times (*Ill. 186*).

Unlike Calder, but like many other contemporary artists, Louise Nevelson (1890–) uses commonplace objects. Her walls and columns are made up of stacks of shallow boxes containing bits of balusters, fragments of chairs and other furniture, and other pieces of turned, carved, or sawn wood, composed with elegance and variety, and painted a uniform black, gold, or white. With the added dimension of color, her constructions create a mysteriously other-worldly atmosphere, winning her a leading place among environmental sculptors, as well as proving her to be perhaps the most consistently satisfactory of those practising assemblage.

Questions of reality and identity, anticipated in the late 19th century by the paintings of Harnett and others who pushed illusionism toward a new factuality, keep recurring in various guises. They appear in Andy Warhol's repetition of soup cans and detergent packages, which not only monumentalize the commonplace, but, like the bronze beer cans and cans with paint brushes of Jasper Johns (1930–), so carefully sculptured and painted that it is difficult to tell them from the originals, provide an ambiguous substitute. They are present also in the life-size figures, often completed with a

waxworks-like fidelity in various media, that a number of artists have produced from the late '60s, and in the detailed descriptive naturalism of a group of painters who emerged at about the same time. On the other hand, the soft telephones, typewriters, and other appliances of Claes Oldenburg (1929-), and his soft toilet, recalling Salvador Dali's fictile watches, satirize American pre-occupation with plumbing and other such amenities. His 'monuments for today' have similar implications – schemes for colossal enlargements of objects of equal triviality (*Ill. 187*), like gargantuan toilet tank floats to be fastened to London's Tower Bridge to rise and fall with the tide. Such notions enter the realm of conceptual art, projects, existing only in idea, that are not only incapable of realization but that the artist has no intention of carrying out, or projects that involve merely a process, gesture, or ritual like a fragment of a happening.

There is an element of ambiguity in all this which also appears in the idea that any object whatsoever may be selected and displayed as art, like Marcel Duchamp's 'readymades', or incorporated in a work of art, like the found objects in Smith's sculpture or in Rauschenberg's 'combines'. This sort of thing was pioneered by Picasso and Braque in collage, and by Picasso in assemblage, in the early years of the century, and was soon taken up by a number of Americans, perhaps most successfully by Arthur Dove. Though not present in Dove's work, there is frequently a Dadaist element involved, as Duchamp proved when he submitted a porcelain urinal entitled *Fountain* and signed 'R. Mutt' to the exhibition sponsored by the Society of Independent Artists in New York in 1917. Though the emphasis is on novelty, there seems to be also a frequent turning back in this way to pick up threads of the recent past and to recombine familiar elements with the new in a search for continuities to create a new and viable tradition.

The new dimension of movement, initiated by Calder, has led to all sorts of experiment with the kinetic, from simple, wind-activated forms to elaborate transistorized devices and remote-control or computer-programmed mechanisms. But the insistent presence of the human figure remains, both in individual pieces, as most impressively proven by the works of Leonard Baskin, and in groups, like the curious families and other gatherings of semi-abstract characters of the Venezuelan-

187 CLAES OLDENBURG (1929-) *Giant Icebag, 1971. Vinyl, hydraulic mechanism and wood, expandable, h. between 7′ and 16′ (214–488). Executed in collaboration with Gemini, G.E.L. for the Art & Technology Exhibition, Los Angeles County Museum of Art, May 10– August 29, 1971*

186 *(opposite)* ALEXANDER CALDER (1898-) *Black Widow, 1959. Stabile, painted sheet steel, 7′7⅞″ × 14′3″ (233 × 436). Collection, The Museum of Modern Art, New York, Mrs Simon Guggenheim Fund*

188 GEORGE SEGAL (1925–)
*Woman in Doorway, 1965. Wood
and plaster, life-size. Stedelijk Mu-
seum, Amsterdam*

189 EDWARD KIENHOLZ
(1927–) *The Beanery, 1965. As-
semblage, life-size. Stedelijk Museum,
Amsterdam*

born Marisol Escobar (1930–), and the white plasters
cast direct from live figures in the often elaborate settings
of George Segal (1925–), which possess an atmosphere
of eerie stillness and the suggestion of alienation (*Ill. 188*).
Another of the more interesting exponents of this
environmental concept of sculpture is Edward Kienholz
(1927–), whose work has a further dimension of social
commentary with disturbing implications that go beyond
much of Pop Art.

In *The Beanery* (*Ill. 189*), for example, Kienholz has
recreated at consistent scale a real environment. A cheap
lunch counter, with juke box, cigarette-vending machine,
paper and magazine rack, bar and bar stools, is peopled
with figures of intense realism. But instead of faces, all
have the dials of clocks, which, like the clock on the wall,
are stopped at precisely the same moment. Everything,
including the beer bottles, sandwiches, figures, and
setting, is covered with a layer of dust. There is a dis-
quieting sense of menace in the result, with suggestions
of time's passing, that the hour has struck, the judgment
has come, and that all are subject to the same inexorable
fate.

So, in sculpture, as in painting, architecture, and all
the other arts, experiment continues with unabated
variety, from the utterly simplified anonymous forms of
Minimal structures to the elaborations of such works as

those of Segal and Kienholz. Further possibilities of movement are still being explored with the assistance of the latest technology. Sound has been added to movement to create results with something of the qualities of theatre and the performing arts. The computer has been employed to reveal the patterns of infinite variation possible in form and movement, applicable to virtually any art form including cinema, painting, graphics, and music, and to program such changes for ever-evolving effects. Such developments suggest yet new directions of experiment and new possibilities of synthesis, as artists go on 'seeking', in Walt Whitman's words, 'what is yet unfound.'

CLOSING THE CIRCLE

Just as each age must rewrite history for its own purposes and understanding, so it must also redefine its concept of reality. The latter is a matter not only for the philosopher but, as the record has shown, for the artist as well. American artists, like their counterparts elsewhere, seek to identify the place and function of the arts in the modern world, and to express the truths of a post-nuclear age. Because of the variety inherent in their tradition, with its often extravagant emphasis on adventure, experiment, and individualism, Americans, especially since mid-century, have restlessly pushed forward. Scarcely ever have inherited concepts been so deeply questioned, and the drive to change, no matter how destructive, been so strong.

Today innovation is everywhere. Thanks to modern communications, influences and ideas fly with the speed of light to maintain a state of ferment in the arts that reflects the tensions and the conflicts of an era that is launching men into space and probing the inner secrets of life, yet is unable to allow man the full expression of his human dignity, to live in peace, or to cease despoiling his vanishing natural heritage.

The internationalization of the arts is now a fact. In this sense, despite a divided world, Crèvecoeur's 'great circle', from the quotation with which we began this

brief survey, is now complete. No longer can we speak of an 'American' art in the same sense as in the past. In our own times the arts have accomplished much that wars and statesmanship have been unable to do, to create a sense of world community perhaps to a greater degree than ever before. Americans can be proud of the part their artists have played and continue to play in this constructive process.

ACKNOWLEDGMENTS

Andover Art Studio, Mass. 124; Wayne Andrews 1, 30, 112, 148; The Biltmore Co. 1972 110; Mario Carrieri, courtesy Peter Bellew 31, 145; Chicago Architectural Photographing Co. 113, 115, 118, 119, 143; George M. Cushing 33, 47; Detroit Public Library, Automotive History Collection (photo Joseph M. Klima Jr.) 146; The Fairbanks Family in America, Inc. 9; Fasch Studio, Milton, Mass. 17; R. Buckminster Fuller 157; Yukio Futagawa 156; Henry Whitfield State Historical Museum, Guilford, Conn. (courtesy William C. Bixby Jr., Killingworth, Conn.) 12; Pennsylvania Historical and Museum Commission, Harrisburg, Pa. 8; Hedrich-Blessing, Chicago 114, 144; courtesy Philip Johnson 152 (photo Ezra Stoller), 154; Robert E. Lee Memorial Foundation Inc. 26; Allan Ludwig 21; Richard McLanathan 13; Thomas Jefferson Memorial Foundation, Monticello, Va. 51; Eric H. Muller 72; Hans Namuth 171; National Trust for Historic Preservation (photo Edmund Barrett) 79; The Preservation Society of Newport County, Newport, R.I. 29; Leo Castelli Gallery, New York 177; Sidney Janis Gallery, New York (photo Geoffrey Clements) 175; The New-York Histori-cal Society, New York City, by courtesy of the New York City Park Department 138; courtesy Rockefeller Center, Inc., New York 149; Museum of Arts and Sciences, Norfolk, Va. (photo Haycox Photoramic Inc.) 10; Sandak Inc., New York 14; Collections in the Museum of New Mexico, Santa Fé (photo T. Harmon Packhurst) 2; Sleepy Hollow Restorations, Tarrytown, N.Y. 5; Taylor and Dull, New York 64; Ralph Thompson 53; courtesy Trans World Airlines (photo Klaus Drinkwitz) 153; United States Information Service, London 54, 141; United States Travel Service, London 82; Virginia Chamber of Commerce (photo Phil Flournoy) 11, 27; Herbert P. Vose, Wellesley Hills, Mass. 34; Library of Congress, Washington, D.C. 3, 15, 25, 28, 32, 42, 48; U.S. Department of the Interior, National Park Service, Washington, D.C. 103; Colonial Williamsburg photograph 24. Ill. 7 is from H. W. Rose, *The Colonial Houses of Worship in America*, 1963; Ill. 22, from Robert Sears, *Pictorial Description of the United States*, 1848; Ill. 23, from J. H. Stark, *Stark's Antique Views of Ye Towne of Boston*, 1907; Ill. 111, from M. G. Van Rensselaer, *Henry Hobson Richardson and his Works*, 1888

The following, partly annotated list of books has been selected from the vast amount written on American art as being most useful for further reading. Only a few of the more important monographs are included. For periodical literature the reader is referred to the quarterly *Art Index* available in any library. An asterisk denotes works available in paperback, while a dagger marks those containing especially useful bibliographies. The few catalogues listed have been identified by the museum that published them. For clarity, full titles have been generally used; otherwise references have been kept to a minimum. Works are listed alphabetically by author under headings corresponding to the sections of the book in the order in which they occur in the text.

CONTEMPORARY SOURCES

William Dunlap, *History of the Rise and Progress of the Arts of Design in the United States*, 1834, ed. Alexander Wykoff, 3 vols., 1965; the first, still lively and useful. Henry T. Tuckerman, *Artist Life: or Sketches of Eminent American Painters*. 1847, and *Book of the Artists: American Artist Life*, 1867, ed. James F. Carr, 1966; pioneering works by a sympathetic critic. Horatio Greenough, *The Travels, Observations, and Experiences of a Yankee Stonecutter*, 1852; the sculptor-author was one of the most acute interpreters of American creative life (see also below). James Jackson Jarvis, *The Art-Idea*, 1864, ed. Benjamin Rowland, Jr., 1960; by an important early collector. Sadakichi Hartmann, *A History of American Art*, 1902, rev. ed. 1932; the first attempt at a comprehensive survey. Lorado Taft, *The History of American Sculpture*, 1903; until recently the only survey, dated. Samuel Isham, *The History of American Painting*, 1905, enlarged ed. by Royal Cortissoz, 1927; still useful though dated. *John W. McCoubrey, ed., *American Art 1700–1900 – Sources and Documents*, 1965; valuable anthology.

CURRENT GENERAL WORKS

*Wayne Andrews, *Architecture, Ambition, and Americans, A History of American Architecture*†, 1955; selective, interpretive. Wolfgang Born, *American Landscape Painting, An Interpretation*, 1948, and *Still Life Painting in America*, 1947; both useful. *John Burchard and Albert Bush-Brown, *The Architecture of America, A Social and Cultural History*†, 1961; the best survey. Wayne Craven, *Sculpture in America*, 1968; the only survey since 1903. *Cedric Dover, *American Negro Art*, 1969; with Porter (see below) basic for the subject. Henry Dorra, *The American Muse*, 1961; documents American attitudes as reflected in the arts. George C. Groce and David H. Wallace, *The New-York Historical Society's Dictionary of Artists in America*, 1564–1860; essential reference. Oskar Hagen, *The Birth of the American Tradition in Art*, 1940; a thought-

ful study. *Henry-Russell Hitchcock, Albert Fein, Winston Weisman, and Vincent Scully, *The Rise of an American Architecture*, ed. by Edgar Kaufmann, Jr., 1970; contains excellent essays on American architecture, urban planning, and environmental design from the 19th century. Oliver W. Larkin, *Art and Life in America*†, rev. ed. 1960; the best general survey. *John W. McCoubrey, *American Tradition in Painting*, 1963; a brief, thoughtful analysis. *Richard McLanathan, *The American Tradition in the Arts*, 1968; a selective, interpretive study of the major and minor arts from earliest times to the present. Hugh Morrison, *Early American Architecture from the First Colonial Settlements to the National Period*†, 1952; the best survey. *James A. Porter, *Modern Negro Art*†, 1969; with Dover (see above) basic for the subject. Edgar P. Richardson, *Painting in America: The Story of 450 Years*†, new ed., 1965; the best survey. Aline B. Saarinen, *The Proud Possessors: The Lives, Times, and Tastes of Some Adventurous American Art Collectors*, 1958; entertaining account of major 19th- and 20th-century American collectors. Vincent Scully, *American Architecture and Urbanism*, 1969; by one of our best architectural historians. *Christopher Tunnard and Henry Hope Reed, *American Skyline, The Growth and Form of Our Cities and Towns*†, 1956; brief, excellent. John Wilmerding, *A History of American Marine Painting*, 1968; useful survey.

'A LAND OF DIVERS AND SUNDRY SORTS'

Paul L. Grigaut, *The French in America, 1570–1763*, Detroit Institute of Arts, 1951. Rexford G. Newcomb, *Spanish Colonial Architecture in the United States*, 1937. Trent E. Sanford, *The Architecture of the Southwest: Indian, Spanish, American*, 1950. Mitchell A. Wilder and Edgar Breitenbach, *Santos: The Religious Folk Art of New Mexico*, 1943.

THE BEGINNINGS OF SETTLEMENT TO 1700

*James T. Flexner, *First Flowers of Our Wilderness*, 1947. Allan Ludwig, *Graven Images*, 1966; a beautifully illustrated essay on Puritan gravestones, the first native school of sculpture. Thomas T. Waterman, *The Dwellings of Colonial America*, 1950. *Louis B. Wright, *The Cultural Life of the American Colonies, 1607–1763*†, 1957.

FROM 1700 TO THE REVOLUTION

*Carl Bridenbaugh, *The Colonial Craftsmen*, 1961, and *Peter Harrison, First American Architect*, 1949. *James T. Flexner, *America's Old Masters*, 1939. Henry Wilder Foote, *Robert Feke, Colonial Portrait Painter*, 1930, and *John Smibert, Painter*, 1950. *Fiske Kimball, *Domestic Architecture of the American Colonies and the Early Republic*, 1922; a pioneering work and a classic study. Jules David Prown, *John Singleton Copley*, 2 vols., 1966.

THE REVOLUTION TO THE AGE OF JACKSON

Grose Evans, *Benjamin West and the Taste of His Times*, 1959. James T. Flexner, *Gilbert Stuart*, 1955, and **The Light of Distant Skies, 1760–1835*, 1954. Ihna T. Frary, *Thomas Jefferson, Architect and Builder*, 1931. Albert TenEyck Gardner, *Yankee Stonecutters, The First American School of Sculpture, 1800–1850*, 1954. *Talbot Hamlin, *Greek Revival Architecture in America*†, 1944; a comprehensive, classic study. Fiske Kimball, *Mr. Samuel McIntire, Carver, The Architect of Salem*, 1940. *Russell Blaine Nye, *The Cultural Life of the New Nation, 1776–1830*, 1960. Charles A. Place, *Charles Bulfinch, Architect and Citizen*, 1925. Edgar P. Richardson, *Washington Allston, A Study of the Romantic Artist in America*, 1948. Charles Coleman Sellers, *Charles Willson Peale*, 2 vols., 1934.

THE AGE OF JACKSON TO THE CIVIL WAR

Alexander B. Adams, *John James Audubon*, 1966; one of the best among recent monographs. Marion V. Brewington, *Shipcarvers of North America*, 1962. Edwin O. Christensen, *The Index of American Design*, 1950. Carl W. Condit, *American Building Art, The Nineteenth Century*, 1960. *James T. Flexner, *That Wilder Image, The Painting of America's Native School from Thomas Cole to Winslow Homer*, 1962. Lloyd Goodrich, *American Genre*, The Whitney Museum, 1935. *Horatio Greenough, *Form and Function*, ed. Harold A. Small, 1947; contains most of Greenough's important critical writing. Oliver W. Larkin, *Samuel F. B. Morse and American Democratic Art*, 1954. Nina F. Little, *The Abby Aldrich Rockefeller Folk Art Collection*, 1957; more than just the catalogue of an important collection. Jean Lipman and Mary C. Black, *American Folk Decoration*, 1967. Jean Lipman and Alice Winchester, *Primitive Painting in America*, 1950. *M. & M. Karolik Collection of American Paintings, 1815–1865*, intro. by John I. H. Baur, 1949, and *M. & M. Karolik Collection of American Water Colors and Drawings 1800–1875*, intro. by Henry P. Rossiter, 1962; both important landmarks. *Russell Lynes, *The Tastemakers*†, 1954; an amusing and discerning account of American taste from the 19th century on. Harold McCracken, *George Catlin and the Old Frontier*, 1959. Roger Hale Newton, *Town & Davis, Architects*, 1942; a study of the wide practice of the first, and among the most influential, architectural partnerships in the U.S. Barbara Novak, *American Painting of the Nineteenth Century, Realism, Idealism, and the American Experience*, 1969. Edgar P. Richardson, *American Romantic Painting*, 1944; brief text, many illustrations. Everard M. Upjohn, *Richard Upjohn, Architect and Churchman (1802–1878)*, 1939.

THE CIVIL WAR TO THE TURN OF THE CENTURY

Wayne Andrews, *Battle for Chicago*, 1946; a lively account of the development of the skyscraper. Albert TenEyck Gardner, *Winslow Homer, American Artist: His World and His Work*, 1962. Lloyd Goodrich, *Thomas Eakins, His Life and Work*, 1933; Goodrich's monograph on Homer is also excellent; his **Albert P. Ryder*, 1959, has more information than his *Ryder Centenary Exhibition Catalogue*, The Whitney Museum, 1947. Alfred Frankenstein, *After the Hunt: William Harnett and Other American Still Life Painters 1870–1900*, rev. ed. 1969; an interesting piece of scholarly detective work. Henry-Russell Hitchcock, *The Architecture of H. H. Richardson and His Times*, 1936: a definitive work by a leading architectural historian. *Hugh Morrison, *Louis Sullivan, Prophet of Modern Architecture*, 1935. *Lewis Mumford, *The Brown Decades, A Study of the Arts in America, 1865–1895*, 2nd ed. 1955. *Nikolaus Pevsner, *Pioneers of Modern Design from William Morris to Walter Gropius*, 1964; excellent account of both European and American design. Vincent Scully, *The Shingle Style: Architectural Theory and Design from Richardson to the Origins of Wright*, 1955. Frederick A. Sweet, *Sargent, Whistler, and Mary Cassatt*, Chicago Art Institute, 1954; an excellent presentation of the three leading expatriate painters of the period.

THE TWENTIETH CENTURY

John I. H. Baur, *Revolution and Tradition in Modern American Painting*, 1951. *Milton W. Brown, *American Painting from the Armory Show to the Depression*, 1955, and *The Story of the Armory Show*, 1963. Carl W. Condit, *The Rise of the Skyscraper*, 1952. Sigfried Giedion, *Space, Time and Architecture*, 1949; indispensable for modern architecture, both European and American. *Ira Glackens, *William Glackens and the Ash Can Group*, 1957; a delightful account. Lloyd Goodrich, *Pioneers of Modern Art in America: The Decade of the Armory Show, 1910–1920*, 1963. *Clement Greenberg, *Art and Culture*, 1961; Greenberg and Rosenberg (see below) are two major interpreters and critics of recent artistic developments. Frederick A. Gutheim, ed., *Frank Lloyd Wright on Architecture*, 1941; most of Wright's writings are available in paperback. Henry-Russell Hitchcock, *In the Nature of Materials: 1887–1941: The Buildings of Frank Lloyd Wright*, 1942; comprehensive, outstanding. Henry-Russell Hitchcock and Arthur Drexler, *Built in U.S.A.: Post-War Architecture*, 1952, and Henry-Russell Hitchcock and Philip Johnson, *The International Style: Architecture since 1922*, 1932, are both important studies. Sam Hunter, *Modern American Painting and Sculpture*, 1959. Jane Jacobs, *The Death and Life of Great American Cities*, 1961; controversial, influential. *Lewis Mumford, *The City in History*, 1961, and **Roots of Contemporary American Architecture*, 1959; both important, the second a very valuable anthology. *Barbara Rose, *American Art Since 1900*, and **Readings in American Art Since 1900*, 1967. *Harold Rosenberg, *The Tradition of the New*, 1959, and **The Anxious Object*, 1964; interpretive criticism of artistic developments of the '40s and '50s. Jackson Pollock, *Jackson Pollock*, ed. Bryan Robertson, 1960. Andrew Ritchie, *Abstract Painting and Sculpture in America*, 1951; one of the many useful publications of the Museum of Modern Art, which include Alfred H. Barr et al, *American Realists and Magic Realists*, 1943, James J. Sweeney, *Stuart Davis*, 1945, Sam Hunter, *Jackson Pollock*, 1956, James T. Soby, *Ben Shahn*, 1947, William Carlos Williams, *Charles Sheeler, Paintings, Drawings, Photographs*, 1939, and William C. Seitz, *Mark Tobey*, 1962. Vincent Scully, *Modern Architecture*, 1961.